POOLS AND SPAS

First published in the United States of America by
Rockport Publishers, Inc.
33 Commercial Street
Gloucester, Massachusetts 01930-5089
Telephone: (978) 282-9590
Fax: (978) 283-2742
www.rockpub.com

Library of Congress Cataloging-in-Publication Data
Sanderfoot, Alan E.
 Pools & spas : new designs for gracious living / Alan E.
Sanderfoot.
 p. cm.
 ISBN 1-56496-941-X (hardcover)
 1. Swimming pools. 2. Spa pools. I. Title: Pools and spas.
II. Title.
TH4763 .S285 2003
643'.55-dc21 2002011366

ISBN 1-56496-941-X

10 9 8 7 6 5 4 3 2 1

Design: **Deep Creative**
Cover Image: **Tim Street-Porter**

Printed in China

GLOUCESTER MASSACHUSETTS

ROCKPORT
PUBLISHERS

POOLS AND SPAS

NEW DESIGNS FOR GRACIOUS LIVING

ALAN E. SANDERFOOT
Foreword by Jennifer Bartlett

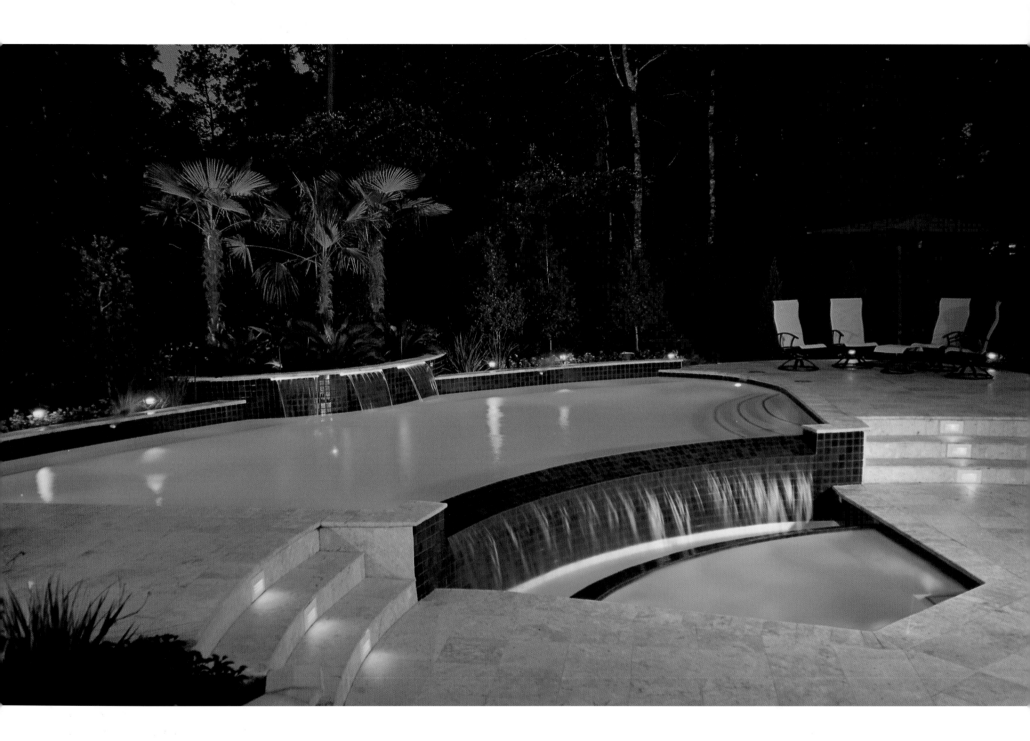

6 FOREWORD by Jennifer Bartlett

8 INTRODUCTION

CONTENTS

10 MODERN MARVELS
Contemporary Pool
and Hot Tub Designs

32 NATURAL PHENOMENA
Natural-Looking Designs
That Incorporate Real and
Artificial Rock

50 WATER IN MOTION
Unique Water Features
in Pool and Spa Designs

66 ALLURING ILLUMINATIONS
Outstanding Examples
of Pool and Hot Tub Lighting

80 VANISHING ACTS
The Magical World
of Negative-Edge Pools

102 SMALL SPACES
Installations That Make
the Most of a Small Yard

116 INDOOR OASES
Indoor Installations
That Bring the Outdoors In

138 GARDENS OF EDEN
Pools and Hot Tubs in Luxurious
Garden Settings

158 ARTISTIC INTERPRETATIONS
Unique Pool and Hot Tub Designs

172 DIRECTORY OF DESIGN
PROFESSIONALS

174 DIRECTORY OF
PHOTOGRAPHERS

176 ACKNOWLEDGMENTS

Six P.M. from the "Air.24 Hours" series

In the Garden — Drawing #62

FOREWORD

In 1989 I purchased an old warehouse in the West Village in New York City. Acting as my own architect and contractor, I designed the interiors, three levels of gardens and an indoor lap pool on the fourth floor. This room, with a view of the Hudson River, eventually became my bedroom.

Bodies of water—whether taking the form of oceans, creeks, or pools—have been recurring subjects in my work. There's *Swimmers Atlanta*, a 1978 public commission for the Federal Courthouse; *Up the Creek*, a ten-part installation from 1982; *The Seasons and Elements*, a series of paintings and pastels made in the early 1990s; and then a series of paintings, sculptures, and plate pieces entitled *Water*, which I completed in 1997.

But perhaps the most relevant body of work in light of this book was *In the Garden*. I spent the winter of 1980 in a dilapidated rented villa in Nice. Expecting sunny days and temperate weather, I was met by dampness, cold, and rain. Despite the sad garden, crumbling pool, and miserable weather, a series of two hundred drawings were borne from this stay. And nearly all of them featured that pool.

While water and, specifically, pools have not been the primary subjects of my work in recent years, I still find myself drawn to them, especially when they are found in unexpected locations. Given the time of day and the direction of the sunlight, the same pool can appear translucent and refreshing or dark and foreboding. It can offer a distorted view of what lurks beneath, or it can mirror the world above like a reflecting pond.

As a pool owner and someone who is drawn to water, I am pleased that this beautifully illustrated book explores pool designs, both exotic and familiar.

Jennifer Bartlett

Of all the elements in nature, none is more life affirming than water. We're born into this wonderful world after swimming in the mysterious elixir for nine months, and then we spend the rest of our days seeking out its sustaining powers.

INTRODUCTION

When you consider that two-thirds of our bodies are composed of water, it's no wonder we are so drawn to it—be it in the form of lakes, rivers, oceans, bays, ponds, creeks, or even (as children) puddles after a spring rain. And when nature doesn't place water where we can easily access it, we have no problem bringing water to us in the form of luxurious swimming pools and hot tubs.

When I was a young boy growing up in a small town, the public swimming pool was my summer home away from home and a place where childhood memories were made. I remember the warm concrete deck almost burning my feet as I made a beeline for the diving board so I could try to get the lifeguards wet for the thousandth time. When I was twelve, my family moved to the country, and it took just one summer without easy access to a swimming hole before my parents had our very own pool installed in the backyard. It was as if life wasn't complete without one.

More recently, the "nesting" phenomenon of the eighties and nineties has been a boon to swimming pool and hot tub designers. As people continue to seek ways to make their limited free time at home more relaxing and enjoyable, aquatic environments naturally top the list. Indeed, homeowners aren't stopping with the bathroom remodel, gourmet kitchen, or home theater. Along with these lavish amenities, people are looking outside their abodes for ways to expand their living space. Consider the increasing number of outdoor kitchens, high-end barbecue grills, elaborate gardens, casual furnishings, swimming pools, and hot tubs, and you can see that the concept of the "outdoor room" has caught on.

The biggest change in pools and hot tubs over the years has been in the area of design—especially above the waterline. Long gone are the days of cookie-cutter pools, whereby one size is supposed to fit every backyard. Increasingly, a swimming

pool of the new millennium is designed to match the lifestyle of its owner, the architecture of the home, and the topography of the land. In fact, many of today's pools have very little to do with swimming—they're more about creating a scene for entertainment and relaxation. That requires moving water, nighttime illumination, and architectural details that please the eye. From modern, geometric designs to natural-looking pools with amazing rockwork, contemporary swimming pools are about individual style.

With that in mind, I'm excited to present this collection of outstanding and unique interpretations on the modern swimming pool and hot tub. May they inspire you to create your own aquatic oasis wherever you live.

Alan E. Sanderfoot

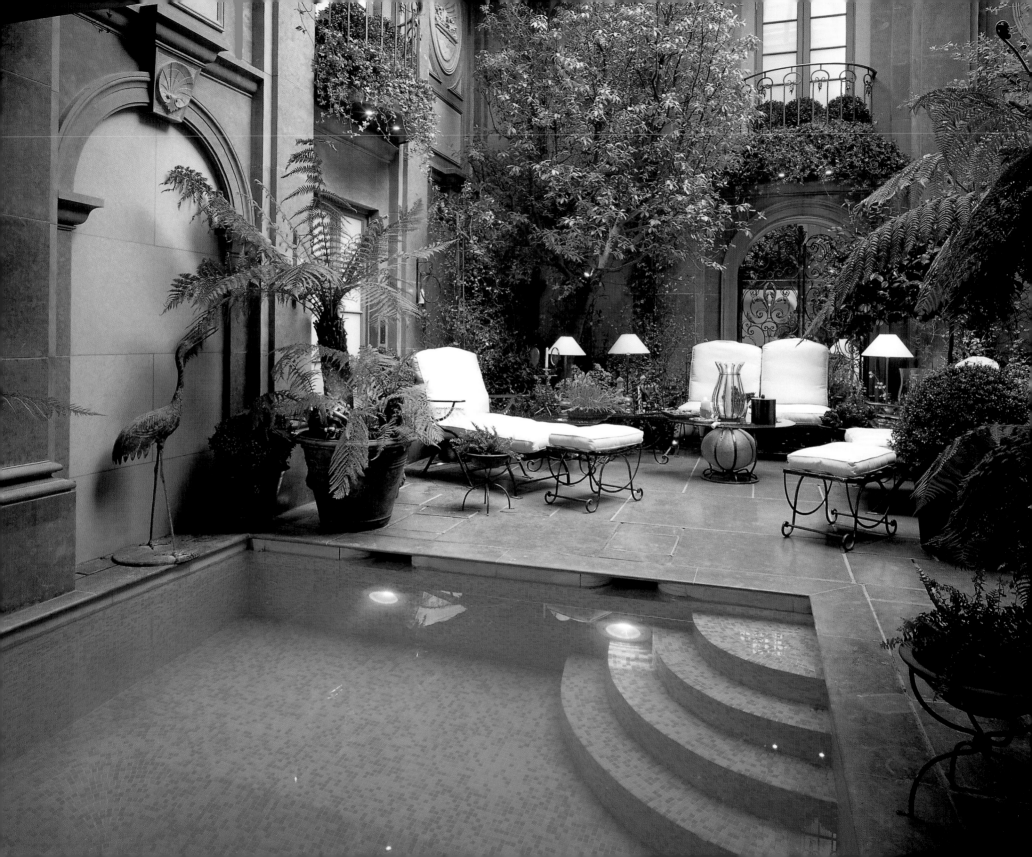

"Water is H_2O, hydrogen two parts, oxygen one, but there is also a third thing that makes water and nobody knows what it is."

D.H. Lawrence (1885–1930), *Pansies*, 1929

MODERN MARVELS

Geometric, minimalist, futuristic… all words to describe modern swimming pool and hot tub designs. Yet there was a time when what passed for modern design was a 40-foot lap pool with cantilevered decking. Today's architects—armed with space-age materials and engineering prowess—surpass earlier notions by taking residential pool design to new levels. The result: swimming pools and hot tubs that are as innovative as the homes that surround them.

Alternative purification methods—such as ozonators, ionizers, and mineral purifiers—mean that modern swimming pools can be safely sanitized with fewer harsh chemicals. Likewise, automatic cleaning systems have eliminated much of the maintenance woes

pool owners lament. In fact, everything about a swimming pool and hot tub, from the pumps and heaters to the lights and water features, can be easily controlled with the touch of a few buttons, either from inside the home or via remote devices, including the Internet.

By merging the latest technologies with innovative designs, modern architects are proving that "minimal" doesn't have to mean sterile, "modular" doesn't have to be uncomfortable, and "contemporary" can be timeless. From the California coast to the hilltops of Tokyo, here are inspiring examples of swimming pools and spas with superb engineering and stylish interpretations of what modern living is all about.

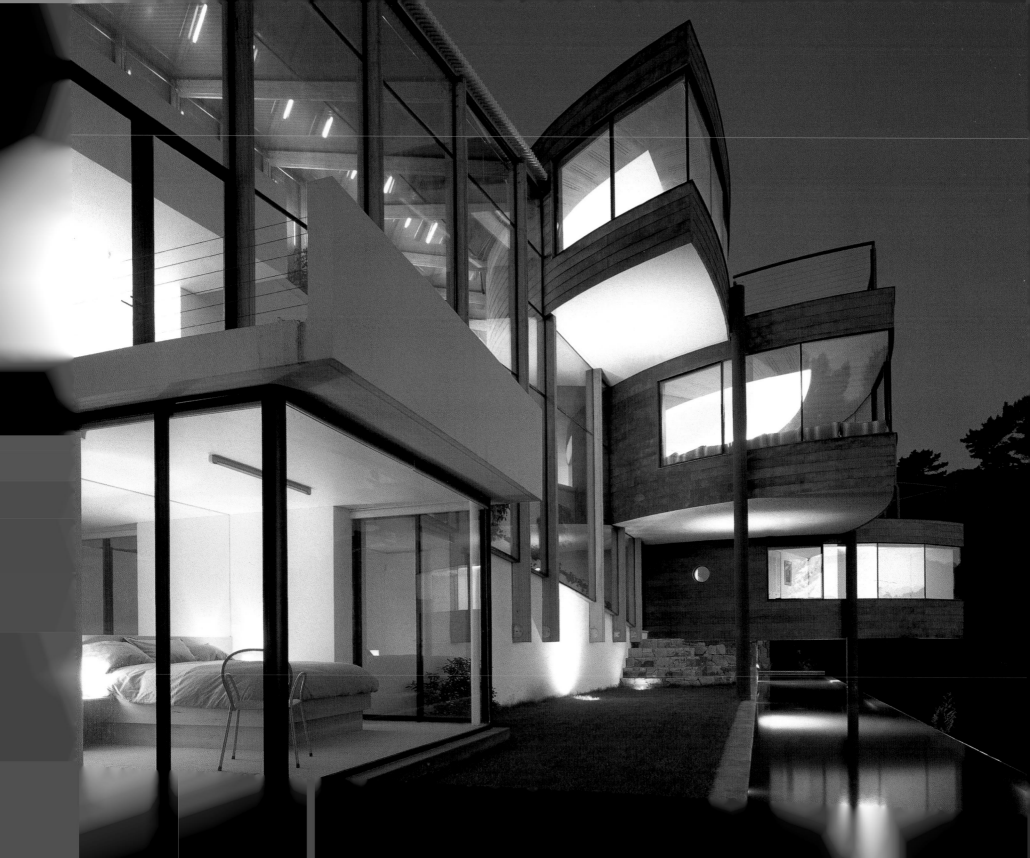

CLEAR VISION

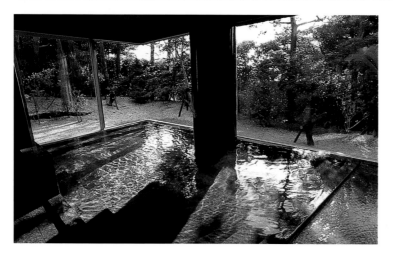

You can be pretty sure the residents of this house don't throw stones. What makes the glass structure impressive, however, is the way it's intermingled with water. Combining the clarity of translucent glass, reflective water, and clear skies, the architect has created a home where what you don't see is as significant as what you do. If you've ever wanted to walk on water, this lucent home—simply titled Water/Glass by the architect—is as close as you can get. Call it divine inspiration without heavenly intervention.

∧
Steel louvers cover the glass house, filtering sunlight over the clear structure and reflective water.

>
The shallow pool's vanishing edge creates the illusion that the water is flowing into the Pacific Ocean.

Location: **Atami, Shizuoka Prefecture, Japan**
Type of construction: **Concrete**
Pool/spa finish: **Granite**
Decking and coping: **Granite**

DESIGN DETAILS
Figuring out where the house ends and the pool begins is a challenge with this all-glass guesthouse, which overlooks the Pacific Ocean on a bluff high above the Atami coast. The transparent villa is essentially three pods surrounded by water. Bridges and staircases made from laminated safety glass link these pods. Even the floors and furniture are made of safety glass to create visual continuity between the home's architecture, the water features, and the ocean.

Especially intriguing is the third-floor lounge, which is set atop a black granite surface that's continually flooded with 6 inches (15 centimeters) of water. Black granite was chosen for the way it blends with nature and reflects light.

In order to blur the line between the floor of the lounge and the Pacific Ocean, the floor is made of two pieces of safety glass laminated together. Lighting fixtures set beneath the floor create the illusion that the room is floating on the water at night. Because nothing is allowed to obstruct the aquatic view, even the lounge's table and chairs are made of laminated safety glass for strength and clarity.

Equally amazing, the third level of the villa can be accessed from a first-floor deck by way of a covered glass bridge. All parts of the bridge—from the floor to the handrails—are made of glass, giving guests the feeling that they are floating on air as they approach the building. Along the way, they can enjoy an unobstructed view of a waterfall to one side.

PROFESSIONALS | Architect: **Kengo Kuma & Associates** Photographer: **Mitsumasa Fujitsuka**

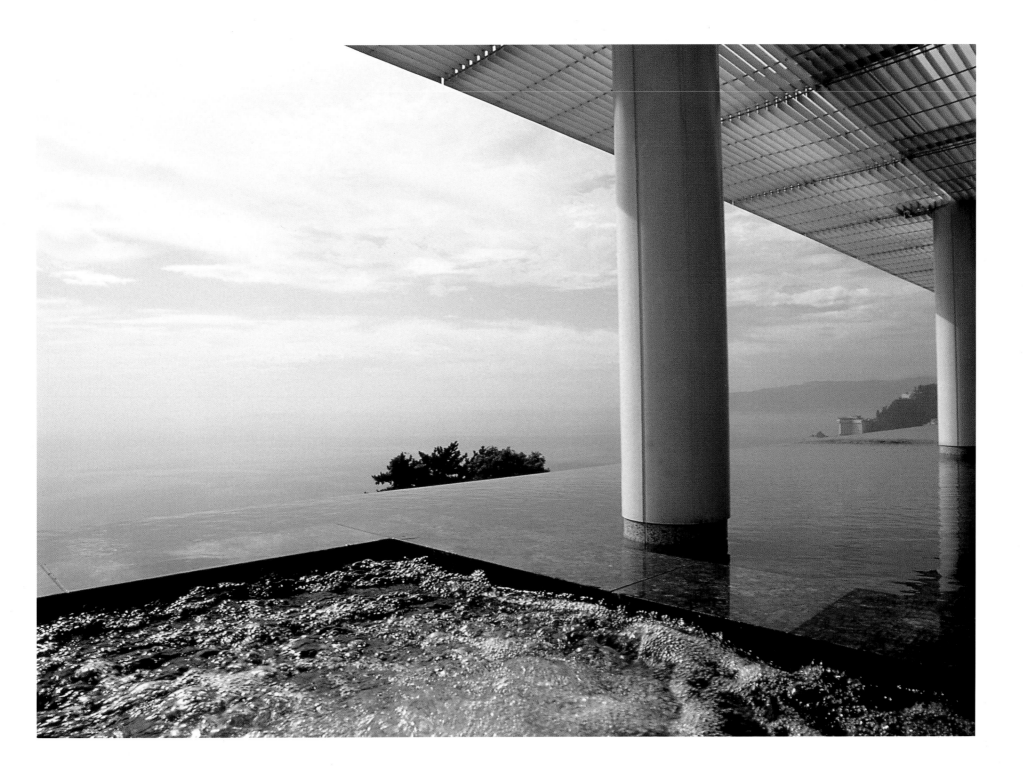

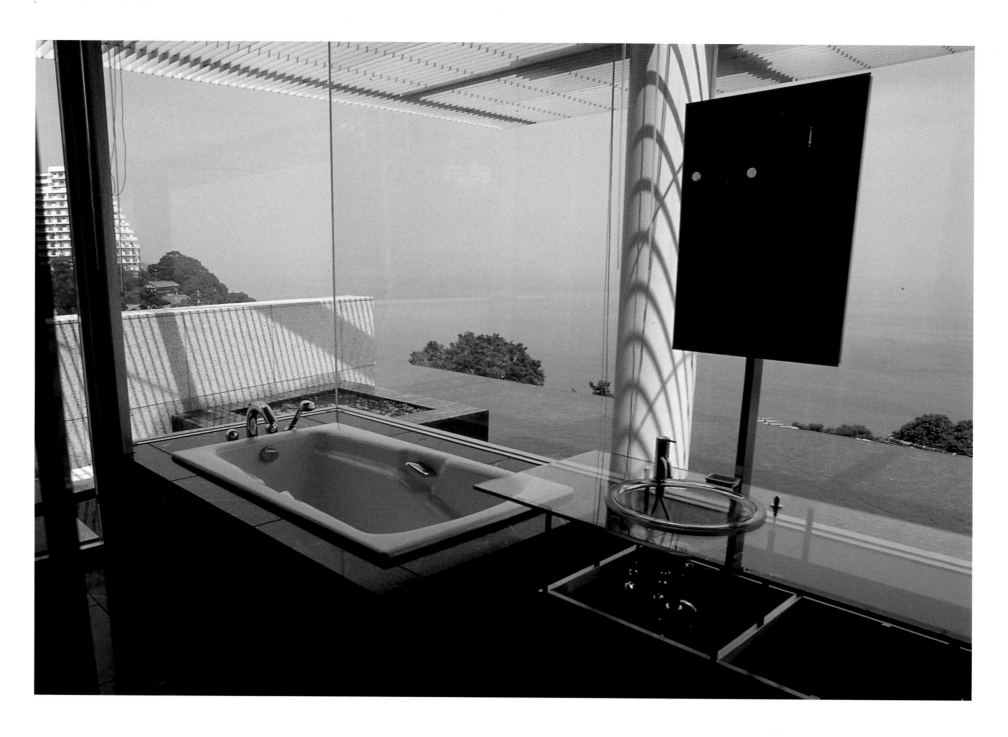

A black granite hot tub on the first floor offers more than aquatic therapy; it provides the perfect respite from which to view the vanishing-edge effect created by the blending of the granite surface with the distant sea.

A canopy of stainless steel louvers covers the entire water-covered section of the third level. Thus, one sees just two horizontal planes—the louvers above and the water-covered granite below—with the glass structures in between serving as a filter for light. According to its creator, the villa is an experimental sightline installation.

"I want to erase architecture. That's what I've always wanted to do," wrote architect Kengo Kuma. "I want to create a condition that is as vague and ambitious as drifting particles. The closest thing to such a condition is a rainbow. A rainbow is not an actual object, and that is what makes it attractive."

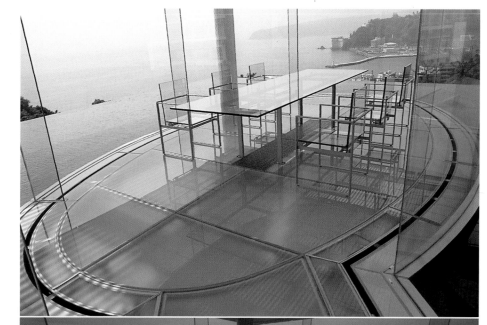

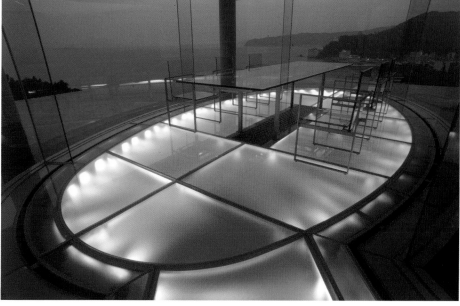

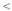

↗
Glass walls provide a 360-degree view and create the feeling of walking on water.

>
Lighted glass floors cast a glow across the waterscape while creating the illusion that the house is floating on water.

<
The outdoor spa is a fluid extension of the transparent bathroom.

ON THE EDGE

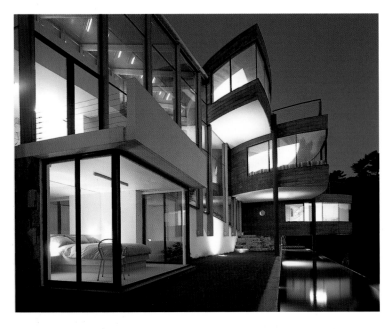

∧
Interior lighting bathes the poolside at night, requiring minimal landscape lighting.

>
A room cantilevered over the pool creates a shady grotto effect, which is enhanced by the stone wall.

> **Far right**
Three rooms are thrust over the pool like fish leaping out of water.

Location: **Zapallar, Chile**
Type of construction: **Concrete**
Pool/spa finish: **Paint**
Decking and coping: **Stone**

Picture yourself swimming laps in this hillside pool, the vanishing edge pulling you toward the ocean beyond. Skimming alongside the treetops, you feel connected to the sky, close enough to touch the clouds—or at least swim through their reflection on the water's surface. You could play it safe and lounge on the grassy pool deck, but isn't it more exciting to live on the edge—especially a fluid one that appears to vanish? If you swim your laps hard enough, this pool might just carry you out to sea, setting you free.

DESIGN DETAILS
Perched along the crest of a hillside overlooking the Pacific Ocean, this 30-yard (25-meter) lap pool bridges the gap between natural and man-made waters.

Though the water spills over the entire length of the pool, this is not a true vanishing-edge design because the top of the weir is sloped toward the pool, as opposed to away from it, thus making the top of the weir visible. This was necessary to keep the water from spilling past the catch basin on the

back side, which is rather narrow due to the severe slope. In fact, grounding the pool on the steep incline was an engineering feat in itself, requiring an extraordinarily deep foundation.

A trio of tiered rooms juts out from the house and over the pool, like a school of fish making its way toward sea. The scalloped design and sea green color enhance the illusion. The lowest tier actually extends past the pool, creating a shady grotto like section near one end. A narrow patch of grass

flanks the opposite end of the pool and forms a perfect spot for poolside lounging.

Though each room of the house is designed to maximize the ocean view, one can't help but notice the pool as well—especially at night when underwater lights illuminate the blue edge that one hears cascading over the hillside.

PROFESSIONALS | Architect: **Enrique Browne y Asociados** Contractor/Engineer: **Juan Eduardo Saavedra** Landscape Designer: **Juan Grim and M. Angelica Schade** | Photographer: **Guy Wenborne**

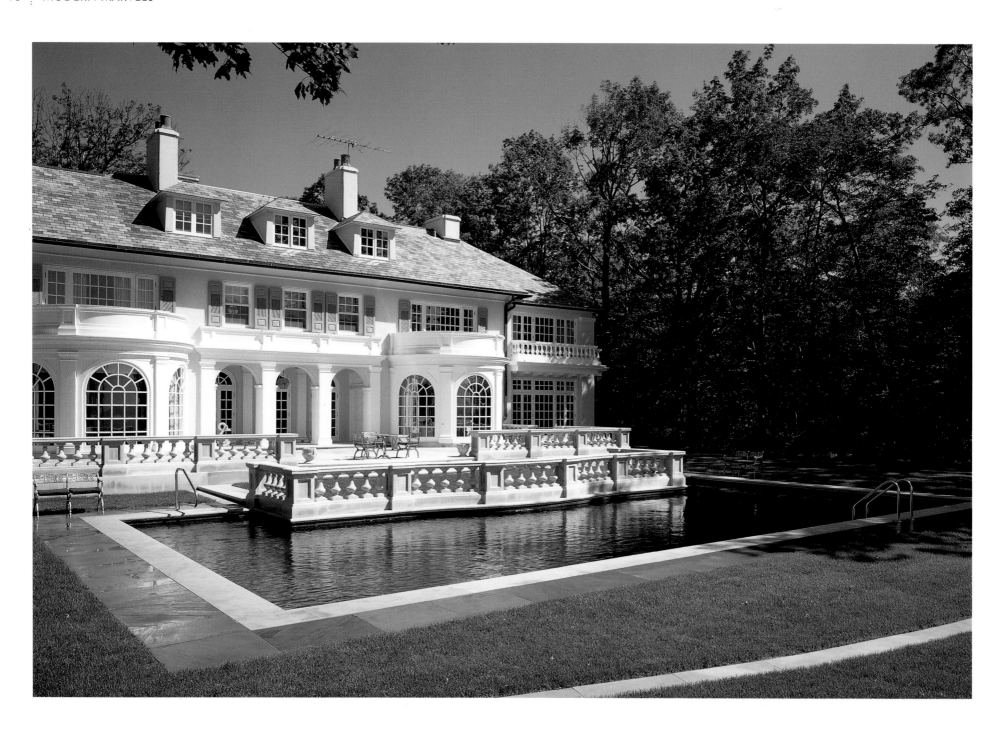

ESTATE PLANNING

Like something out of *The Great Gatsby*, this pool and spa installation oozes opulence. The sprawling, raised terrace and massive, manicured lawn are architectural invitations for lavish, lakeside entertaining. Though extravagant in its size, the pool appears more stately than self indulging. Such sinful delights are left to the nearby spa, which can't help but be a bit hedonistic. Then again, an epic estate demands a little decadence—especially of the aquatic variety.

Location: **Lake Forest, Illinois, USA**
Type of construction: **Gunite**
Pool/spa finish: **Black plaster**
Decking and coping: **Limestone and bluestone**

↗
The nearby spa mirrors the look of the reflecting pool.

<
The pool's black plaster surface contrasts nicely with the limestone coping and bluestone deck.

DESIGN DETAILS
A monumental home requires a monumental pool. Situated on a bluff overlooking Lake Michigan, this 25-by-57-foot (7.6-by-17-meter) pool fits the bill. Surfaced with black plaster, the pool acts as a reflecting pond, mirroring the classically styled home and neighboring trees. A grass-covered patio juts into the pool and is surrounded by concrete balusters that one can lean over to see his or her reflection in the pool.

The pool walls are a massive 20-inches (51-centimeter) thick to support the extra wide limestone coping, which is framed by bluestone decking. With a maximum depth of 9 feet (3 meters), the 45,000-gallon (170,000-liter) pool is suitable for diving. For those seeking hot water therapy, a round, black-bottom spa sits off to the side.

The soft and sprawling lawn is like the velvet lining in a jewelry box. While it helps to highlight the impressive architecture, the sod's rich green hue contrasts nicely with the black of the pool and the white of the mansion. Though modern in their construction, this pool and spa are timeless in their design.

PROFESSIONALS Landscape Architect/Contractor: **Downes Pool Co.** Photographer: **John Frantz**

ISLAND REFLECTIONS

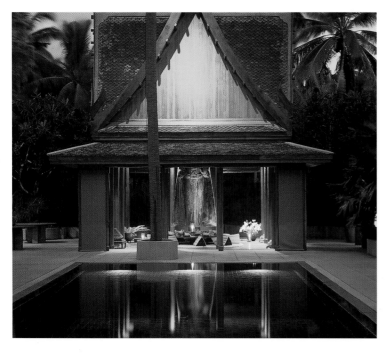

Any construction can be a challenge on Thailand's rugged islands due to the difficulty in shipping materials to job sites. But perseverance paid off in this case, where the architect managed to create a modern, outdoor living space under somewhat primitive conditions. The rectangular pool appears simple, but a "zero deck" treatment—whereby the water appears flush with the deck—adds a contemporary element. Sage green is the defining color scheme that pulls the surrounding elements together, including the Thai-inspired pool house, where one can escape from the sun and enjoy a tropical drink.

∧
At night, the illuminated hut is reflected in the black-tiled pool.

＞
This four-sided vanishing edge pool is flush with the deck that surrounds it.

Location: **Phuket Island, Thailand**
Type of construction: **Concrete**
Pool/spa finish: **Tile**
Decking and coping: **Granite and concrete**

DESIGN DETAILS

Situated atop Thailand's largest island, this poolscape—which is part of a private resort home—offers panoramic views of white sand beaches and tranquil coves embraced by the South China Sea. So as not to distract from nature's beauty, the pool's design is simple, yet striking. The most stunning architectural detail is how the surface of the water is maintained flush with the deck. A gutter system installed around the pool enables water to spill over on all four sides, thereby keeping the pool and deck on the same plane.

In addition to a functional swimming pool, the architect strived to create a modern reflecting pond. To accomplish this, he surfaced the pool in 4-by-4-inch (10-by10-centimeter) black tiles glazed with mica. Around the perimeter, he installed black granite slabs, which are a stark contrast to the sand-colored, pebble-washed concrete deck. The absence of handrails and ladders keep the installation clean and the view unobstructed.

The long rectangular shape draws the eye toward an exotic hut that anchors one end of the pool. Sage-colored pots and fabric, adorning the market umbrellas, furniture cushions, and pagoda-inspired gazebo, complement the surrounding palm trees and visually tie the aquatic landscape together.

PROFESSIONALS Architect: **Edward Tuttle** Photographer: **Tim Street-Porter**

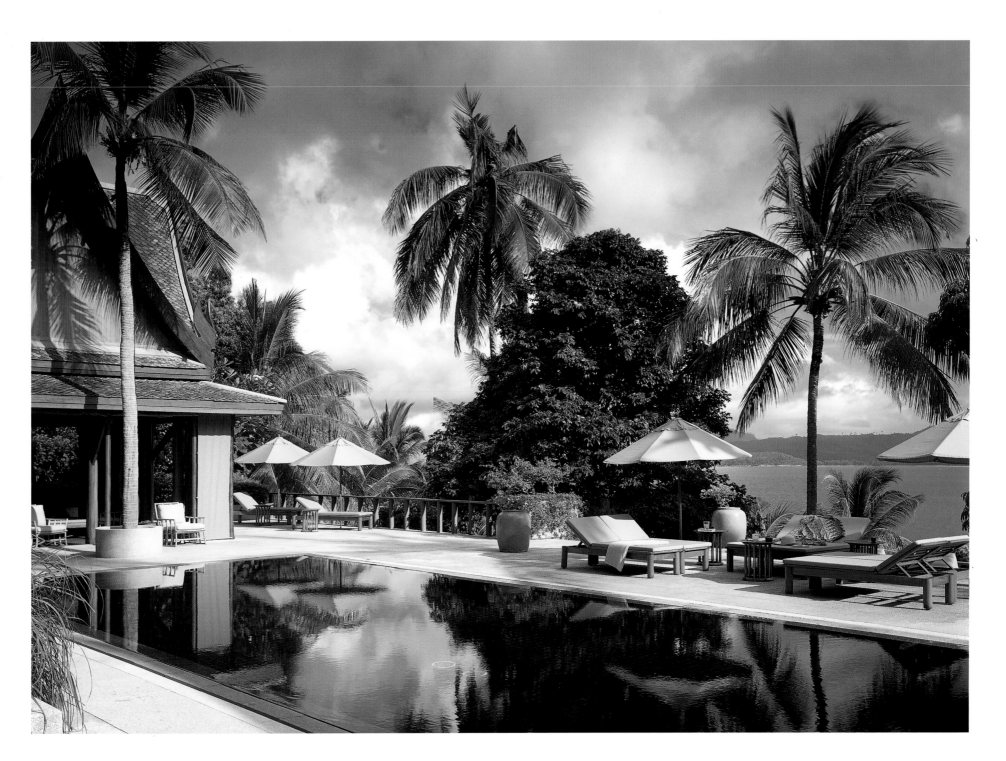

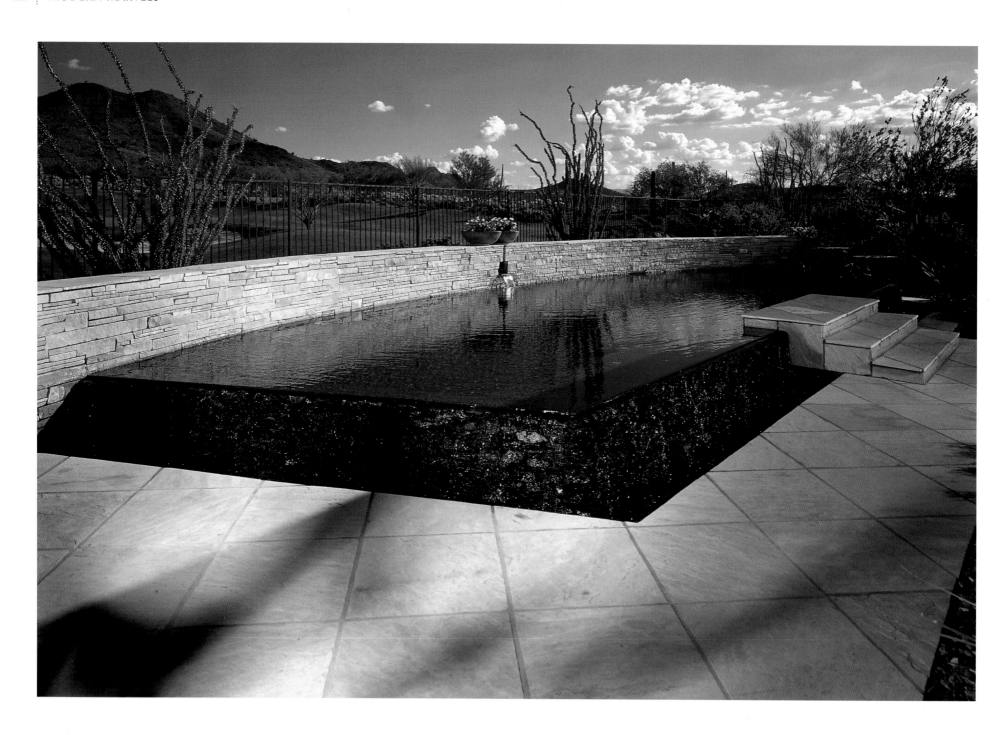

BLACK MAGIC

Suspend disbelief and you'd swear the enchanted stairs leading up to this pool are floating on water. Indeed, as water wells up over the raised pool and spills down its black sides, the pool resembles a freestanding block of water that mysteriously retains its shape. Then, by contrasting the light-colored steps with the dark hue of the pool, the magical illusion is created. The trick might be out of the bag, but even David Copperfield has to be impressed by this supernatural pool design.

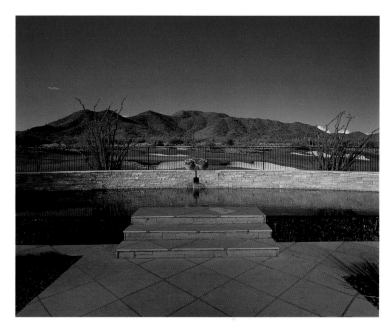

DESIGN DETAILS

Most vanishing-edge pool designs create the illusion of water disapearing into a natural body of water or spilling into some other scenic environment. This modern interpretation, however, turns the vanishing edge around so that it becomes a massive water feature to be enjoyed from the home and the surrounding pool deck.

The raised pool spills into a gutter on three sides, with the stillness of the glasslike surface contrasting with the constant splashing of water down the exterior walls. All of the action appears to originate from a sole waterspout in the center of the stacked-stone wall that forms the fourth side of the 39-foot (12-meter)-long pool. The wall creates privacy for swimmers while preserving the view of the golf course and distant mountains.

To enter the 3- to 5-foot (1- to 1.5-meter)-deep pool, one ascends a trio of light-colored steps. The stark contrast in colors makes the steps appear to be floating on the dark pool surface. Though they look like stone pavers, both the steps and the decking are made from a textured, acrylic-coated cement that stays cool despite exposure to the unyielding desert sun.

Location: **New River, Arizona, USA**
Type of construction: **Gunite**
Pool/spa finish: **Exposed aggregate**
Decking and coping: **Acrylic**

∧
The light-colored pool steps appear to float on top of the dark water.

<
The elevated pool's cascading sides create a striking water feature.

DESERT OASIS

One of the benefits of living in Arizona is year-round indoor/outdoor living. To emphasize that, this pool is fully integrated into the home by continuing the outdoor deck surface indoors and incorporating sliding glass walls that open up to the pool area. The vanishing-edge design directs one's attention toward the arid desert landscape and allows the pool water to visually blend into the background's seemingly infinite view of desert flora and distant mountains. If the sun is too much to tolerate, one can always retreat to the shaded courtyard on the side of the home and still feel connected to the pool—thanks to a portal window that provides an underwater view of the aquatic action.

∧
At sunset, the negative-edge pool becomes a reflecting pond.

>
Artistry and practicality merge to create a contemporary guardrail that provides both beauty and safety.

Location: **Phoenix, Arizona, USA**
Type of construction: **Concrete**
Pool/spa finish: **Plaster**
Decking and coping: **Limestone**

DESIGN DETAILS

The owners of this pool have an extensive collection of Native American artwork, and the house was designed to best display the paintings, sculptures, and photographs while taking full advantage of the views and natural beauty of the site. These same aesthetic principles are reflected in the design of the pool, deck, and guardrails.

To diminish the line between the home's interior and exterior, Beaumaniere limestone tiles from France were used for the inside flooring as well as the outdoor decking. The 18-inch (46-centimeter) square pavers are unique in that they don't absorb heat. Temperatures can reach 130 degrees Fahrenheit (54 degrees Celsius) and the stone tiles will remain comfortable to walk on with bare feet. Also, their natural tan color, grain, and texture complement the desert hues while providing a nonslip surface. A 15-foot (4.5-meter)-wide sliding glass wall separates the interior and exterior spaces, virtually dissolving any barriers.

Curvaceous steps—reminiscent of drifting desert sands—serve as a transition from the house and deck to the shimmering blue waters of the contemporary swimming pool. Because the site is on a sloping hillside, three of the four pool walls are above ground and constructed of reinforced concrete. A graceful negative edge continues the design theme while creating a water feature that brings soothing aquatic sounds to the arid landscape.

The catch basin for the negative-edge water feature is surfaced with earth-toned ceramic and limestone

PROFESSIONALS Architect: **Michael Shelor Architect** Structural Engineer: **Slaysman Engineering** General Contractor: **Construction Zone** Pool Contractor: **Supreme Pools & Saunas, Inc.** Photographer: **Michael Shelor**

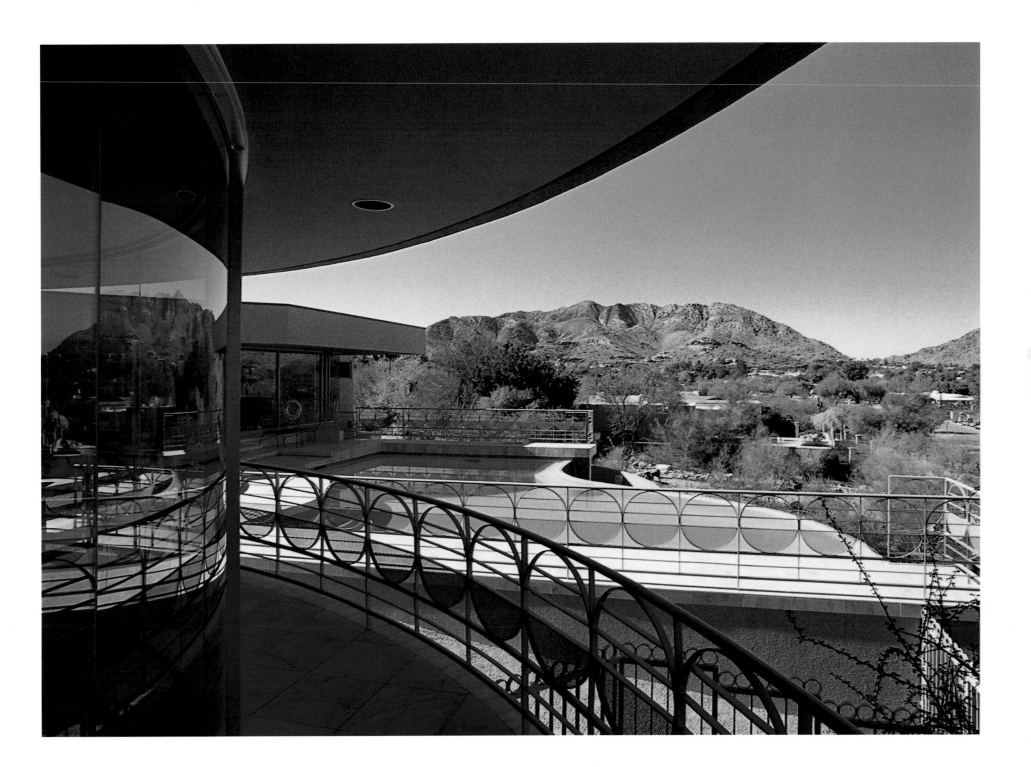

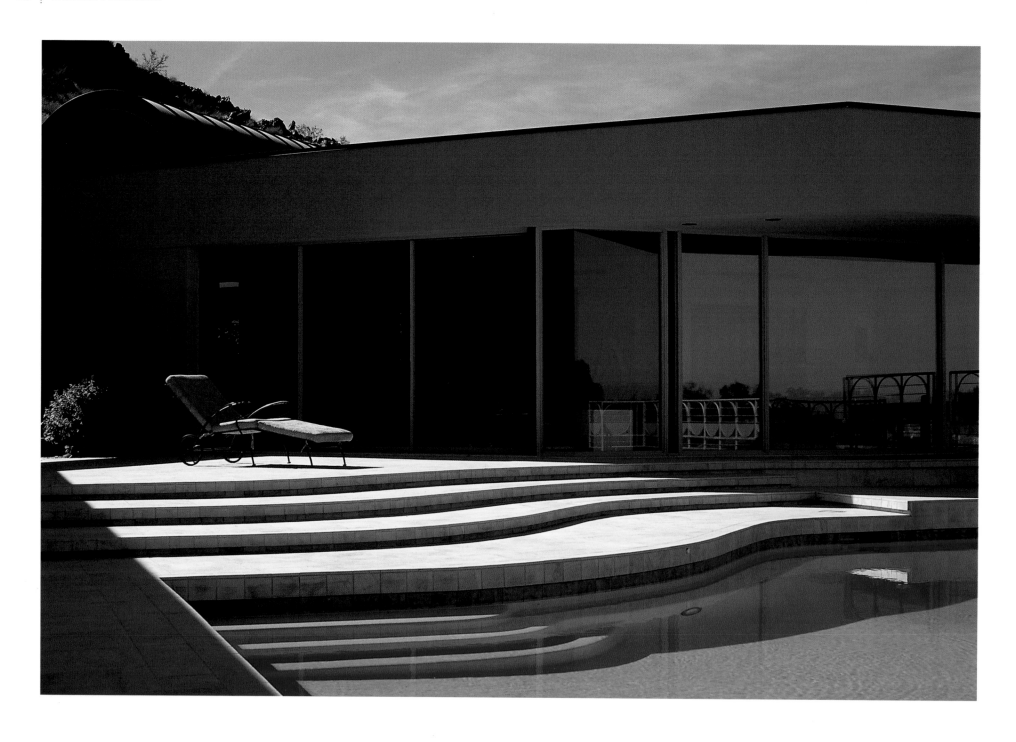

tiles that blend with the desert environment. Fiber-optic lighting lines the catch basin to illuminate the waterfall at night.

The design motif of the custom 3-foot (1-meter)-high guardrail casts intriguing shadows upon the deck and inside the pool. Meanwhile, a spiral staircase leads from the pool deck down to a lower courtyard, where a portal in the thick concrete pool wall offers a fascinating underwater view. At night, when the pool lights are on, the window casts a soft blue light into the courtyard, which is enclosed by a 5-foot (1.5-meter) masonry wall and steel fence. A masonry wall also hides the adjacent pool equipment, which includes a gas-fired heater for those cool desert nights.

↗
Curved, limestone steps evoke sandy dunes across the desert landscape.

>
A window in the pool wall provides an aquatic view from the courtyard. At night, it casts pool light into the garden.

<
By using the same limestone pavers indoors and out, the line between interior and exterior is blurred. A sliding glass wall makes the illusion a reality.

DIVINING WATER

In the arid desert, water is a precious commodity. Architect Antoine Predock pays homage to this earthly element by positioning a circular pool in the center of a vast courtyard and physically tying it to the home's architecture. Water from an interior fountain travels a straight path along a channel that leads out of the house, across the courtyard, and into the pool. Calling it the pool's umbilical cord may be a bit exaggerated, but the design is nonetheless life affirming.

Location: **Phoenix, Arizona, USA**
Type of construction: **Concrete**
Pool/spa finish: **Plaster**
Decking and coping: **Stone**

↑
The stone courtyard adjoins a curved loggia, which provides shade for swimmers.

<
Water wells up from a black granite fountain that appears to feed the swimming pool.

>
A rambling of boulders and a residential-size pyramid surround the pool.

DESIGN DETAILS

One of the goals of this desert home was to blend the four elements—earth, wind, fire, and water—in a modern setting that evokes images of ancient times. Upon entering the home, one is greeted by a small fountain made from a block of polished black granite set in a basin beneath the stone floor. The water wells up and runs in sheets down the block's four sides. It then flows into a perfectly straight and narrow channel cut into the stone floor. This room is used as the resident's gallery, and the water flows through the center, pulling visitors toward the windows at the other end of the long room. Two sets of low steps enhance the feeling of water cascading down and moving onward.

The water passes through an outer wall and continues its determined path across a stone courtyard, where it empties into the pool. Circular with a black surface, the pool seems bottomless. Though it's surrounded by ancient images—such as a pyramid-shaped study—the round pool is quintessentially modern in the way it's tethered to the home. The stream of water, though thin, defines the axis of the house and offers an obvious contrast to the arid desert landscape.

The pool and courtyard are separated from the desert by a low stucco wall. Sand and boulders, however, have made their way into the private space. Boulders are piled over the wall, where they surround a platform designed for outdoor fires. This "altar" of sorts is tied to the pool by additional boulders scattered across the courtyard. A few more rest in the pool itself.

PROFESSIONALS | Architect: **Antoine Predock** Photographer: **Timothy Hursley**

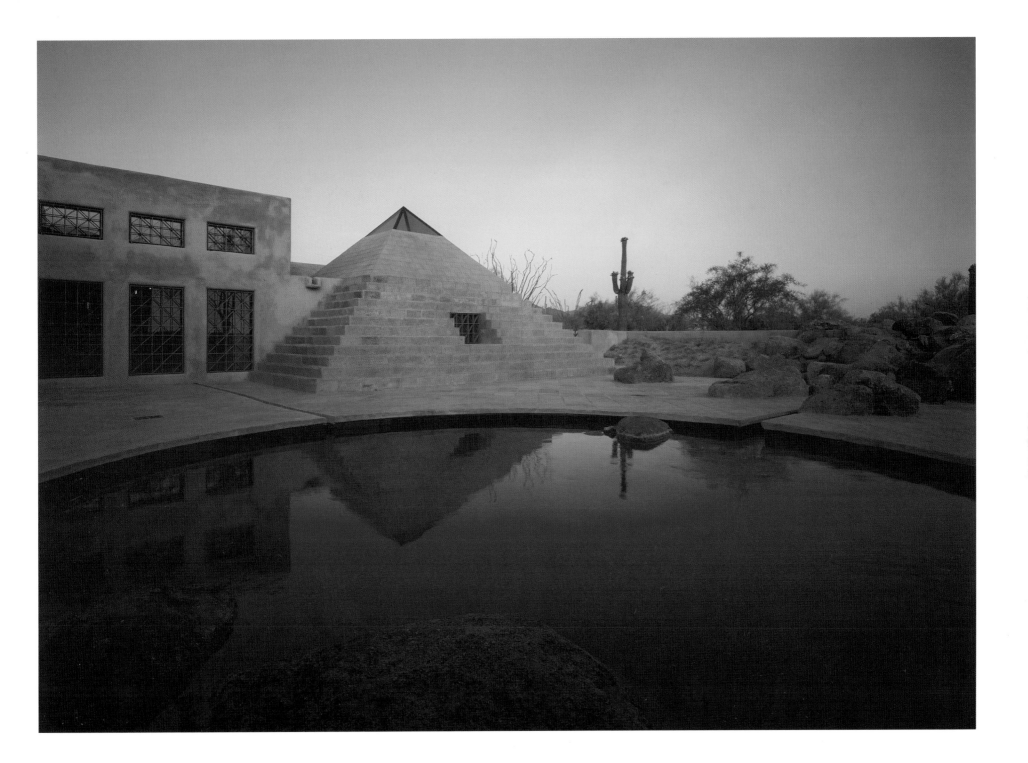

ELIPTICAL ABYSS

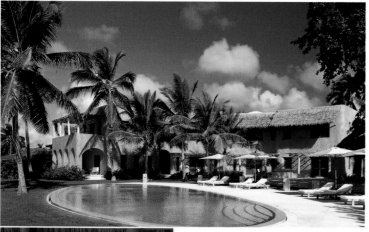

Circles and squares have their place in modern design, but it's nice to break out of the box once in a while. This oval pool stretches the imagination (as well as the circle) to create an elongated design that's both contemporary and functional. The designer raised the pool slightly above deck level and made the entire circumference a vanishing edge, thereby emphasizing the fluid silhouette. Reminiscent of the Earth's elliptical orbit around the sun, the pool doubles as a reflecting pond that mirrors the heavenly clouds during the day and echoes the twinkling stars at night.

Location: **Casa De Campo, La Romana, Dominican Republic**
Type of construction: **Concrete**
Pool/spa finish: **Plaster**
Decking and coping: **Cement**

⌃
The elliptical pool is set within a proportionally larger deck made from cement mixed with marble and granite.

>
A wet deck at one end of the oval pool provides a cool spot for sunbathing.

<
A checkerboard area of grass and concrete squares visually transitions one from the deck and lawn areas to the terrace.

DESIGN DETAILS

Clean and simple, this elliptical-shaped pool is set within a proportionally larger elliptical deck. As if cut from the larger oval, the pool rises 2 1/2 inches (6 centimeters) above the deck to show off a 360-degree vanishing-edge treatment that creates the illusion of water floating above the ground.

A white plaster pool surface causes the water to look blue—a color that contrasts nicely with the white concrete deck and green lawn. The deck is a hand-chiseled concrete surface made from equal parts white

Portland cement, powdered marble, and white granite chips. The result is a bright, textured surface that's slip resistant and doesn't distract from the pool's modern shape.

Measuring 72 by 29 feet (22 by 8.8 meters), the ellipse-within-an-ellipse pool design is ideal for a variety of aquatic activities, including lap swimming. A wet deck area at the deep end provides the perfect relaxation spot for sunbathers looking to stay cool while soaking in the rays. The opposite end contains semioval steps leading into the pool's shallow area.

The pool deck is separated from the home's terrace by a checkerboard of lawn and cement squares made from the same material as the deck. The checkerboard serves as a transitional area between the pool, the terrace, and the garden—integrating all three while minimizing the use of concrete.

Incorporated into the design is a subtle ramp that cuts through the checkerboard area from the terrace to the pool deck, providing handicap access for one of the wheelchair-bound residents.

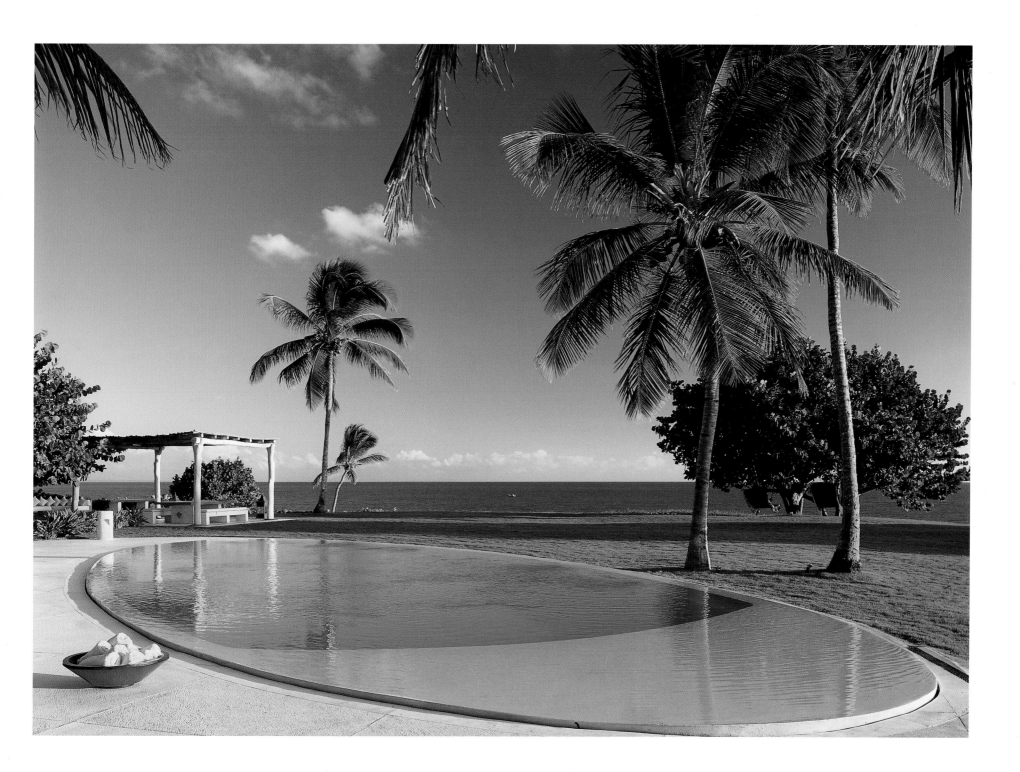

"A lake is the landscape's most beautiful and expressive feature. It is earth's eye; looking into which the beholder measures the depth of his own nature."

Henry David Thoreau, *Walden*

NATURAL PHENOMENA

Whereas some people are drawn to the clean lines of modern design, others long for the genuine beauty and unadulterated forms found in nature. Few people can resist the natural splendor of a babbling brook that spills into a pond, or the stillness of a mountain lake that reflects the passing clouds.

Regrettably, the scarcity of waterfront property—whether adjacent to a lake, river, or ocean—means that it costs a premium to live next to nature's aquatic environments. Strange as it may seem, it's often cheaper to bring "nature" to you in the form of swimming pools or hot tubs that look like the real deal. Using a palette of natural tones and materials culled from the earth, architects are creating spectacular pools and spas that blend seamlessly with their native surroundings.

What if you're fortunate enough to have waterfront property? You may still need a pool to ensure a clean and safe swimming environment. Just make sure it complements rather than competes with the real thing. How? Flagstone decks, aggregate pool surfaces, rock outcroppings, and realistic waterfalls are tricks of the trade that help us imagine that we—and our swimming pools—are one with nature.

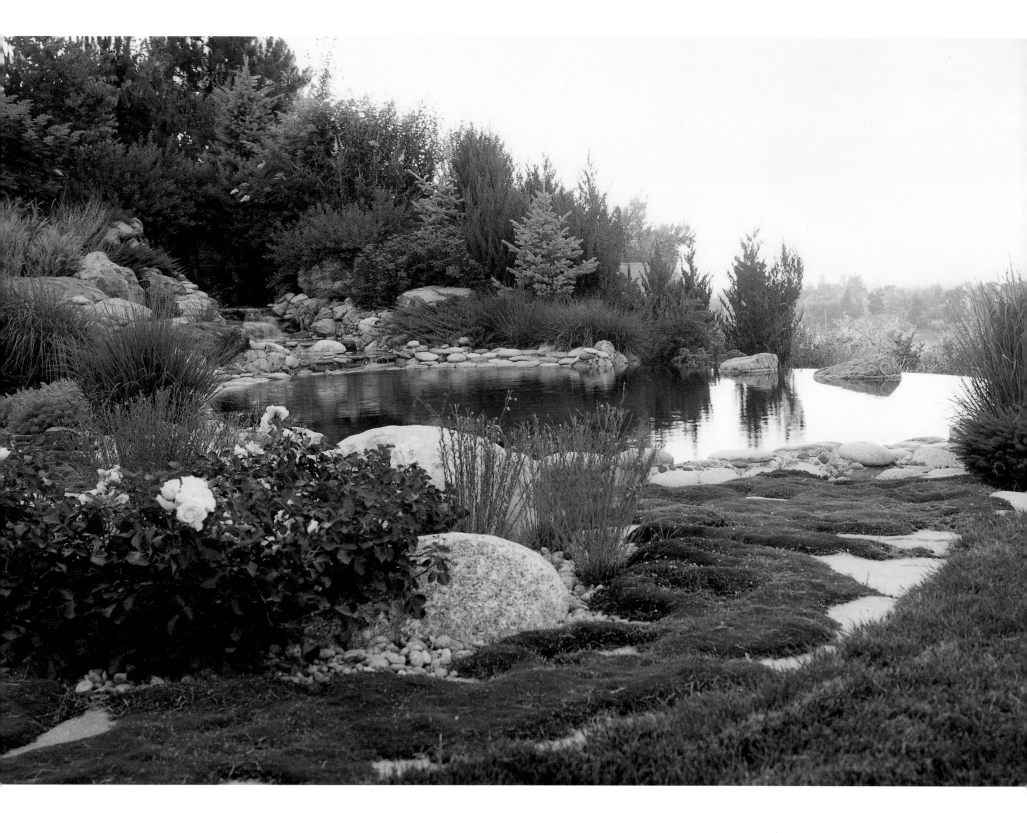

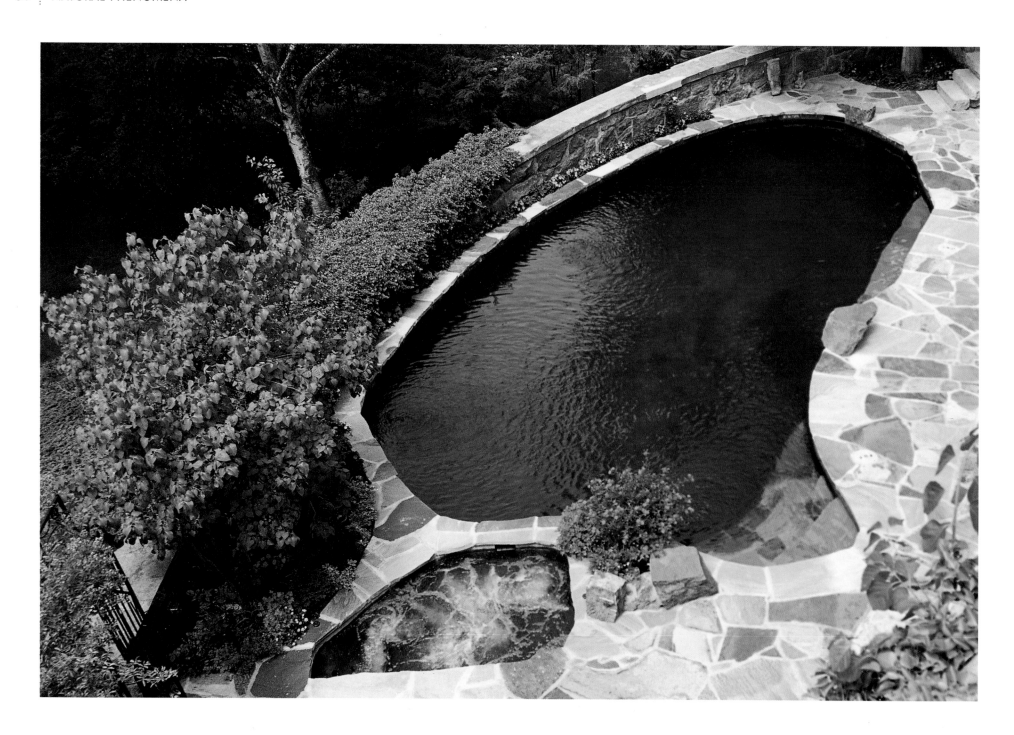

ROCK OF GIBRALTAR

Natural pool design suggests a seamless unification of the pool with its pure, unadulterated environment. In this case, that meant making the pool a believable extension of the historic home's rock foundation and stone facing—a triumph realized through the use of stone fencing, flagstone decking, and an aggregate pool finish. Accompanied by a man-made waterfall cascading down the natural rock facing, the pool looks as native to the massive home as the majestic hillside does to the lake below.

Location: **Orange County, New Jersey, USA**
Type of construction: **Gunite**
Pool/spa finish: **Exposed aggregate**
Decking and coping: **Flagstone**

↗
Colorful plantings soften the transition between the flagstone deck and stone wall.

<
A dark aggregate pool surface creates on pondlike effect for this lakeside installation.

DESIGN DETAILS
Built on a 200-year-old terrace alongside a stone mansion, this 37-by-22-foot (11-by-7-meter) pool and spa installation blends seamlessly with the indigenous landscape. Construction on this fortressed site, however, wasn't easy. The only access to the terrace was through a garage door. Also, the pool and spa equipment had to be housed in a cellar behind a 3-foot (1-meter)-thick stone wall, which contractors had to drill through in order to install the plumbing.

The pool and spa surface is a custom ebony-colored exposed aggregate, formulated to match the hue of the lake in the background. In addition, a variety of flagstones were chosen for the decking and coping to complement the stone architecture of the mansion. The spa is equipped with custom-formed bucket seats and lounger with neck massage jets, and the pool features flagstone steps and underwater bench seating. A jumping rock at the 8.5-foot (2.6-meter) deep end is a functional and natural-looking addition.

Adding sound and motion to the waterscape, a waterfall cascades down the natural boulder base of the upper terrace into a catch basin at pool level. Meanwhile, a combination of ozone and mineral purifiers keep the 36,000 gallons of water sanitized, while automated controls run everything from the pumps to the fiber-optic lighting.

BLUE LAGOON

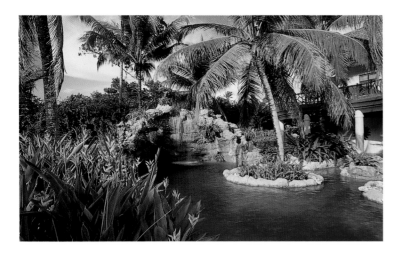

As with any natural pool design, it's best to leave intact as much of the native environment as possible. Mature trees are especially desirable to create the impression that the man-made pond, lake, or beach has always been there. In this case, the designer worked around existing palm trees, which provide a bit of shade for swimmers and help to counterbalance the towering waterfall. The outcome is a lagoonlike venue that blends faux and real features to fashion a veritable backyard paradise.

∧

An 18-foot (5.5-meter) waterfall creates a quintessential tropical paradise.

>

White tile decking contrasts with the varying shades of blue tile used in the pool.

Location: **Guatemala City, Guatemala**
Type of construction: **Concrete**
Pool/spa finish: **Tile**
Decking and coping: **Tile**

DESIGN DETAILS

With its mountainous waterfall and lush vegetation, this 63-by-29-foot (19-by-9-meter) swimming pool looks right at home in its tropical environment. The 18-foot (5.5-meter) waterfall is made from reinforced concrete that's been handcrafted to resemble natural rock. The realistic structure creates a private oasis in the backyard while providing a spectacular water feature that can be viewed from both the patio area and the second-story balcony.

In the pool, sea-blue mosaic tiles line the floor and walls, where man-made coral "grows" to further reflect the nearby Caribbean Sea.

Meanwhile, black-and-yellow tropical fish—made from mosaic tiles—appear to swim amongst the coral.

To ease the transition from the home to the pool, the deck is surfaced with off-white Italian ceramic tiles, offering a stark contrast to the varying shades of blue used in the pool.

The entire project was constructed around existing palm trees, which explains the circular islands in the middle of the 72,500-gallon (274,442-liter) pool. Additional plantings at the pool's edge complete the exotic, lagoonlike setting.

PROFESSIONALS Landscape Architect/Contractor: **Watermania, S.A.** Photographer: **Alan Benchoam**

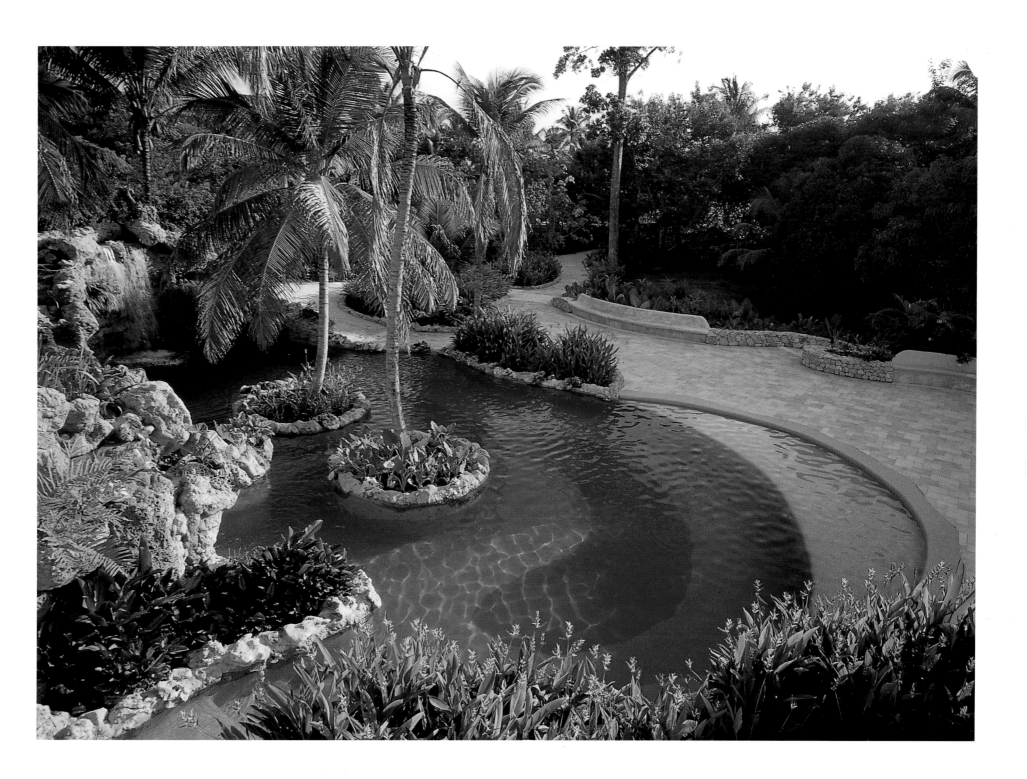

GRECIAN YEARN

A hut once used for harvesting olives is now a primordial guest house overlooking the dramatic Grecian shoreline. Near the water's edge is an equally primitive swimming pool, constructed of stacked stones quarried by local craftsmen. The seashore is too rugged for swimming, so holiday seekers find the rustic pool a refreshing amenity. Water is pumped into the pool from a well and drained out to sea when it needs to be changed. No modern plumbing or sanitization systems are employed, making this pool about as unsophisticated as they come.

∧
The stone interior of the primitive hut shows how well the pool complements the other buildings on the site.
>

Despite the rocky terrain, the pool area is surrounded by lush vegetation.

Location: **Mt. Pelion, Magnesia-Volos, Greece**
Type of construction: **Concrete and stone**
Pool finish: **Paint**
Decking and coping: **Slate and mortar**

DESIGN DETAILS

Located on the rocky eastern coast of Mount Pelion, this primordial pool is truly from the earth. The architect relied solely on stone from the site, which is dominated by a great rock that cuts through the landscape on its way to the sea. The same stone was used to refurbish an ancient shack into a guest house. The hut originally was used when harvesting olives, which continue to grow throughout the area. Now its primitive design also includes stone benches and tables, covered terraces, and verandas with views of the ocean and pool below.

The entire complex blends seamlessly with the Grecian landscape. The rock-and-mortar pool—built by local craftsmen—measures 16.5 feet (5 meters) wide and 40 feet (12 meters) long. Its stone walls are actually sloped upward like retaining walls, and the deck and coping are finished with slate and a fine cement mortar colored light gray to match the stone.

"It was very interesting to restrict the design and allow every intervention to be regarded as a natural extension of the landscape," the architect says. Along those lines, the pool lacks any modern sanitation system. Instead, water originates from a low well on the site that contains a mix of fresh and salt water from the ocean. As new water is brought into the pool, the old water is recycled naturally to the sea draining from the 8.5-foot (2.5-meter) deep end. Despite the primitive nature of the pool, it's still a welcomed luxury—especially since waves crashing against the rocky shoreline make swimming in the ocean rather dangerous.

PROFESSIONALS Landscape Architect/Contractor: **Katrina Tsigarida Architects** Photographer: **Katrina Tsigarida**

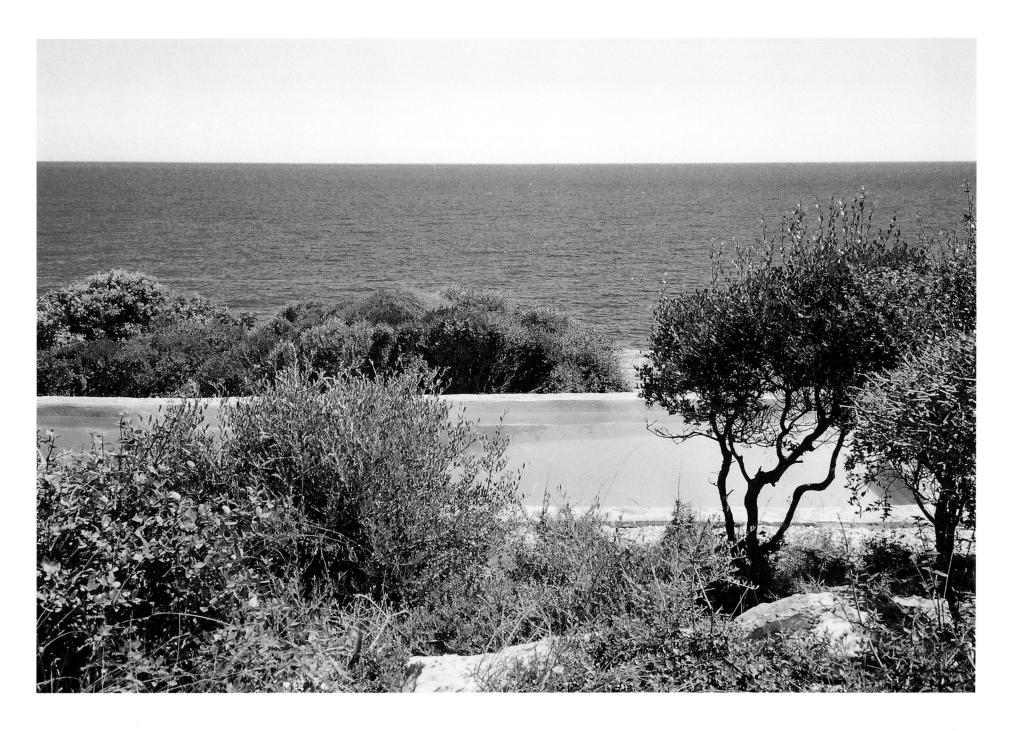

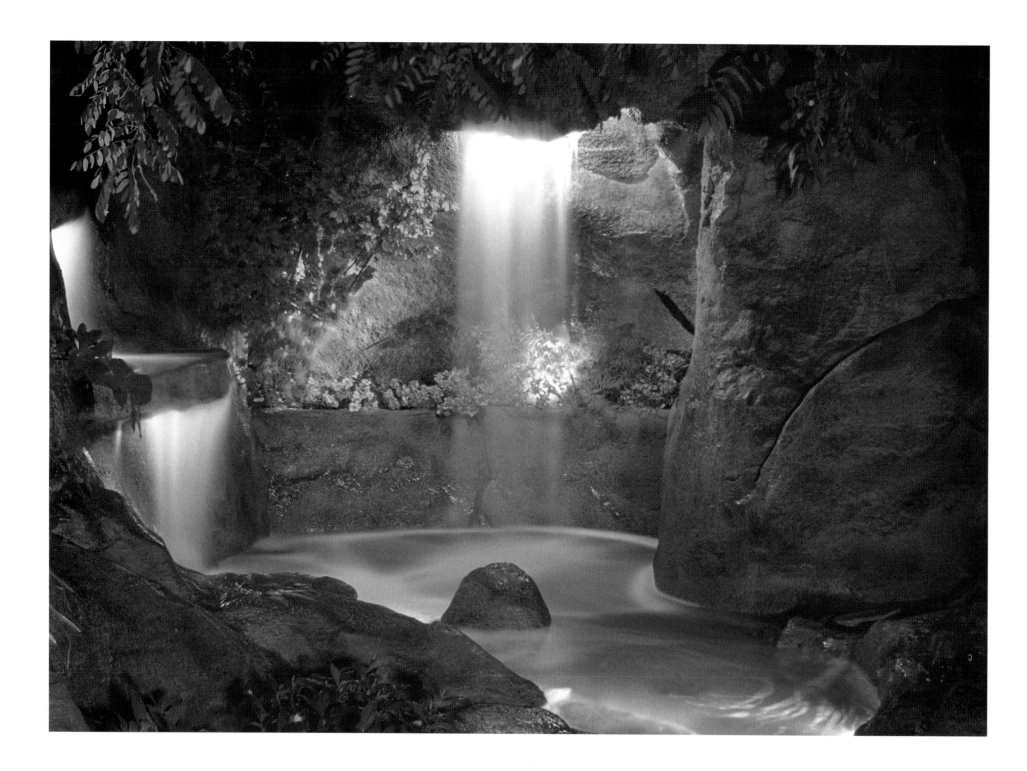

ROCK ON

This elaborate spa installation puts the "art" in artificial rock. Made with concrete that's been hand sculpted and painted, the artificial rock blends seamlessly with the preexisting natural stone formation. The result is a stone grotto that's home to what appears to be a natural hot spring. An opening in the top of the cave allows natural light to stream in so that colorful plantings can thrive around the spa, thereby softening the rockwork. Fiber-optic lighting equipped with a color-changing feature further sets the mood—from a flora-enhancing green to a passion-producing red.

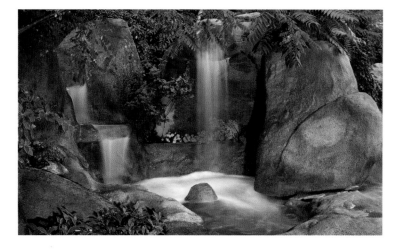

DESIGN DETAILS

Creating an all-stone spa like this one requires equal parts brawn and artistry. First, the existing rock had to be stabilized with steel rebar and shotcrete, a sprayed form of concrete. Then the bowl of the spa was formed using additional rebar and shotcrete. Next, the artificial rocks were hand sculpted to form the waterfalls, planting areas, patios, outcroppings, and benches. The designer even created a built-in area for a barbecue grill.

To ensure a seamless transition between the real and artificial rock, the color and texture of the natural rocks were meticulously copied and set into the spa's interior plaster finish so that no difference can be seen between the interior and exterior surfaces.

At night, fiber-optic lighting illuminates the water, the waterfalls, and the landscaping around the 12-by-9-foot (3.7-by-2.7-meter) spa. A rainbow of colored lighting options is available to match the mood of the bathers. The flow rate of the waterfalls can also be adjusted. Thanks to a 400,000 Btu heater, the cascading water can be set to the same temperature as the spa water, making it ideal for

Location: **Nevada City, California, USA**
Type of construction: **Concrete and stone**
Spa finish: **Plaster**
Decking and coping: **Hand-sculpted concrete**

∧

Artificial rock planters soften the rockscape while adding to the realism of the project.

<

Sunlight shines through a natural skylight created in the rocks.

PROFESSIONALS | Landscape Architect/Contractor: **Natural Design** Photographer: **Christine Rydell**

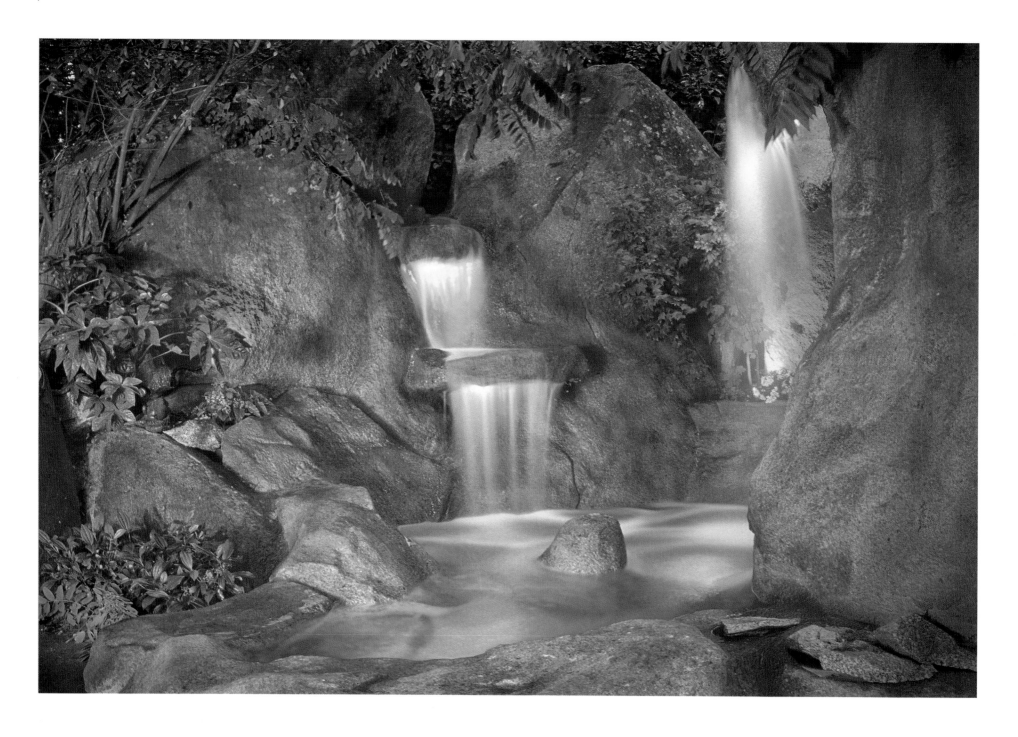

hydromassage. For additional hydrotherapy, the 1,100-gallon (4,163-liter) spa includes eight jets, including four foot-massage jets.

Deeper than most hot tubs, this spa has a maximum depth of 4 feet (1.2 meters). Completely automated, it can be controlled using an eight-button, spa-side remote, an indoor control panel, or a telephone link. The latter enables the homeowner to call from his car while traveling home and set the temperature, turn on the lighting, and start up the waterfalls, so everything is ready upon arrival.

>
The waterfalls all appear to spill from natural rock formations.

<
Artificial rock imitates the look of a real rock formation for a seamless installation.

STONE AGE

∧
Pool water spills into a catch basin on the lower deck, producing pleasing sounds near the covered patio.

>
Strategically placed rocks and lush plantings contribute to the natural design of this free-form pool.

One of the best views of this desert pool and spa installation is from the cool and shaded comfort of the covered patio. From here, one can watch the water cascade down a rocky waterfall into the pool, where it works its way across the pool and spills over a vanishing edge. The movement of water amidst the parched desert air is a refreshing sight, and the sound of falling water quenches the thirsting soul. It's almost enough to make one forget that he or she is, after all, in the desert.

Location: **Scottsdale, Arizona, USA**
Type of construction: **Gunite**
Pool/spa finish: **Exposed aggregate**
Decking and coping: **Flagstone and exposed aggregate**

DESIGN DETAILS
Real and artificial rocks were used around this pool and spa installation, creating a natural-looking aquatic setting where there was once barren desert. A bluish aggregate finish on the pool and spa's interiors enhances the pond effect.

Built into a rolling landscape, the pool takes advantage of the varying elevations by incorporating upper and lower deck areas.

Two water features add movement and sound to the outdoor room. A waterfall spills over rock into the pool from the upper deck. A short, vanishing-edge section of the pool then allows water to cascade into a small catch basin in the lower deck.

A covered patio area offers a shady spot to relax, while the upper pool deck is large enough for dining without distracting from the pool's natural design. In fact, the decking is made of exposed aggregate and flagstone, which blends nicely with the brown and tan desert shades. Meanwhile, colorful plantings surround the pool, tucked into rock gardens and raised planting beds. The lush foliage softens the rockwork and naturalizes the entire project.

PROFESSIONALS Landscape Architect/Contractor: **Shasta Pools & Spas** Photographer: **Pam Singleton**

MY PRIVATE IDAHO

∧
A spa nestles up to the pondlike pool, which appears to spill into the adjacent river.

>
A vanishing edge draws the eye toward the river beyond.

Serenity amidst the tranquil sounds of water in motion is the cornerstone of this pool and spa installation. Set on a hillside in Meridian, a picturesque, agricultural community in southwestern Idaho, the pool blends perfectly with the native landscape. Spanish moss creates a soft bed between well-spaced deck stones, while river rocks connect the vanishing edge pool to the riverbed at the bottom of the hill. The result is a private paradise that seems as indigenous to this western town as chili cook-offs and harvest festivals.

Location: **Meridian, Idaho, USA**
Type of construction: **Gunite**
Pool finish: **Plaster**
Decking and coping: **River Rock and sandstone**

DESIGN DETAILS
A dark plaster finish on this pool's interior creates the appearance of a deep, natural pond. The reflective surface mirrors the surrounding vegetation and also changes color depending on the position of the sun and the clouds—sometimes taking on a deep bluish tint. "Between the dark plaster and the blueness of the sky, you never know what color you're going to end up with," says pool builder Steve Chandler.

Meanwhile, a vanishing edge casts the illusion that the pool is spilling into the nearby Boise River. Sandstone and smooth river rock coping enhance the natural aesthetic. The 16-by-36-foot (4.9-by-11-meter) pool features a raised spa elevated 3 feet (1.5-meter) above the pool, opposite the vanishing edge. Although the spa water appears to flow into the pool, its plumbing is completely separate. Meanwhile, a 5-foot (1.5-meter)-tall waterfall spills down a face of rock

into the pool from the side. Equipped with its own pump, the waterfall is fully adjustable to create a range of effects—from a trickle to a surge.

Flagstone pavers are widely spaced around the pool to allow emerald-green moss to spread far and wide between the stones. Evergreen shrubs ensure a bit of color year-round, while tall grasses soften the rocky pool edges and provide a bit of privacy for swimmers.

PROFESSIONALS | Landscape designer: **Loring Montgomery Evans** Pool Contractor: **Custom Pools & Patio** Photographer: **Suzie Bell**
Stone Supplier/Consultant: **International Stone**

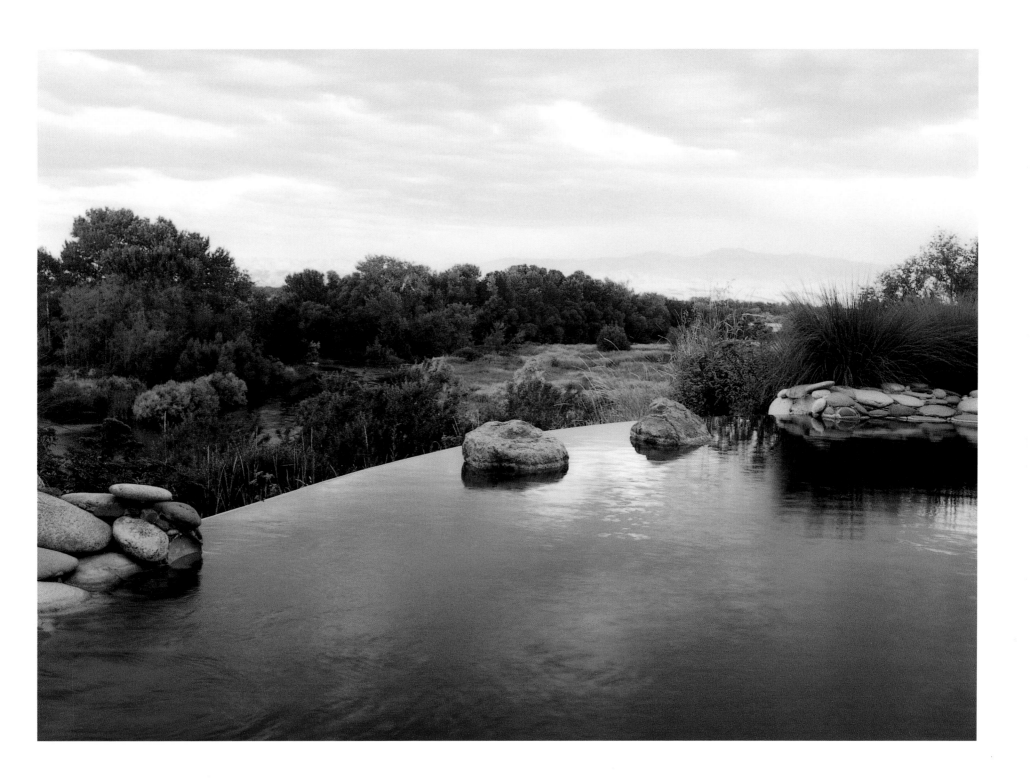

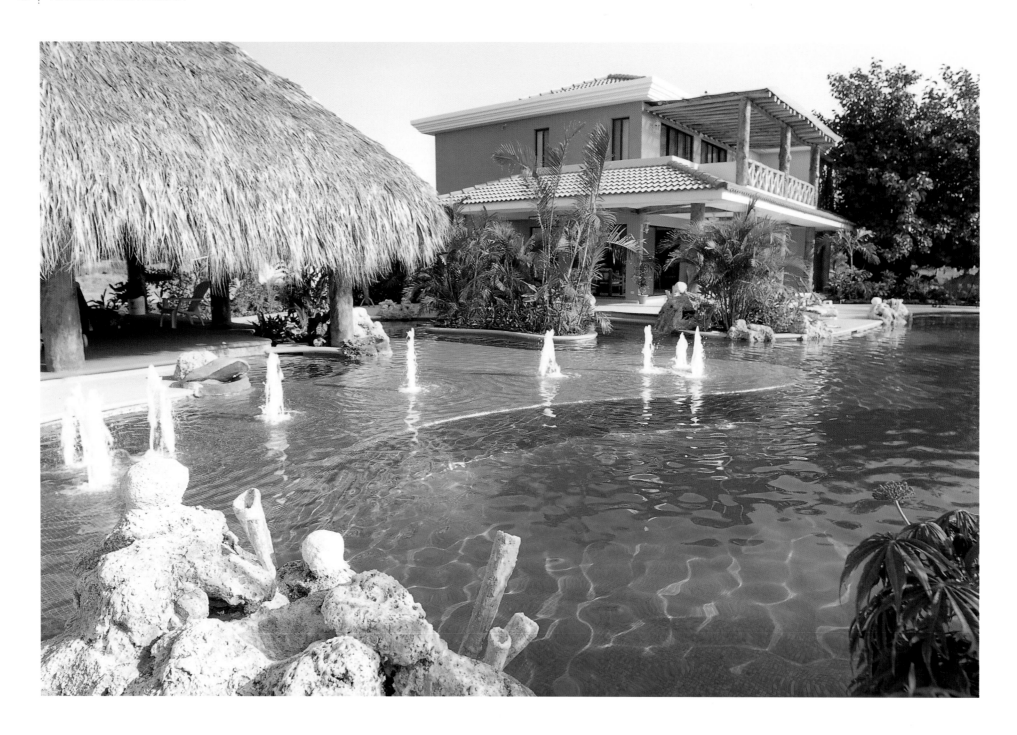

LAKE GUATEMALA

Why sit on a hot pool deck when you can relax on a cool, wet deck, instead? Growing in popularity, wet decks are shallow pool areas covered with just 1 inch (2.5 centimeters) or so of water. Adored by serious sunbathers, these areas are now being equipped with tables, chairs, and umbrellas and used for "refreshing" conversation. This massive pool boasts two such areas, both shaded by palm trees and surrounded by tropical foliage. Handcrafted coral around the pool furthers the natural design.

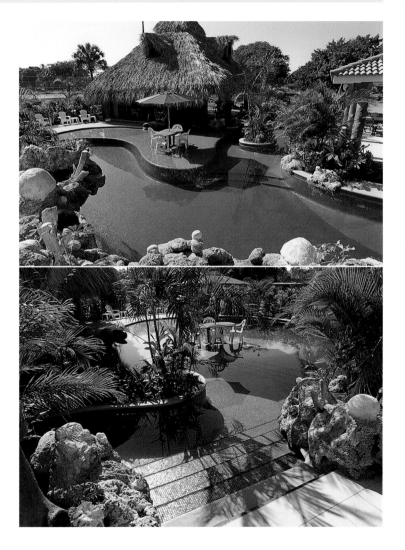

Location: **Lindamar, Escuintla, Guatemala**
Type of construction: **Concrete**
Pool/spa finish: **Tile**
Decking and coping: **Concrete**

>

A shaded conversation area is built atop a shallow-water plane that juts into the pool.

<

Man-made coral and lush plantings evoke a tropical aura around the pool.

Bubbling fountains placed along one of the pool's shallow plateaus add visual and aural interest.

DESIGN DETAILS
With 85,000 gallons (321,760 liters) of water, this massive 92-by-24-foot (28-by-7-meter) pool and spa installation is really six aquatic areas in one. In addition to two areas for swimming, there are two spas and two conversation areas. Among the water features are five cascades and nine bubbler fountains—six of which are lighted for dramatic nighttime effect.

At most, the pool is 4.5 feet (1.4 meters) deep. Blue tile covering the pool surface in gradations from dark to light hues, however, creates a greater sense of depth. Tile also covers the two shaded conversation areas that jut into the pool, where water is designed to flow over the deck surface. Swimmers can sunbathe on these plateaus while staying cool, or they can sit "atop" the water as if defying the laws of gravity.

Handcrafted coral surrounds the free-form lagoon, blending it into the tropical surroundings, which includes a thatched hut for poolside relaxation and entertaining. Strategically placed planting beds in and around the pool further ground this aquatic paradise to its natural habitat.

PROFESSIONALS | Landscape Architect/Contractor: **Watermania, S.A.** Photographer: **Alan Benchoam**

"I understood when I was just a child that without water, everything dies. I didn't understand until much later that no one 'owns' water. It might rise on your property, but it just passes through. You can use it, and abuse it, but it is not yours to own. It is part of the global commons, not 'property' but part of our life support system."

Marq de Villiers, *Water*, 2000

WATER IN MOTION

The presence of water in motion evokes relaxation, whether it's waves lapping against a shore or water babbling down a brook. So it comes as no surprise that increasing numbers of pool owners are looking to create those soothing sounds in their own aquatic environments.

In addition to adding drama to a backyard setting, moving water creates white noise that drowns out the sounds of passing traffic or noisy neighbors. Architects and landscape designers have quickly picked up on this and continue to find wildly imaginative ways to incorporate moving water into pool and spa designs.

While some try to replicate nature with pebble-lined streams and cascading rock-lined waterfalls, others are drawn to more contemporary applications using a vast arsenal of fountain equipment.

Contemporary pool design is all about incorporating the senses, and water in motion satisfies at least three of them: sight, sound, and touch. Alas, if pictures could talk, you'd be able to hear the low whoosh of a jet of water arching overhead and landing mid-pool, the tumbling splash of water rolling down real and man-made rocks, and the thundering blur of water crashing from a torrential falls high above a grotto.

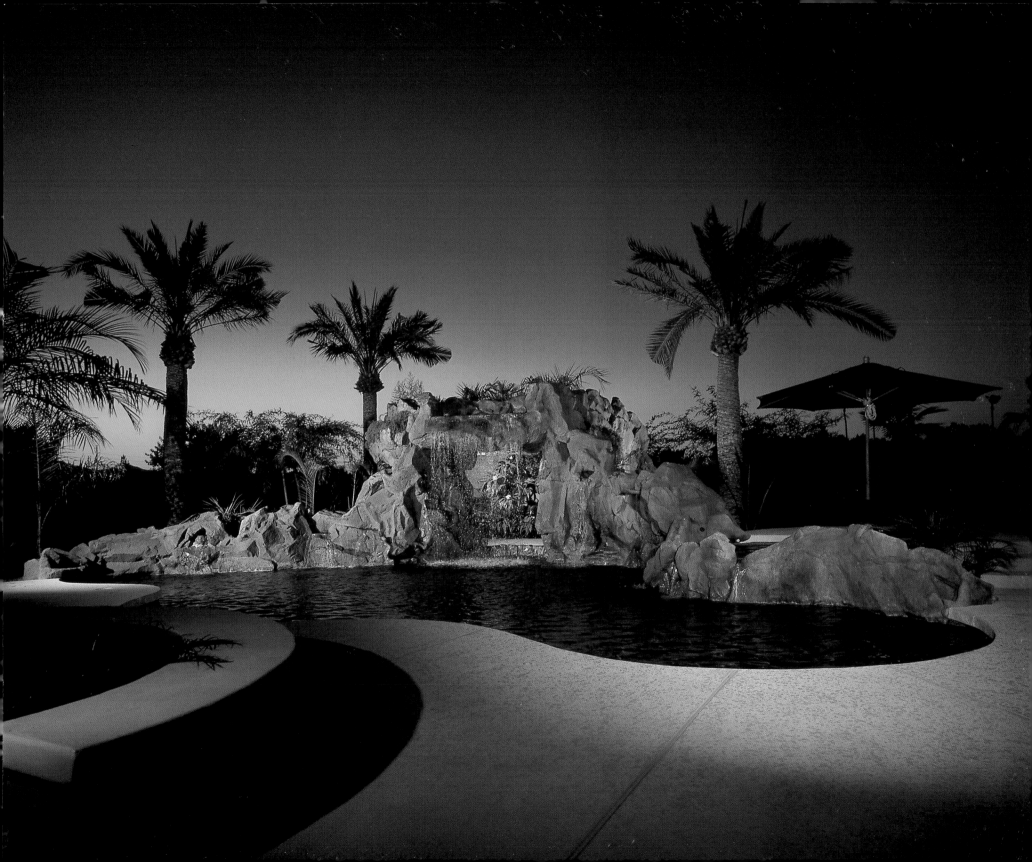

TWIN FALLS

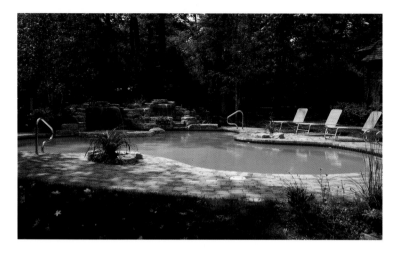

Niagara Falls on the border between Canada and the United States is actually comprised of two major waterfalls—the American Falls on the U.S. side and the much larger Horseshoe Falls on the Canadian side. The two create a marriage, of sorts, with each fall distinctly separate yet joining as one in the rocky basin 173 feet (52.7 meters) below. This pool incorporates a similar idea, but on an immensely smaller scale. One waterfall cascades over a grotto, while the other spills into a therapeutic hot tub. Surrounded by colorful perennials, the man-made water features resemble underground springs emerging from natural rock outcroppings.

Location: **Lake Forest, Illinois, USA**
Type of construction: **Gunite**
Pool/spa finish: **Marbelite**
Decking and coping: **Brick**

∧
With mature trees as a backdrop, the twin waterfalls form a mesmerizing focal point with soothing sounds.

>
Colorful plantings soften the waterfall's rock facing.

DESIGN DETAILS
Falling water can be both beautiful and therapeutic—and in the case of this free-form pool and spa, it's both. The focal point of the 23-by-32-foot (7-by-9.8-meter) project is a pair of waterfalls that cascade from one side of the sparkling pool. One waterfall spills over a grotto, behind which swimmers can retreat for intimacy or aquatic pleasure. The second waterfall plummets into a raised spa, where it provides a soothing massage for stress-ridden soakers.

Behind it all, a grove of pine trees serves as an emerald-green backdrop for the elaborate aquacade.

At their previous home, the owners had a traditional 25-by-50-foot (7.6-by-15.2 meter) rectangular pool. This time around, they wanted something with more drama and excitement. The free-form pool, spa, and water features accomplish that and more. Three "floating" stones define the grotto area and provide an intriguing space to lounge and set drinks. They can also be used as jumping stones for those who

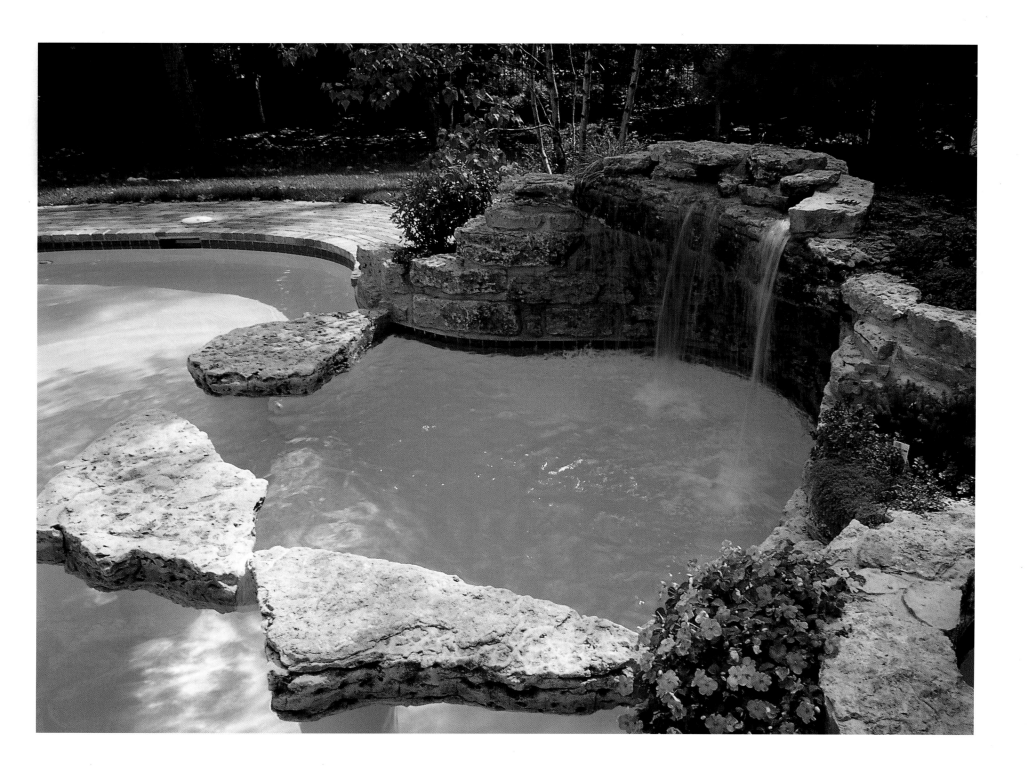

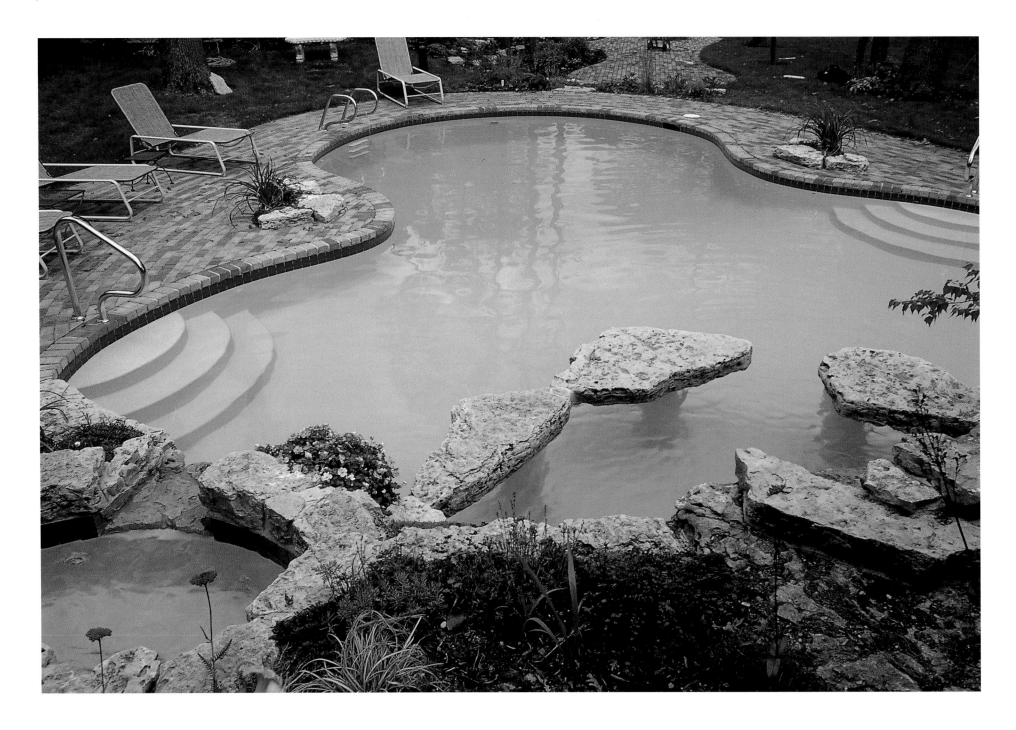

dare to do so in the 3- to 6-foot (1 to 2-meter)-deep pool. The builder created the magical illusion of floating stones by constructing underwater pillars from stainless steel rods and concrete, and then securing the stones to the tops, just above the water line.

A smooth, white marble plaster pool finish gives the pool its intense blue color, which offers a nice contrast to the rugged stonework and formal brick deck. The deck's aged bricks produce an earthy

palette that complements the brick house. Meanwhile, natural rock planters soften the brick deck and set off the stone used to create the twin waterfalls and nearby coping.

To simplify operation, the 21,600-gallon (81,765-liter) pool and spa is equipped with automated controls that enable the clients to fire up the spa, turn on the waterfalls, illuminate underwater lights, and circulate pool water with the touch of a few buttons.

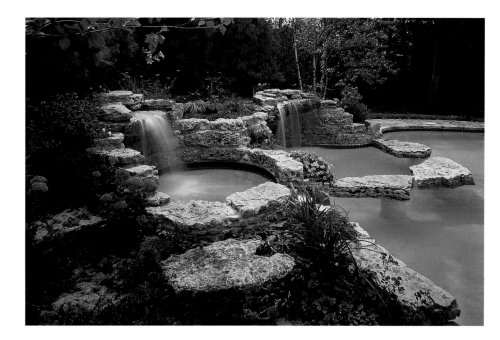

↗

Real rock was used to create two natural-looking waterfalls—one near the spa and the other a grotto.

<

An overview shows the pool's two entry points, formed by trios of curved steps.

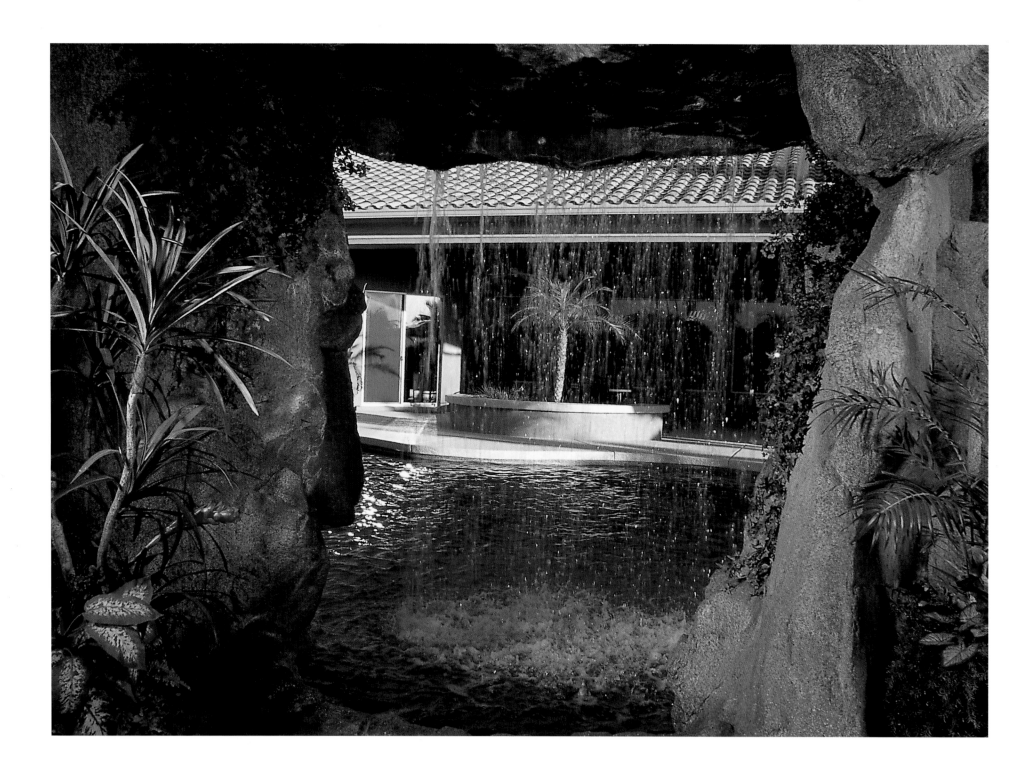

WALL OF WATER

A sprawling pool deck can seem like a vast wasteland without the proper landscaping. This pool incorporates a unique solution to the familiar problem. Faced with a flat yard, the designer created visual interest by erecting a towering waterfall. The sculptural feature not only adds a captivating sight and soothing sounds to the poolscape, it doubles as a dividing structure between two separate deck areas. An opening "carved" in the middle of the water feature provides a passageway between the two outdoor rooms. All you have to do is part your way through the curtain of water that cascades over it.

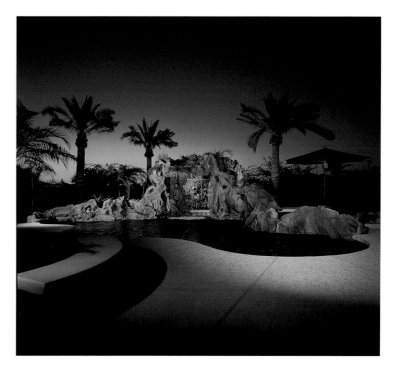

DESIGN DETAILS

A man-made rock waterfall stands like a sculpture along the entire length of this 42-foot (13-meter)-long pool. The mountainous form contrasts with the smooth curves of the pool, whose cantilevered concrete decking is in stark contrast to the rugged surface of the water feature.

Each end of the rock edifice hosts small waterfalls that splash into the pool. The center, however, is carved like an entrance to a cave, and a wall of water cascades over the doorway like a translucent curtain.

The handcrafted structure doubles as a wall that separates the pool into two areas. From the pool side, the waterfall—set against a backdrop of palm trees—is a playful feature that beckons swimmers. From the other side, the doorway—marked by colorful plantings—is something to be entered by those brave enough to part the crashing curtain of water.

In addition, the sandy-colored aggregate pool surface creates a reflecting pond effect mirroring the monumental rock figure and the surrounding palm trees. Blending with the desert landscape, a light-colored acrylic coating over the pool deck provides a nonslip surface that stays cool beneath bare feet.

Location: **Chandler, Arizona, USA**
Type of construction: **Gunite**
Pool finish: **Exposed aggregate**
Decking: **Acrylic-coated concrete**

∧
Three water features are incorporated into this 42-foot (12.8-meter)-long artificial rock sculpture.

<
A curtain of water falls in front of a passageway carved into the rock edifice.

PROFESSIONALS Landscape Architect/Contractor: **Shasta Pools & Spas** Photographer: **Jeff Kidda**

THEATRICAL VISION

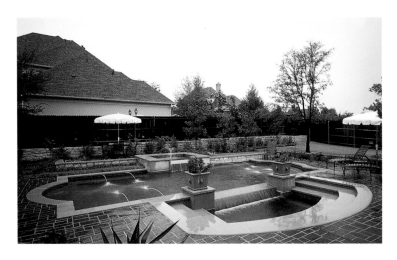

Dancing fountains, rushing falls, streaming water…let your imagination run free and you could picture yourself in one of those perfectly choreographed Esther Williams films from the 1940s and 1950s. Leaping fountains enter left and right, while a tiered fountain takes center stage atop a raised spa that cascades into the deep blue pool. The project even incorporates its own stadium-style seating for a truly theatrical experience. No need for an encore, however, because this is one aquatic show that never ends.

Location: **Southlake, Texas, USA**
Type of construction: **Gunite**
Pool finish: **Plaster**
Decking: **Patterned concrete**

⌐
Tiered steps recessed in the deck provide the perfect vantage point from which to view the aquatic show.

>
From the raised spa, one can witness the vanishing-edge effect created on the opposite side of the pool.

DESIGN DETAILS

Creating a vanishing-edge pool on virtually flat ground is a difficult task, but the designer of this project rose to the challenge by reversing the typical vanishing-edge design so the water flows toward the house and into a catch basin recessed in the deck.

The vanishing edge is best viewed from the raised terrace behind the spa, which incorporates adjoining stone walls to retain the grade. Guests can also enjoy front-row seats thanks to amphitheater-style seating that surrounds the catch basin for the vanishing edge. From these recessed bleachers, set about 12 inches (30.5 centimeters) below the deck, one can enjoy the entire aquacade—from the spa's tiered fountain and cascading falls to the eight canon jets that stand

sentry on both sides of the pool. Decorative urns planted with colorful blooms adorn pedestals on either side of the vanishing edge.

The classical design is enhanced by the Roman ends of the 3- to 5-foot (1- to 1.5-meter)-deep pool, which is entered by a series of steps that runs the full width of the shallow end.

A blue plaster finish is somewhat mottled to dramatize the light and dark hues of the surface when viewed through the water. The deep blue color also enhances the pool's role as a reflecting pond and contrasts nicely with the light-colored coping and patterned concrete deck, designed to match the home's entry and provide a continuous flow throughout the project.

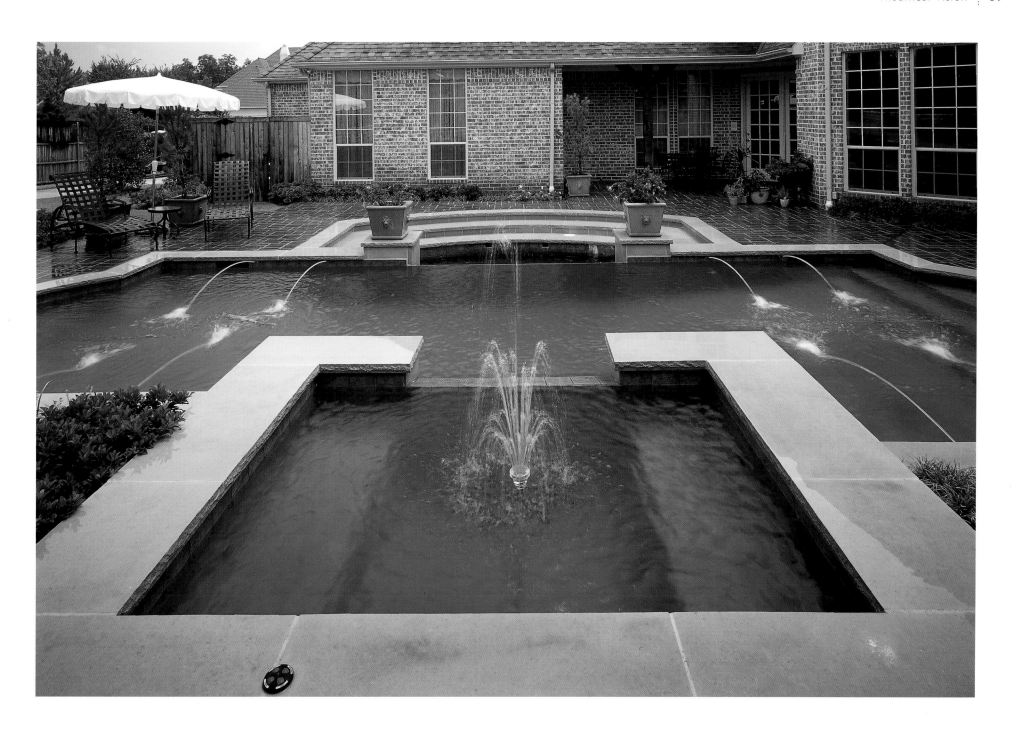

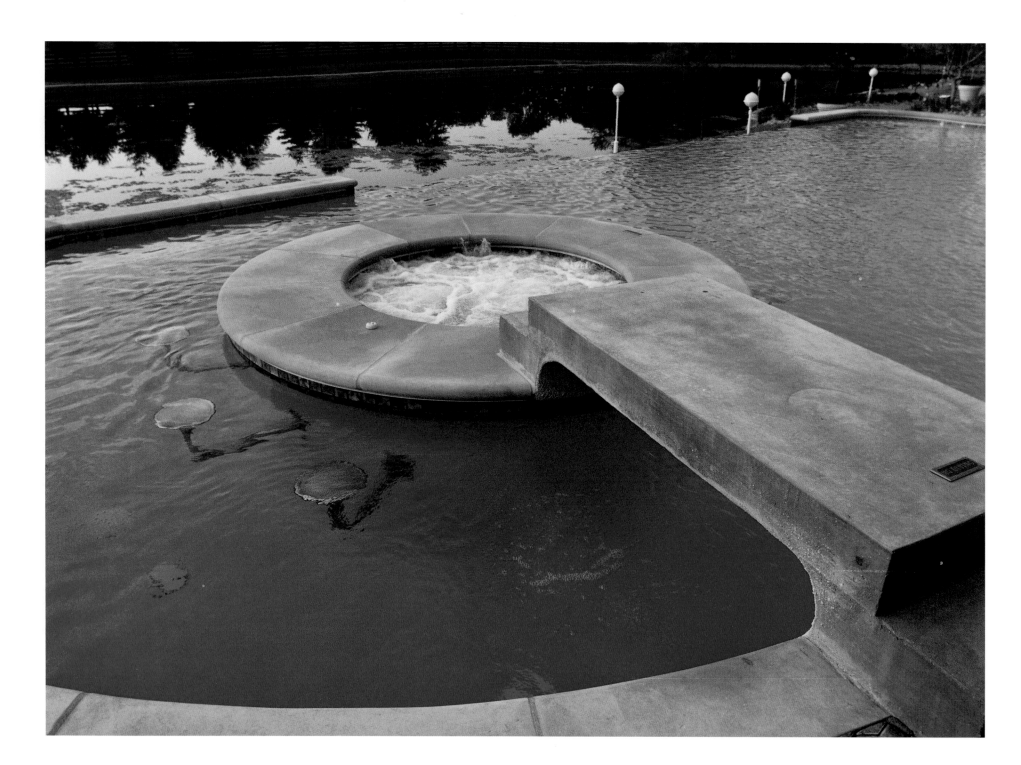

WATER, WATER EVERWHERE

Sheets of falling water, a vanishing edge, bubbling fountains —they all come together in this massive aquatic mission, which takes full advantage of the site's dramatic elevation changes. Even the lake water is forced into action with a 65-foot (19.8 meter) fountain. Regardless of your vantage point, you see water in action—whether you're standing atop the stairs overlooking the pool or are down at the lakefront gazing up toward the house. A spa set within the pool and accessed via a bridge, however, offers the most relaxing spot from which to view the water show.

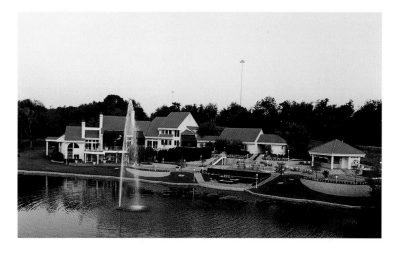

DESIGN DETAILS

It's a rare client who will spend $700,000 for a pool and spa, even if he or she can afford it. Yet, when you frequently host gala events at your sprawling mansion for hundreds of people, that may be a small price to pay for a private aquatic resort that's both impressive and functional.

The poolscape is built into an incline that leads from the main residence down to the lake's shore. The 50- to 60-foot (15- to 18-meter) change in elevation created the perfect situation for a variety of cascading water features. At the top, steps lead down to a platform, from which one can turn left or right to step down to the pool deck. Beneath the platform is a grotto with mosaic tiles, piped-in music, and seating for twelve. One of five waterfalls cascades over the grotto, while the other four spill from the terraced levels on either side.

A spacious deck adjoins the pool and leads up to a pool house with an outdoor bar. The deck offers the perfect vantage point for viewing the 36-foot (11-meter)-long black granite vanishing edge. From the

Location: **Louisville, Kentucky, USA**
Type of construction: **Gunite**
Pool and spa finish: **Plaster**
Decking: **Interlocking pavers**

∧
From the lakefront, one can sense the flow of water through the pool's various features.

<
A circular spa surrounded by underwater stools is set in the pool to conserve space.

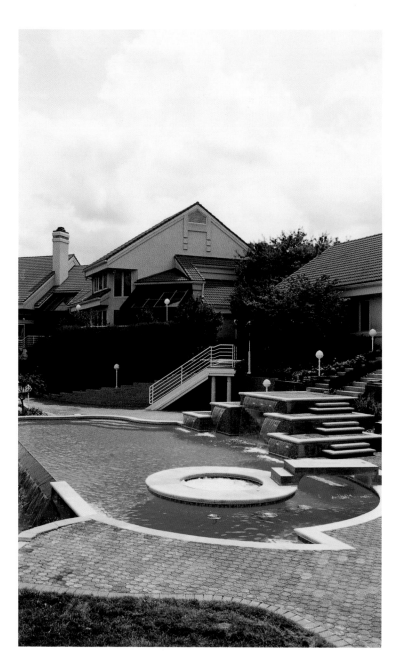

back side of the pool, the cascading water appears to be part of an additional water feature that includes a trio of bubblers that send water spilling into three interlocking basins. This smaller water feature is plumbed separately from the pool.

To handle the large volume of water, a second set of equipment was installed at the lower level. To keep it out of sight, the equipment is housed in an underground vault accessed via a manhole cover.

To maximize the limited space between the house and lake, the 20-by-50-foot (6.1-by-15.2-meter) pool runs parallel to the property. Also, engineers were brought in to dam up a portion of the lake to create an additional 15 feet (4.6 meters) of space for the project. The result is a wide set of steps that rises from the lake to the lower deck.

An additional space saver was placing the circular spa within the pool. Accessed by a bridge, the spa is surrounded by underwater stools so swimmers and soakers can easily mingle. Meanwhile, the water show continues offshore, where a 65-foot (19.8-meter)-tall spray shoots up from the lake itself.

The entire project is framed in a light-colored limestone with no grain, giving the pool coping and ledges a clean look. The rest of the decks and terraces are filled in with interlocking red pavers. Though a mortared stone deck would have been a more elegant choice, the designers needed a material that would be forgiving as the hillside settled over time.

<

A series of descending water features were used to accommodate the 50-foot (15.2-meter) change in elevation.

>

The bubbling fountain below the pool is plumbed separately from the rest of the aquascape.

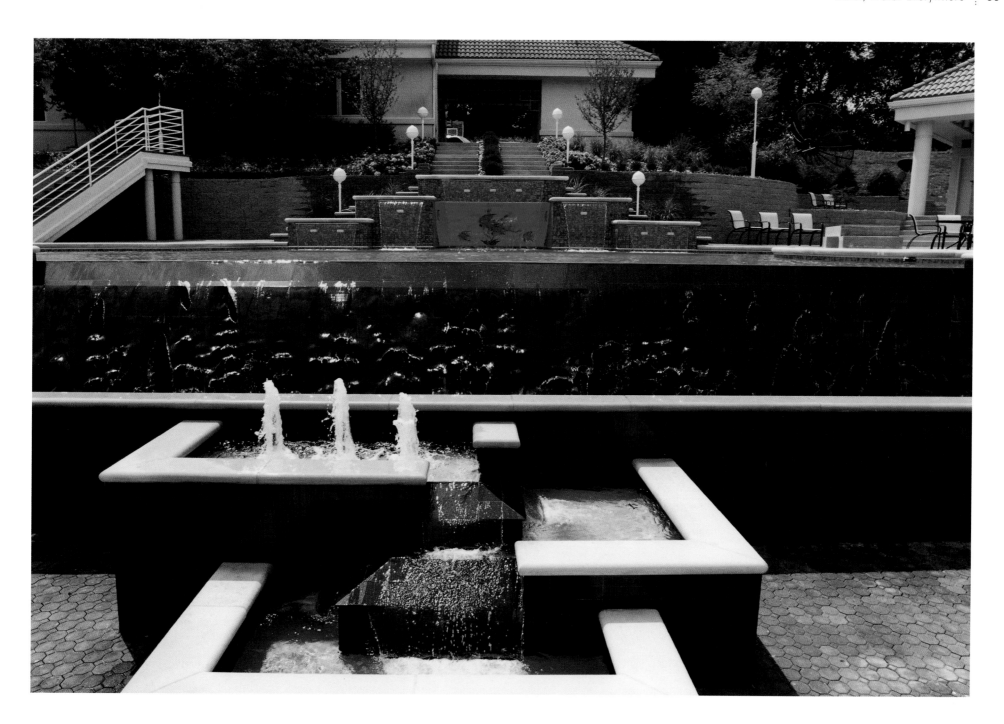

FALLING WATERS

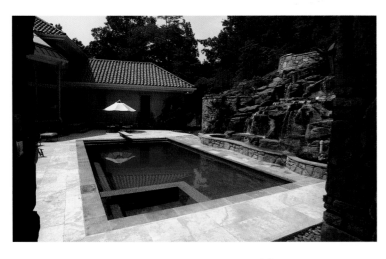

Carved into the hillside, this pool and spa would soon be filled with mud if it weren't for the 12-foot (3.7-meter) retaining walls. To take advantage of the height, the wall design incorporates a large waterfall, producing a dazzling poolside attraction. A bench-high stone wall surrounds the catch basin and beckons guests to come and enjoy the water feature up close. Surrounded by raised planting beds and cascading flowers, it's also a tranquil place from which to supervise the aquatic play in the pool.

∧
A spa set in the corner of the pool provides a relaxing vantage point from which to view the waterfall.

>
Raised planters and pockets of flowers soften the hardscape.

Location: **Alpharetta, Georgia, USA**
Type of construction: **Gunite**
Pool and spa finish: **Exposed aggregate**
Decking: **Stone**

DESIGN DETAILS

A rugged waterfall—a massive assemblage of rocks and plantings that towers 12 feet (3.7 meters) above the ground—dominates this 18-by-36-foot (5.5-by-11-meter) pool. The water feature's size is functional, too, as it's part of an enormous retaining wall that keeps the forested hillside at bay.

Practical by design, the pool is 3-feet (1-meter) deep on the shallow end and descends to 8.5-feet (2.5-meters) deep for diving. A spa in one corner provides hot-water

therapy and a relaxing spot from which to enjoy the visual and aural effects of the water feature.

Surfaced with a black stone aggregate, the pool and spa complements the flagstone deck and natural boulders used to create the water feature. Two-inch (2-centimeters)-thick cut stone coping surrounds the pool, providing a clean edge that contrasts with the random flagstone deck.

With all this rock, plantings were a must to soften the hardscape and add a splash of color. Pockets of

flowers are even tucked within the waterfall to make it seem more natural. The catch basin doubles as a miniature pond, which can be enjoyed by sitting on the capped stone wall surrounding it.

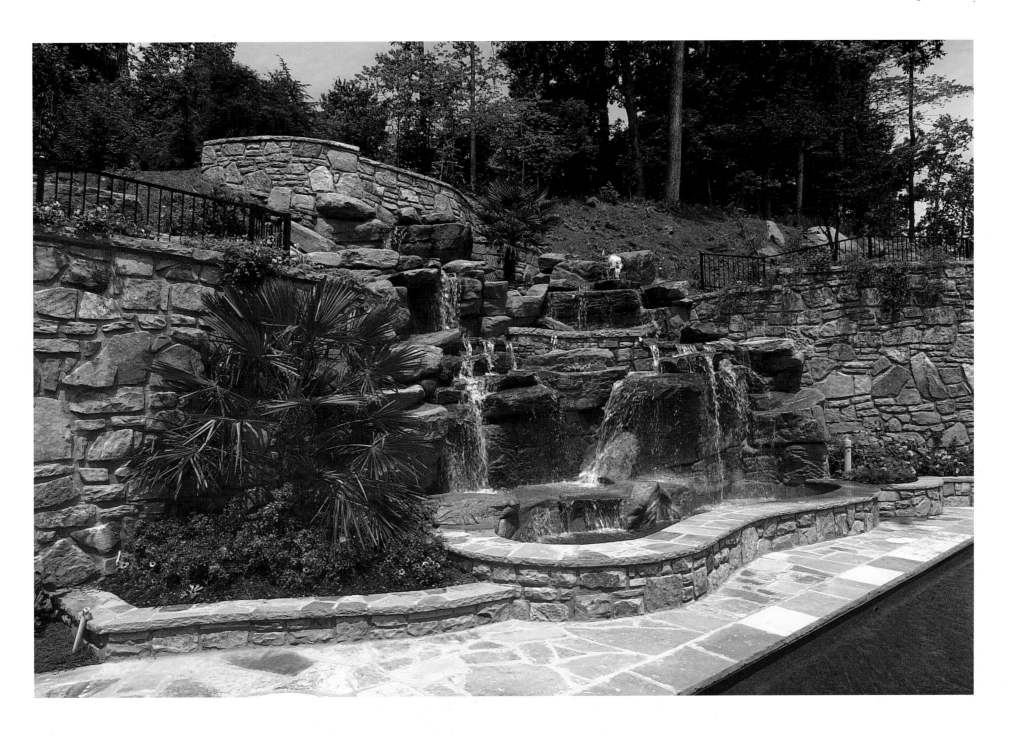

"The noblest of the elements is water."

Pindar, 476 B.C.

ALLURING ILLUMINATIONS

A midnight swim is one of the little luxuries afforded pool owners, and nothing sets the mood for a moonlit dip like strategically placed landscape and pool lighting. Also, it's a well-known fact that homeowners spend more time looking at their pools than they do swimming in them—and proper exterior lighting extends their viewing pleasure into the darkest hours of the night.

Long gone are the days when a single underwater light mounted in the pool wall sufficed as pool lighting. Today, low-voltage fixtures and fiber-optic cables have reinvented the way we view and use swimming pools at night.

One of the greatest advances in the past decade has been fiber-optic lighting, which is composed of fiber-optic cables set aglow by an illuminator positioned away from the water. Depending on the quality of the cable and the strength of the illuminator, it's possible to safely light up the entire perimeter of a pool. Clustered LED lights are also growing in popularity for illuminating pools and spas.

Outdoor lighting fixtures are increasingly used to highlight the undersides of stairs, waterfalls, pathways, statuary, trees, and so much more. In short, lighting has become as important a design element outside the home as it has been within it.

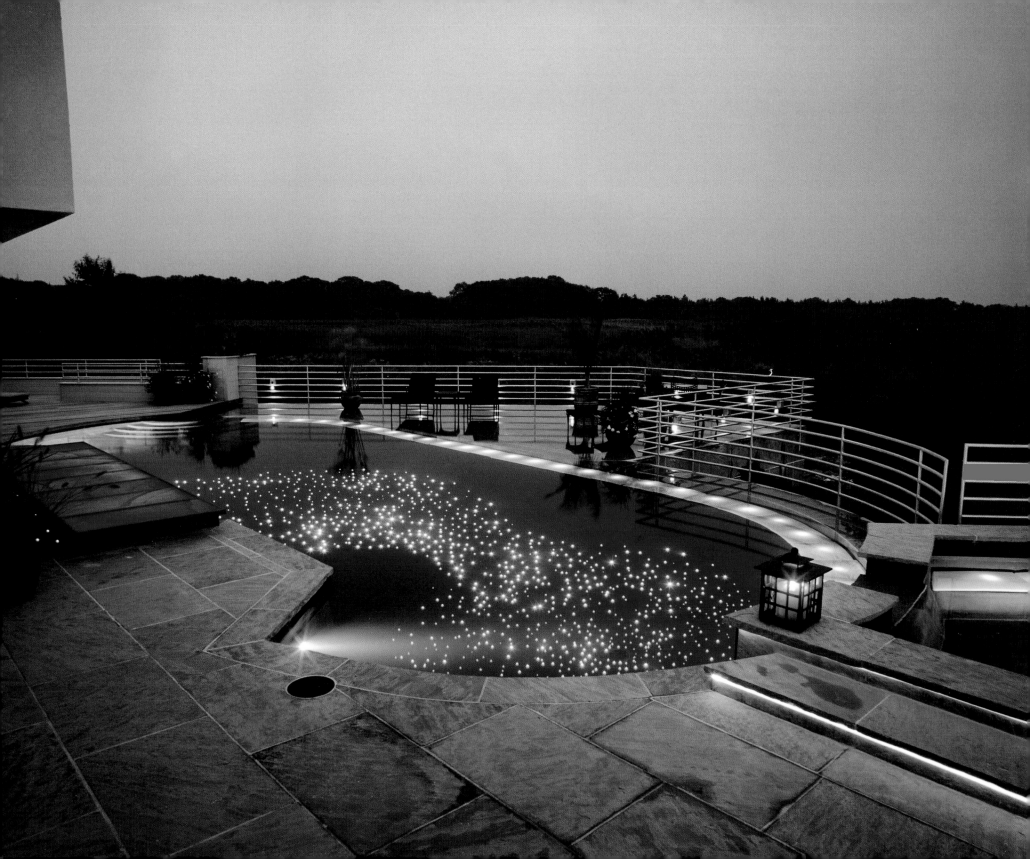

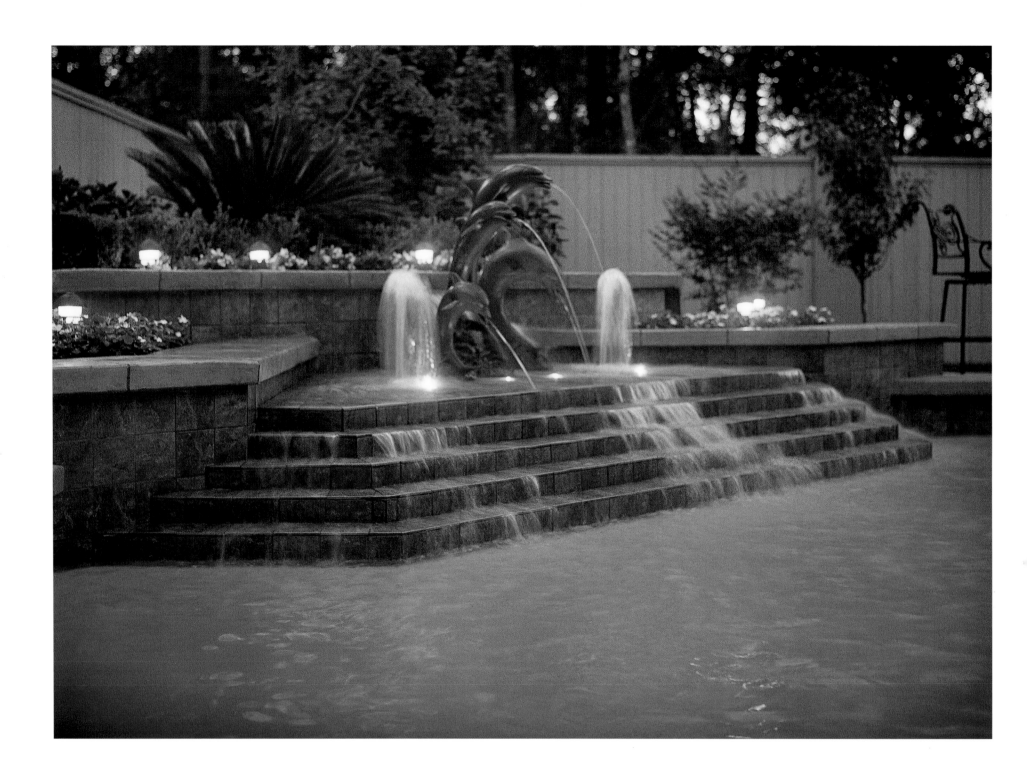

DANCE OF THE DOLPHINS

Swimming with the dolphins is a spiritual ritual the owners of this contemporary pool and spa can experience whenever the mood strikes. Day or night, bronze dolphins leap from the pool's fountain in a lively gesture that beckons swimmers to come and play. The sculptures, as well as the rest of the pool and spa area, are artistically lit for optimal nighttime enjoyment and viewing—whether from a deck chair near the outdoor kitchen or through one of the home's many windows that look out to the pool.

Location: **The Woodlands, Texas, USA**
Type of construction: **Gunite**
Pool/spa finish: **Plaster**
Decking and coping: **Concrete**

↗

A built-in gas fire pit warmly lights the poolside deck.

<

Four bronze dolphins dance atop a cascading fountain illuminated with colored lights.

DESIGN DETAILS

Dubbed "Dance of the Dolphins," this enlightened pool and spa installation truly performs. At night, the spotlight shines on a playful group of bronze dolphins leaping on a "stage" of cascading fountains. The slightly raised spa balances the dramatic water feature while keeping the geometric design symmetrical.

Raised planters with low-voltage landscape lighting act as a backdrop for the graceful sculptures, which are spotlighted with underwater fiber-optic fixtures that allow the home-owner to change the color—from magenta to emerald green. Underwater lighting also sets the pool and spa aglow, while the warm light from a gas fire pit illuminates the deck area. Recessed fixtures above the covered deck area also light the terrace, which contains an outdoor summer kitchen for elegant, poolside entertaining.

The stonelike deck and pool coping are actually concrete that has been custom colored and stamped to create a cut-stone effect. The earthy color contrasts nicely with the white plaster finish on the 15,000-gallon (56,781-liter) pool, which is kept spotless with an in-floor cleaning system. When viewed from the house, however, the lively dolphins remain the focal point, day or night.

LIGHT HOUSE

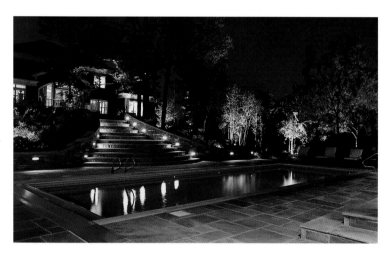

Outdoor lighting must be both functional and stylish to be effective. With this pool installation it's both. Path lights illuminate the grand staircase leading to the pool, which is lit with fiber-optic perimeter lighting. In addition, a warm glow emanating from the pool house provides ample illumination to ensure safe nighttime enjoyment of the pool and surrounding deck area. In theater, stage lighting can either make or break the show. In this well-lit production, the pool delivers a star performance.

∧
Path and landscape lighting create a pool environment that can be enjoyed at night.

>
The pool house provides poolside illumination, while the pool's colored fiber-optic lighting sets the mood.

Location: **Louisville, Kentucky, USA**
Type of construction: **Gunite**
Pool finish: **Plaster**
Decking and coping: **Stone**

DESIGN DETAILS

The 16-by-46-foot (4.9-by-14-meter) pool is set in a hillside that was cut to achieve the desired placement for the pool. Thus, the adjacent pool house is essentially a two-story retaining wall for the pool, with its basement housing the pool equipment.

Bedford limestone frames the pool for a simple, clean look, and the remaining deck is made from rectangular Crab Orchard stone, a type of sandstone that has a high silica content, which makes it much harder and more weather resistant than other varieties of sandstone.

A grand stone staircase connects the house to the pool area. At night, light fixtures in the stone retaining walls on both sides of the staircase light the path. Exterior lights on the pool house, as well as light from within, illuminate the pool deck.

The spectrum of lighting continues within the pool itself, where fiber-optic lighting cable encompasses the pool's perimeter. A color wheel in the fiber-optic cable's illuminator allows the homeowners to change the hue to match their mood. Meanwhile, extensive landscape lighting spotlights trees and colorful flower beds. All of the lighting fixtures can be controlled from within the residence, as well as from the pool house.

PROFESSIONALS Pool Designer/Contractor: **Gym & Swim** Pool House Designer: **Timothy R. Winters, Architect** Photographer: **Bill Grant**
Pool House Contractor: **Karzen-Langan-Burrus Construction, LLC**

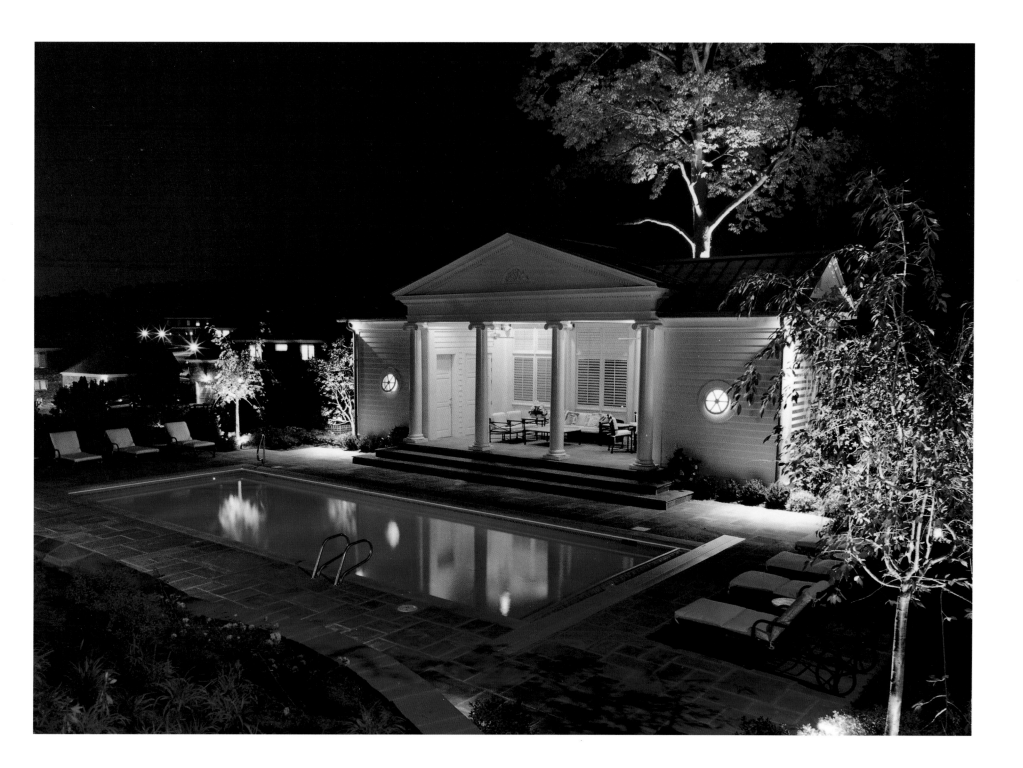

STARLIGHT, STAR BRIGHT

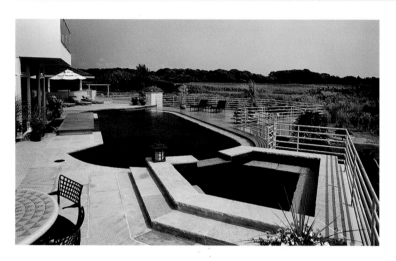

The floor of this uniquely lit swimming pool is dotted with 2,250 points of fiber-optic lighting—an idea that came from the homeowners, who wanted the illusion of stars tumbling into the deep end of the pool. The owners even mapped out the placement of each light to ensure the desired effect. Now, even on a cloud-covered evening, swimmers are guaranteed a starry night.

Location: **Westhampton Beach, New York, USA**
Type of construction: **Gunite**
Pool finish: **Plaster**
Decking and coping: **Stone**

∧
Silicone-filled cushions soften the bench seating in the pool and spa.

>
More that 2,000 points of light create a starry path along the pool's bottom.

DESIGN DETAILS

Installing 2,250 fiber-optic lights in the floor of a pool sounds as complicated as it is. In this pool, each fiber-optic cable was coated with epoxy to protect it from the gunite pool structure. The lenses covering the fiber-optic cables were set roughly 4 inches (10 centimeters) apart, which necessitated great care in the application of the marble-dust pool finish.

In addition to the in-floor lighting, the pool includes sixty fiber-optic lights recessed in the spa seats and the pool's 60-foot (18.3-meter)-long underwater bench. Translucent cushions, filled with silicone, are attached to the bench seats with Velcro strips secured directly to the plaster finish with epoxy. The cushions provide comfort for bathers as well as unique filters for the recessed lighting.

The lighting scheme continues on the pool deck, where fiber-optic cables illuminate the steps leading to the raised spa. The stainless steel guardrail surrounding the wet deck area is also illuminated with fiber-optic fixtures.

The wet deck area connects to a dry teak deck, which then connects to a dry stone deck via a glass bridge over the pool. The effect is three distinctive deck environments around one brilliantly lit pool.

PROFESSIONALS Contractor: **Ron Gibbons Swimming Pool** Photographer: **Carl G. Saporiti**

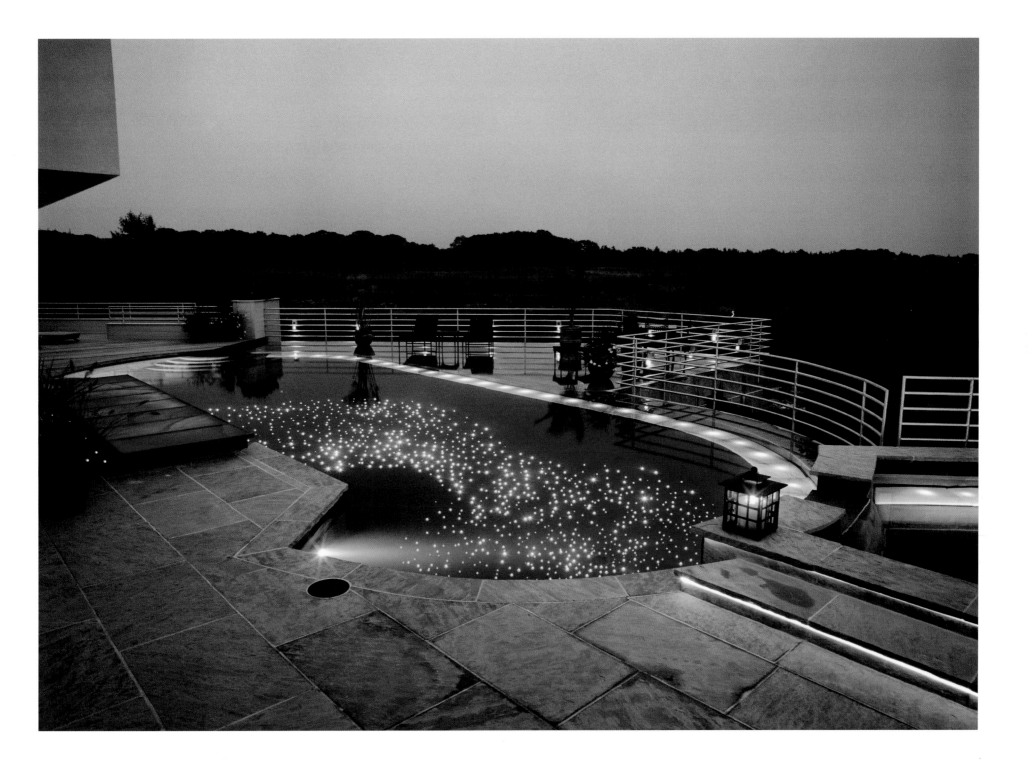

LAP OF LUXURY

A wall of glass is all that separates this second-story lap pool from the adjacent bedroom. When the pool lights are turned on, the resulting glow softly illuminates the home's interior while providing a well-lit pool for evening swims. The home's residents, however, aren't the only ones to enjoy the pool lighting. From the street, neighbors and passersby can view how the refracted pool light filters through the frosted-glass banister, producing a unique form of architectural lighting.

∧
Passersby can catch glimpses of aquatic shadows through the illuminated, frosted-glass guardrail.

>
The 50-foot (15.2-meter)-long lap pool is made of cast-in-place concrete lined with vinyl.

Location: **Atlanta, Georgia, USA**
Type of construction: **Concrete**
Pool/spa finish: **Vinyl**
Decking and coping: **Concrete and wood**

DESIGN DETAILS

Few people would imagine installing a pool outside their second-story bedroom window. But that's precisely what architects Mack Scogin and Merrill Elam did when they were forced to remodel their home after a storm toppled a tree onto their house.

Recalling that they had always wanted a lap pool in their next house, they took advantage of their unfortunate situation to make their dream come true. Faced with a small lot, the duo devised a lap pool that would become an integral part of the home and require no yard space. Situated directly above the living space, the pool structure

is made from cast-in-place, reinforced concrete in a troughlike configuration. Without the use of support columns, the pool spans the entire 50-foot (15.2-meter) width of the house. If the pool were to develop cracks, a blue vinyl liner with black trim around the water line will keep water from leaking into the residence.

Floor-to-ceiling safety glass separates the pool from the bedroom, while frosted-glass panels create a privacy fence on the other side of the pool.

The architects' favorite design feature is the underwater lighting, which turns the pool into an aquatic lamp that illuminates the home's

interior. Equally spectacular is when someone is swimming in the pool at night, because the moving water creates fanciful shadows that dance across the translucent glass. Passersby are rewarded with a show of moving marble patterns across the wide screen.

PROFESSIONALS | Architect: **Mack Scogin Merrill Elam Architects** Photographer: **Timothy Hursley**

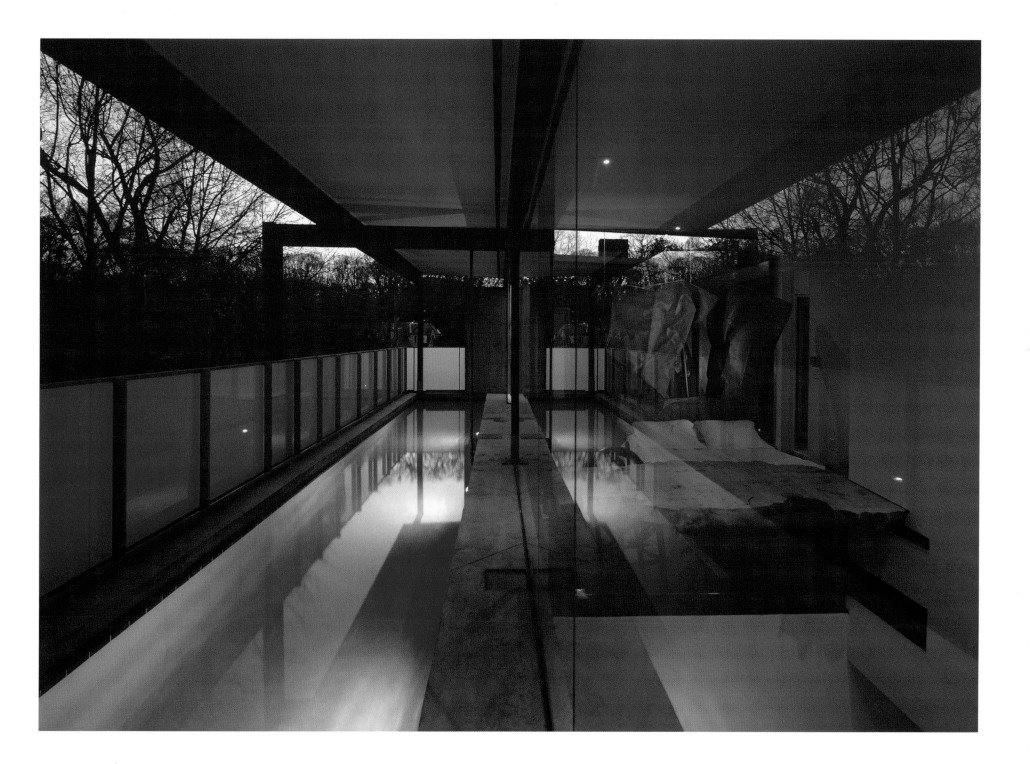

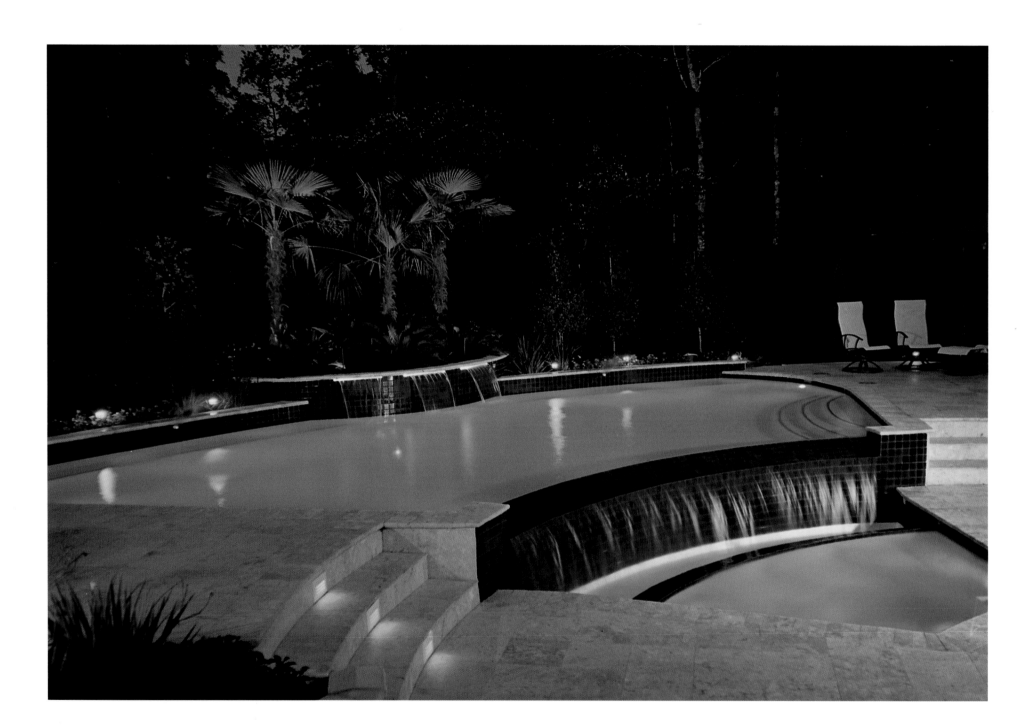

DOUBLE NEGATIVE

Pool and landscape lighting is especially dramatic when it highlights changes in elevation and varying deck levels. With this pool and spa, extensive use of fiber-optic lighting helps create a multilevel entertainment environment that can be enjoyed anytime, day or night. The orchestrated pool lighting breathes new life into several water features, while up-lit trees appear to come out of hiding.

Location: **The Woodlands, Texas, USA**
Type of construction: **Gunite**
Pool/spa finish: **Plaster**
Decking and coping: **Marbella limestone**

↗

The multilevel installation includes a sunken spa, terraced gardens, and a raised pool and gazebo.

<

Strategically placed lighting accents the water features, steps, and landscaping.

DESIGN DETAILS

Beyond its functional purpose, lighting is an important design element, as seen in this tiered pool and spa installation. Fiber-optic lighting illuminates the water spilling from the pool; step lights mark the path to the upper deck; more fiber-optic lighting gives prominence to the three sheeting waterfalls; and up-lighting enhances the palm trees behind the water feature.

The pool and spa lighting also draw attention to the double negative-edge design, whereby both the spa and the pool spill into a common trough. The pool has a "reverse" negative edge, because the water spills toward the viewing area as opposed to away from it.

The spa, which is positioned beneath the pool on the lowest deck level, features contoured seating, including a full-length reclining lounger and a bucket seat with neck and body jets. An air ring in the floor provides a full-body massage.

The deck and coping are made from marbella limestone. Its cream color contrasts with the green lawn, blue pool tile and surrounding foliage. Terraced flowerbeds, a raised gazebo, and an outdoor kitchen for casual dining or elaborate poolside entertainment complete the poolscape.

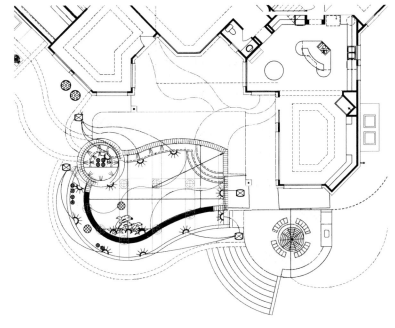

PROFESSIONALS Landscape Architect: **Hoffman Landscape Design** Contractor: **Wise Pool Company** Photographer: **Ted Washington**

WHITE GOLD

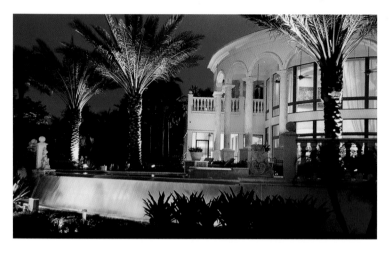

At night, all eyes are on this pool and spa thanks to the brilliant use of underwater and accent lighting. Fiber-optic and halogen lights illuminate the spa and vanishing edge, while landscape fixtures spotlight trees and foliage. The effect is a brightly lit project that leaves nothing in the dark, making this pool and spa as enjoyable at night as it could ever be during the day.

∧
The pool's vanishing edge and surrounding landscape are lit up with fiber-optic and halogen light fixtures.

>
Underwater lights illuminate the raised spa, as well as the steps on each side of the pool.

Location: **Weston, Florida, USA**
Type of construction: **Concrete**
Pool finish: **Marble aggregate**
Decking and coping: **Precast coral pavers**

DESIGN DETAILS

Classically designed, this home radiates with dramatic flare on account of a state-of-the-art pool and spa installation that comes alive when the sun goes down. Extensive underwater and landscape lighting sets the scene aglow—from the two massive palm trees (which flank each side of the symmetrical 10- by 60-foot [3-by-18.3-meter] pool) to the enormous vanishing edge (which seems to spill into the adjacent waterway).

Four 4-horsepower pumps send a torrential 1,600 gallons (6,054 liters) of water over the pool's 40-foot (12-meter)-long vanishing edge

every minute. Halogen lights ensure that passing boaters don't miss the spectacular water show, which also creates soothing aquatic sounds for those lounging poolside.

To blend the pool and spa with the home's Floridian decor and architecture, imitation precast coral pavers are used for the pool deck and coping. The pool and spa are finished with light-colored polished-marble aggregate for a smooth texture, and the waterline is covered with alternating black and white marble tiles set in a diamond pattern. Black tiles also indicate where the pool steps are for safe access to and from the water.

The pool is equipped with an automatic chlorine generator to simplify maintenance. Also, the pool and spa are fully automated, giving the homeowners easy control of the all the equipment, including the pumps, jets, heaters, and lighting.

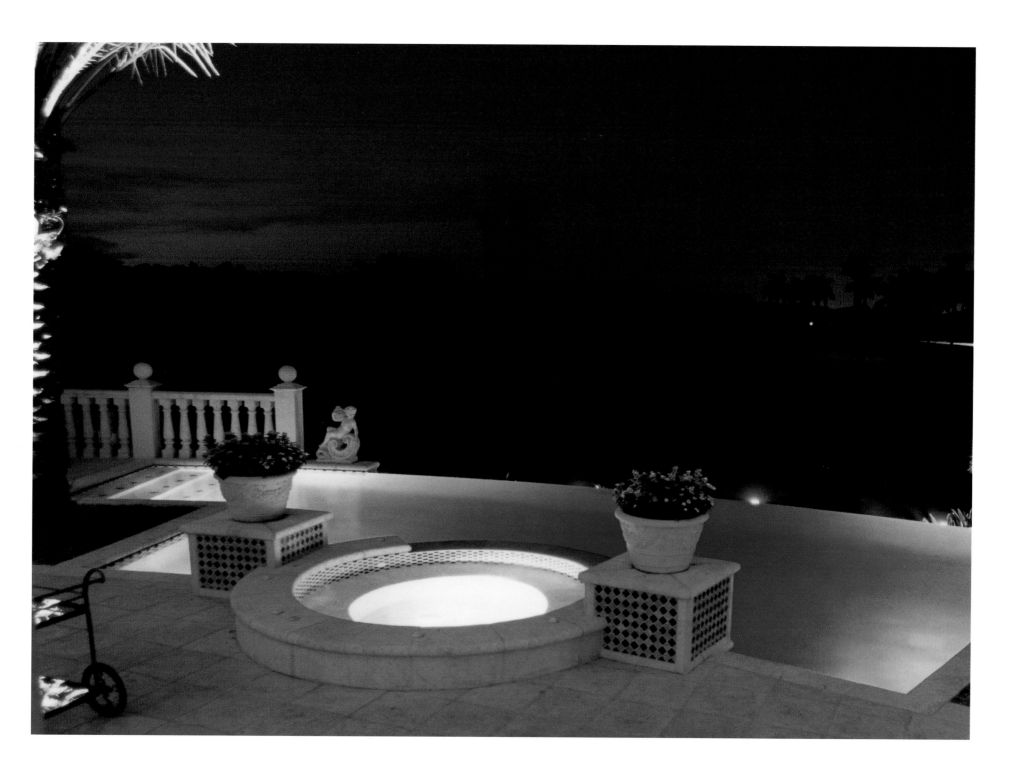

"If there is magic on this planet, it is contained in water."

Loran Eisely, *The Immense Journey*, 1957

VANISHING ACTS

The mysterious qualities of vanishing-edge pools, also known as infinity pools or negative-edge pools, have caused their popularity to skyrocket in recent years. Though the illusion is sometimes unbelievable, the concept behind it is quite simple.

To create a vanishing-edge pool, a portion of the pool wall is lowered so that water is allowed to spill over it. A catch basin or gutter system on the back side of the pool accommodates the excess water required to create the effect. Depending on the pool's site and how well the architect masterminds the design, a vanishing-edge pool may appear to have no wall retaining the water on the negative-edge side.

The best illusion is created when the pool is elevated above a natural body of water, so that the pool appears to flow directly into it. Astonishing effects also have been created on elevated wooded sites and even golf courses. Plus, with the right architectural and landscaping treatments, the back side of a vanishing-edge pool can be transformed into a dramatic water feature.

Like anything that comes into vogue, however, the vanishing-edge design concept has been overused and misused. Here are examples of vanishing-edge pools that keep true to the art form and make aquatic magic an architectural reality.

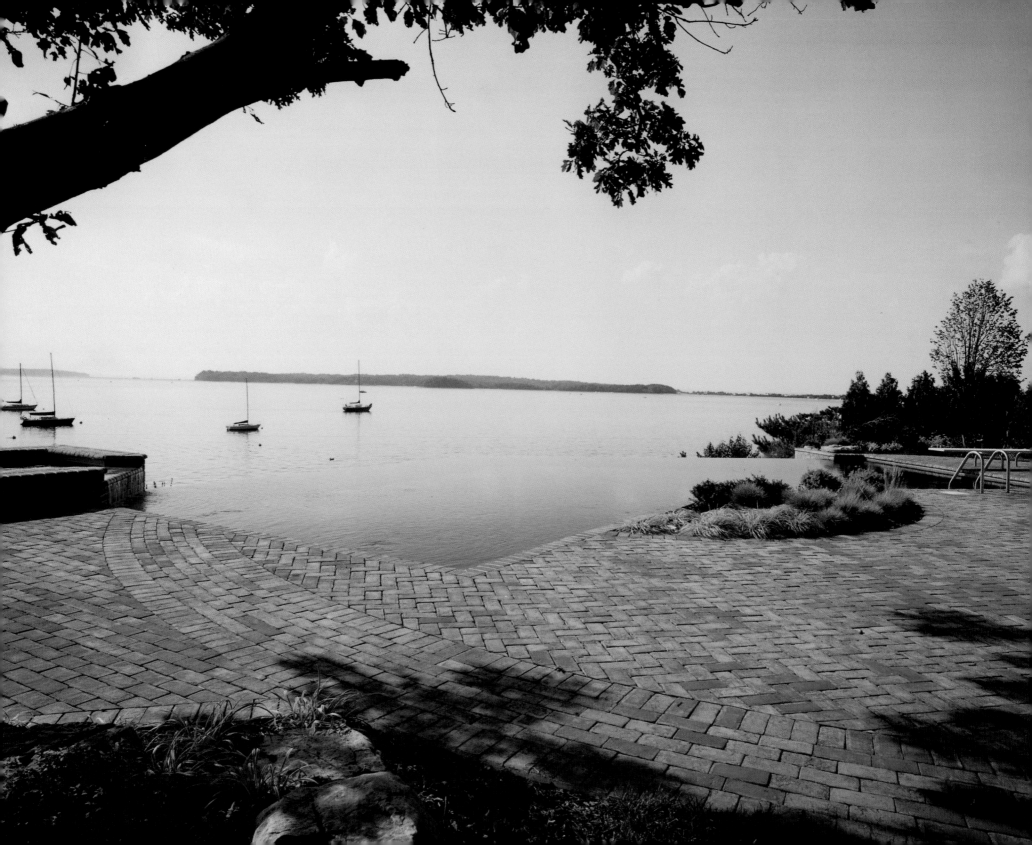

MEXICAN MAGIC

The villas of Careyes, Mexico, are famous for their sweeping ocean views and colorful designs that combine modern elements with primitive materials, such as palapa thatch for the roofs. Many of these Caribbean-style homes include swimming pools, and a good share of those are vanishing-edge creations that appear to send cool, clear water cascading into the surrounding sea. This particular project's graceful curves add to the fluid design, while the color scheme is a study of natural shades and contrasting hues.

∧

The vanishing-edge pool changes colors as the sun moves across the sky.

>

The flower of the dwarf poinciana tree inspired the orange walls.

Location: **Careyes, Mexico**
Type of construction: **Concrete**
Pool/spa finish: **Plaster**
Decking and coping: **Terrazzo**

DESIGN DETAILS

As you approach this vanishing-edge pool from the home, you're immediately struck by the peaceful progression of blues that color the pool, sea, and sky. All contrast beautifully with the white terrazzo deck and orange stucco walls that inherited their bright color from the flamboyant flower of the dwarf poinciana tree.

Measuring 65 feet (19.8 meters) long and 15 feet (4.6 meters) wide, the pool actually spills over all four sides. But the back side, which appears to spill into the ocean,

is the most dramatic. Here, water flows over a concrete weir and into a channel, where it's directed to a holding tank beneath the pool before being filtered and circulated back to the pool. Along the remaining three sides, a recessed gutter system in the pool deck collects water that flows over the pool walls. The expansive terrazzo deck has been skillfully chiseled by hand to make it slip resistant and beautifully textured.

Constructed close to the fragile shoreline, the massive pool is supported by a 19.5-foot (6-meter)

PROFESSIONALS Landscape Architect/Contractor: **Duccio Ermenegildo** Photographer: **Tim Street-Porter**

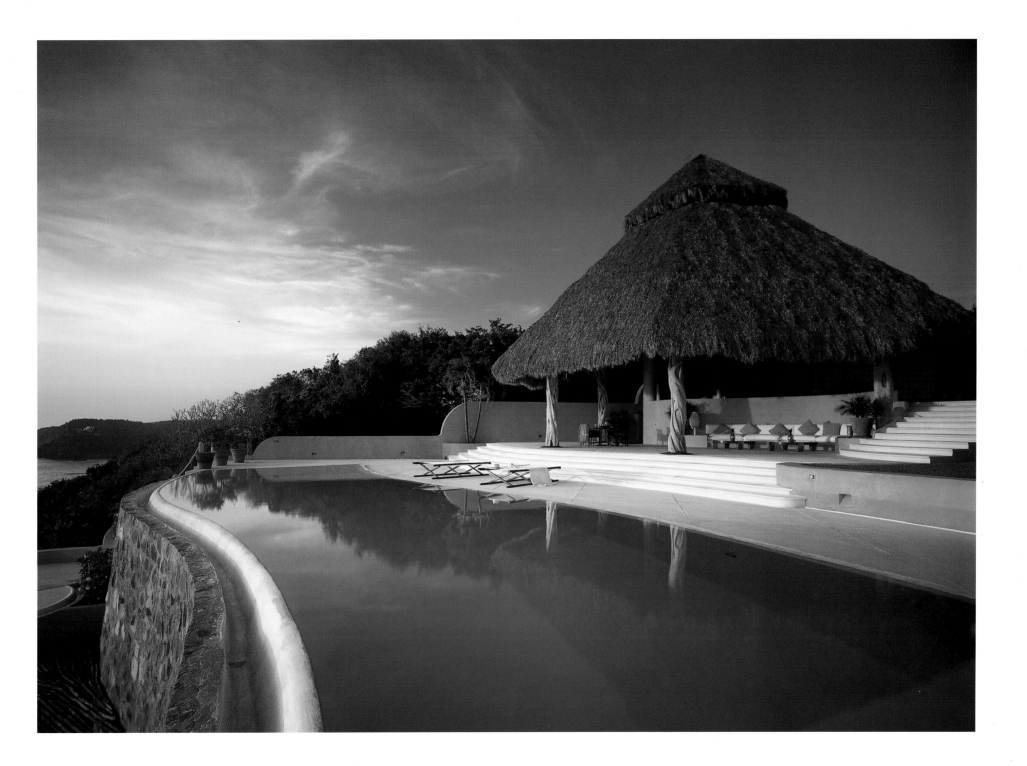

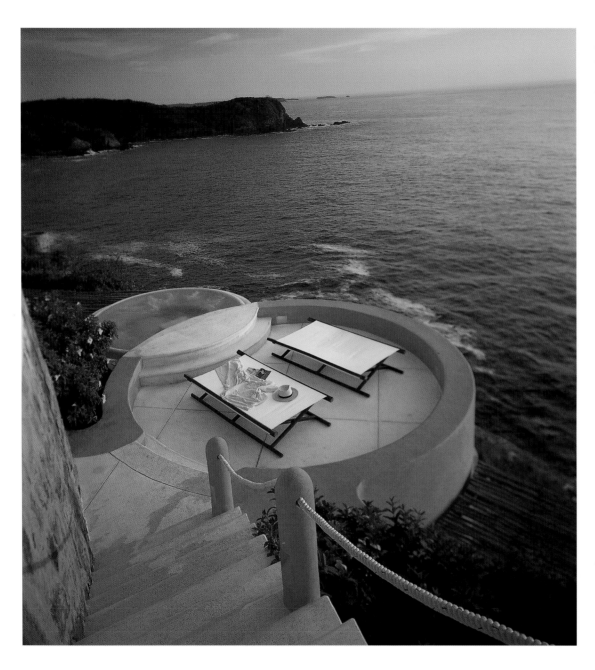

stone retaining wall. As striking as the pool is, there's more to appease the senses. A staircase near the shallow end of the pool leads down to a spa area composed of two intersecting circles—one forms the hot tub while the other serves as a spa-side deck perfect for intimate conversations or private sunbathing.

The tropical design theme continues throughout the home. Tree trunks that have been overtaken by vines support the thatched living space—which opens up to the pool area. The strangled trees are like organic sculptures that add visual excitement to the poolscape.

<
A spa area on the back side of the pool is composed of intersecting circles.

>
The architect likes to play with the different blue hues created by the pool, sea, and sky.

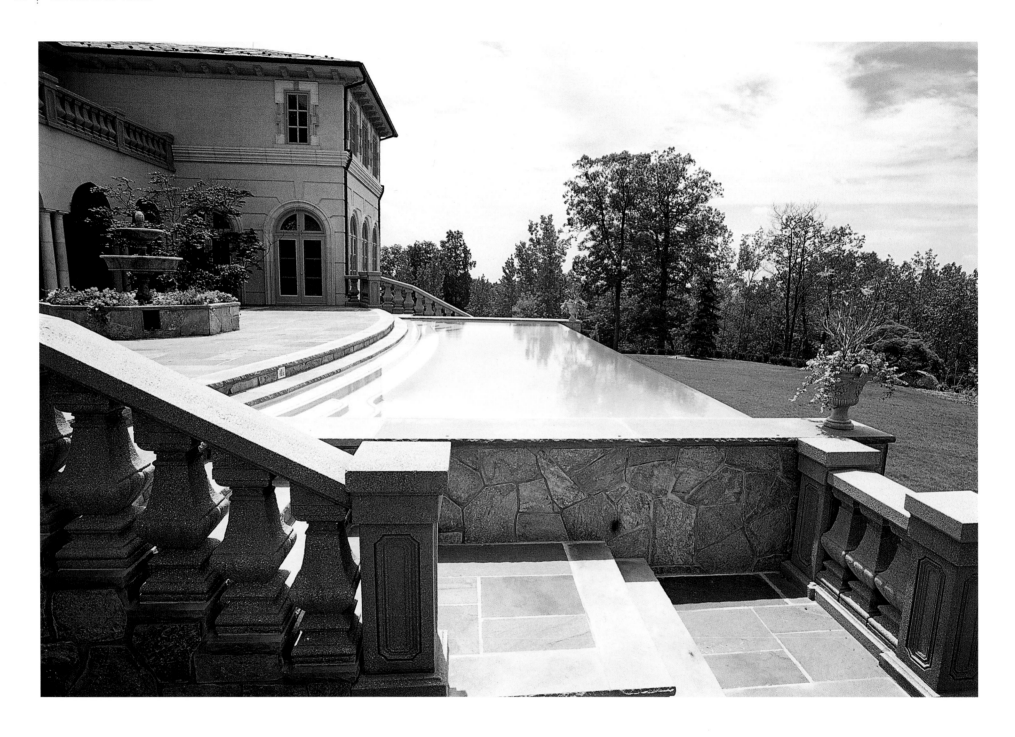

CLASSICAL CASCADE

Inspired by the home's classical architecture, this elegant pool incorporates some modern elements—including a 32-foot (9.8-meter)-long vanishing edge. When viewed from the raised terrace, the water appears to be suspended in midair, as if defying the laws of physics. In reality, the water spills into a catch basin on the back side. When viewed from the great lawn behind the estate, the pool takes on the guise of an enormous waterfall, providing visual excitement and soothing sounds. Revealing its beauty from every vantage point, the pool is both compelling and memorable.

Location:
Alpine, New Jersey, USA
Type of construction: **Gunite**
Pool finish: **Exposed aggregate**
Decking and coping: **Bluestone and limestone**

The pool's vanishing edge doubles as a water feature when viewed from the great lawn.

A vanishing-edge pool gives a contemporary flair to this monumental home.

DESIGN DETAILS

Reminiscent of the opulent homes built by America's plutocracy at the turn of the twentieth century, this grand New Jersey residence brings Old World charm to a new pool environment. The rectangular pool has a slightly concave curve along one side. Here, a series of three steps runs along the entire lengths of the pool, doubling as underwater bench seating. Meanwhile, swimmers can gracefully enter and exit the pool from radius-corner steps at each end.

The far side of the 15,000-gallon (56,781-liter) pool features a 32-foot (9.8-meter)-long vanishing edge, which creates a striking illusion, as well as a boisterous water feature on the back side. In a feat of engineering, water from the catch basin is routed to an equipment room located in a vault beneath the pool—thereby keeping the equipment out of sight yet close to the pool.

The pool is surfaced with a lightly colored exposed aggregate, which keeps the pool bright. Limestone coping matches the treads along the steps, and bluestone complements the patio. Also, carefully selected stones with thin mortar joints comprise the exterior walls of the elevated pool. This makes for an exceptionally beautiful backdrop for the falling water.

For evening enjoyment, fiber-optic lighting illuminates the pool, while underwater lights in the catch basin highlight the falling water feature.

PROFESSIONALS Pool Designer/Contractor: **Creative Master Pools** Photographer: **Eric Auerbach**

HIGH RISE

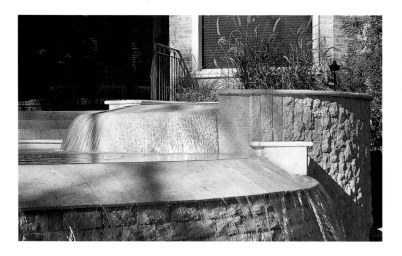

By building this pool and spa entirely above grade, the designer was able to include dual vanishing edges that emphasize the severe change in elevation from the deck level down to the ground. Bronze dolphins leap from the pool's vanishing edge, adding height and drama to the installation. Meanwhile, the back side of the pool is fully landscaped to create a mesmerizing water feature. A monochromatic color scheme—created with tile and limestone—focuses all the attention on the cascading water and enchanting sculpture.

Location: **The Woodlands, Texas, USA**
Type of construction: **Gunite**
Pool/spa finish: **Tile**
Decking and coping: **Limestone**

↖
Light-colored deck tiles, coping, and split-face blocks create a monochromatic look.

>
Fiber-optic lighting makes the water glisten, while garden torches cast a warm glow.

DESIGN DETAILS
With more than 12 feet (3.7 meters) of elevation changes from the back patio to the ground level, this is an ideal site for a vanishing-edge pool. Because the entire pool and spa project was built above ground, however, 12-inch (30.5-centimeter) bell-bottom piers were set 8 feet (2.4 meters) into the ground and extensive concrete beams were used to support the massive structure.

The extra effort paid off for this striking spa and pool combination with two vanishing edges. One leads from the circular spa to the pool; the other spills from the 37-foot (11.3-meter)-long curve of the pool into a catch basin below. Guests can view the pool's vanishing edges from the spacious deck level as well as from inside the home. Meanwhile, the pool's landscaped back side doubles as a curvaceous water feature.

Marbella limestone—characterized by a pale, off-white color; heavy fossilization; and an open-grained surface—appears extensively throughout the project, giving a great sense of permanence to the installation. Honed 12-by-12-inch (30.5-by-30.5-centimeter) deck tiles, bullnose coping around

PROFESSIONALS | Landscape Designer/Contractor: **Wise Pool Company** Photographer: **Ted Washington**

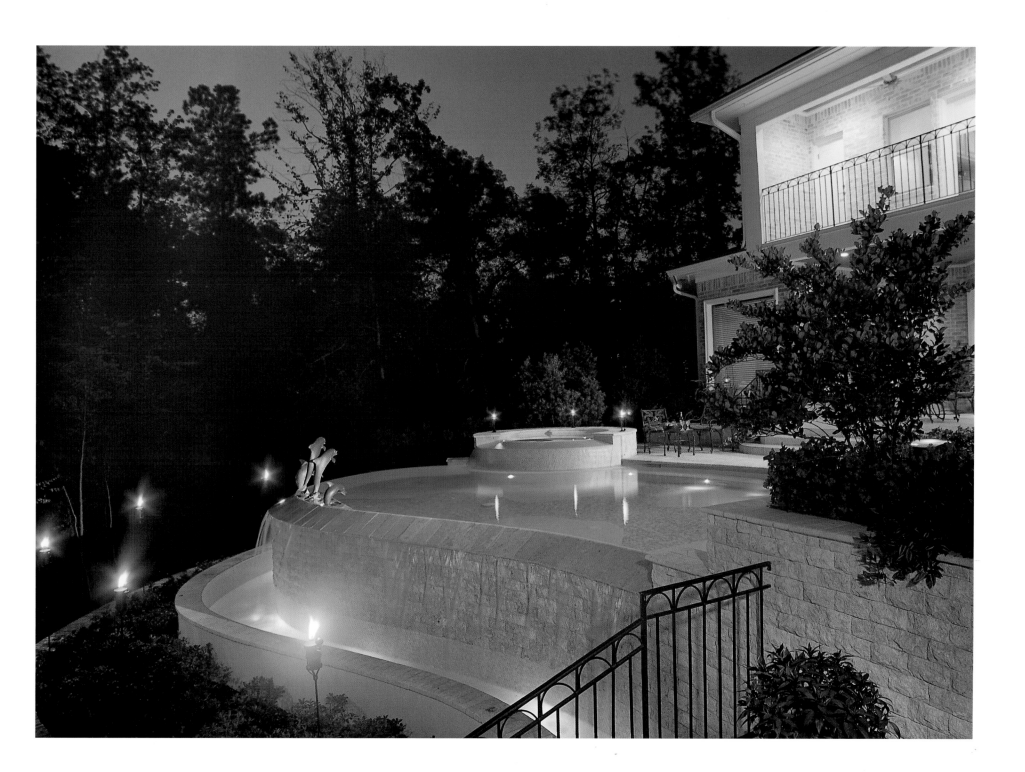

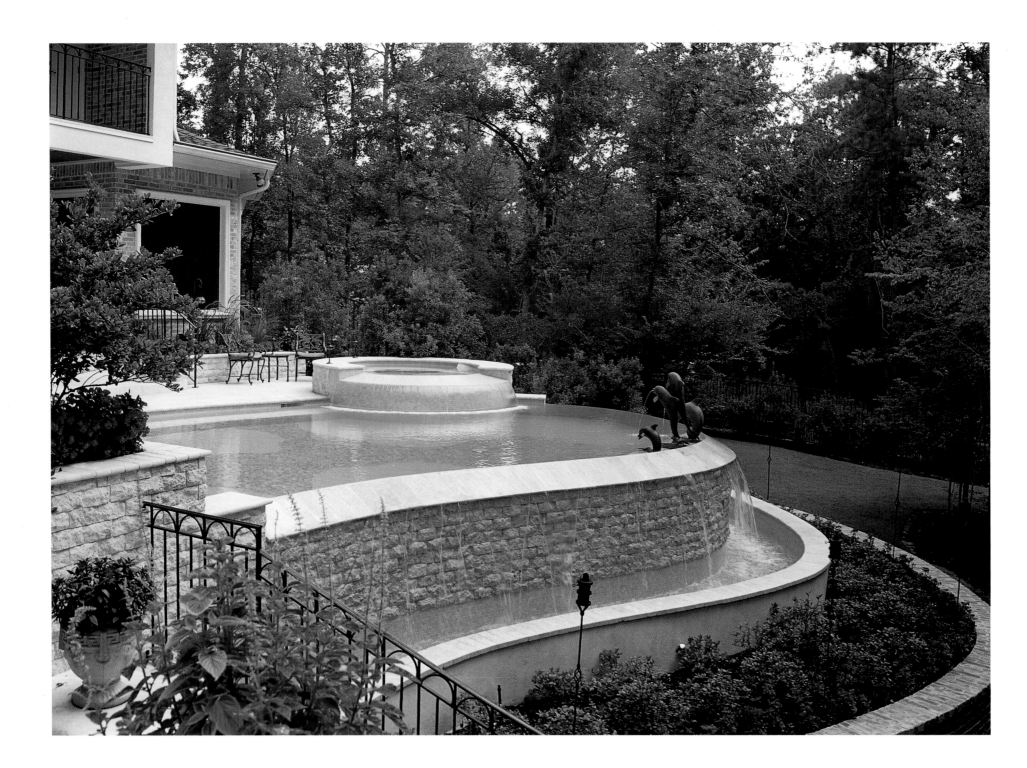

the pool and spa, and rugged, split-face blocks were used to create a monochromatic look that is mimicked by the home's decor. The interior surfaces of the pool, spa, and vanishing-edge catch basin are finished with imported French tile with an inlaid mosaic that extends to the bronze dolphin sculptures.

The poolscape comes alive at night with strategically placed landscape and underwater lights. The frolicking dolphins are spotlit, and even the back side of the pool is illuminated to make sure that passersby can fully enjoy the water feature at night.

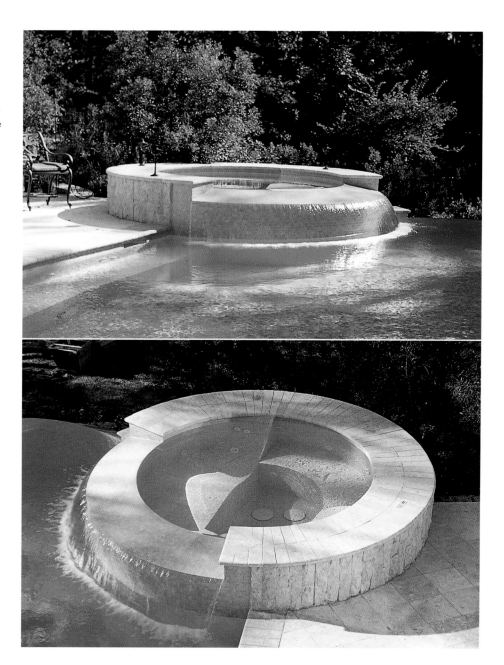

↗

A clear sheet of water spills from the circular spa.

>

The circular spa features a built-in recliner along with conventional seating.

<

Both the spa and pool have vanishing edges that contribute to the 37-foot (11.3-meter)-long waterfall.

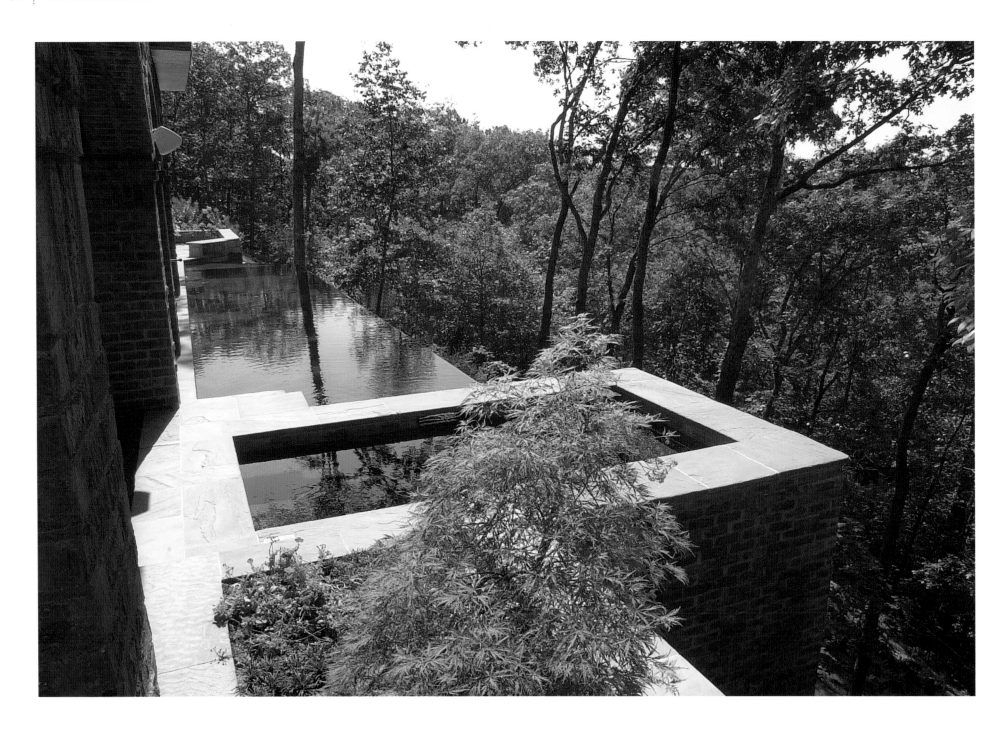

HEIGHTENED SENSATION

In addition to the spectacular views they typically offer, vanishing-edge pools require less space than similar-sized pools with decking on all four sides. That can be a tremendous advantage when space is limited, as it is with this hillside installation, which doubles as a water feature. With a grove of trees as a backdrop, the pool hugs the sloping landscape while enhancing the already spectacular view. An adjacent spa, nested at one end of the pool, provides the perfect place from which to take in the scenery.

DESIGN DETAILS

Nothing but treetops can be seen from this vanishing-edge lap pool perched on the edge of a steep incline. The black aggregate pool surface reflects the trees like a pond—its dark color contrasting with the light bluestone decking and red brick of the house. In addition to the spectacular vanishing edge, the pool also has three retractable fountain fixtures that can turn the calm pool into a showy water feature.

A covered passageway between the house and water leads to a rectangular spa nestled at the far end of the 60-foot (18.3-meter)-long pool. The shaded walkway offers a cool respite from which to view the fountains, vanishing edge, and trees through brick archways. Meanwhile, a spacious flagstone deck, as well as a second-story balcony above the passageway, offer sunnier vantage points.

The entire project is built above ground using reinforced retaining walls covered in red brick to match the house. At night, outdoor lighting illuminates the pool and fountains. The lights, fountains, and vanishing edge features can be controlled with the touch of a button, while an in-floor cleaning system ensures that the water stays sparkling clean.

Location: **Vinning, Georgia, USA**
Type of construction: **Gunite**
Pool finish: **Exposed aggregate**
Decking: **Stone**

∧
Retractable fountains add a new dimension to the lap pool.

<
Black water appears to flow into the treetops from this 60-foot (18.3-meter) vanishing-edge pool.

PROFESSIONALS Architect: **Roy Frangiamore Architects** Engineer: **Macon Gooch Building Consultants** Photographer: **Tony Benner**
Pool Contractor: **Master Pools by Artistic Pools, Inc.**

OVER THE EDGE

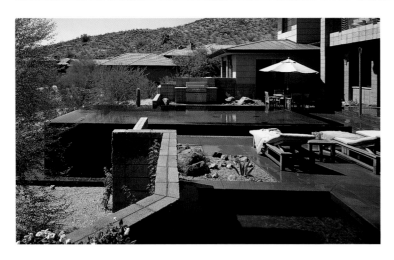

You don't need an oceanfront estate to reap the visual rewards of a vanishing-edge pool. All it takes is some creativity and a builder with some engineering savvy. This pool's four-sided, vanishing-edge design makes it look like a black cube of water rising from the desert sands. Whether viewing the modern creation from the outdoor dining area, the spa, the house, or the surrounding gardens, it's easy to marvel at the aquatic achievement—even without a seashore in sight.

∧
The retaining wall provides privacy for spa bathers.

>
The raised pool wells up and spills over all four sides.

Location: **Phoenix, Arizona, USA**
Type of construction: **Gunite**
Pool finish: **Exposed aggregate**
Decking: **Precast concrete and tile**

DESIGN DETAILS
With the entire deck area elevated, this site was ideal for creating a vanishing edge on the back side of the pool. The designer, however, went one giant step further by raising the whole pool above deck level and forcing the water to well up and run down all four sides. The water spills into a gutter that's been covered with an earth-tone grating system. The grate blends seamlessly with the similarly hued precast concrete pavers used for the deck and spa coping.

The pool's top ledge and exterior walls are surfaced with ebony tile, giving the pool a glossy, monolithic appearance. The dark tile is complemented by a gray aggregate pool surface, which turns the pool into a gigantic mirror that reflects the passing clouds and surrounding landscape. The same interior surface is repeated for the nearby spa.

The back side of the pool doubles as a water feature. Here, pool water falls in broken sheets and streams into a catch basin that mimics the main pool with its aggregate interior and black tile exterior.

PROFESSIONALS Landscape Architect/Contractor: **Shasta Pools & Spas** Photographer: **Pam Singleton**

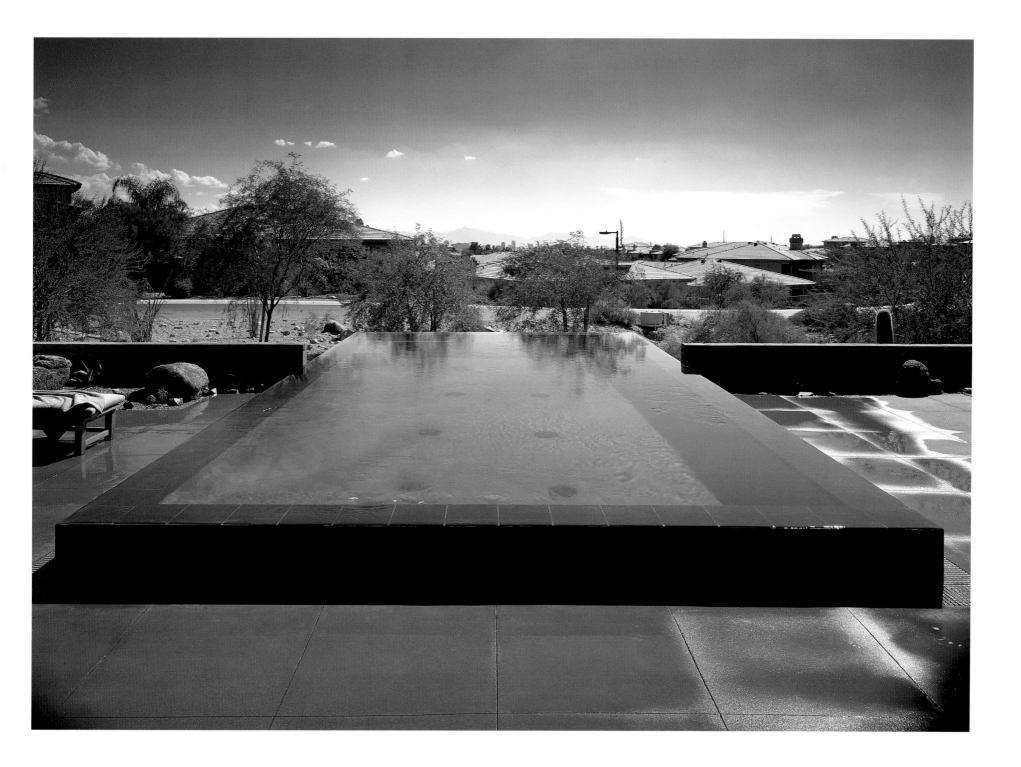

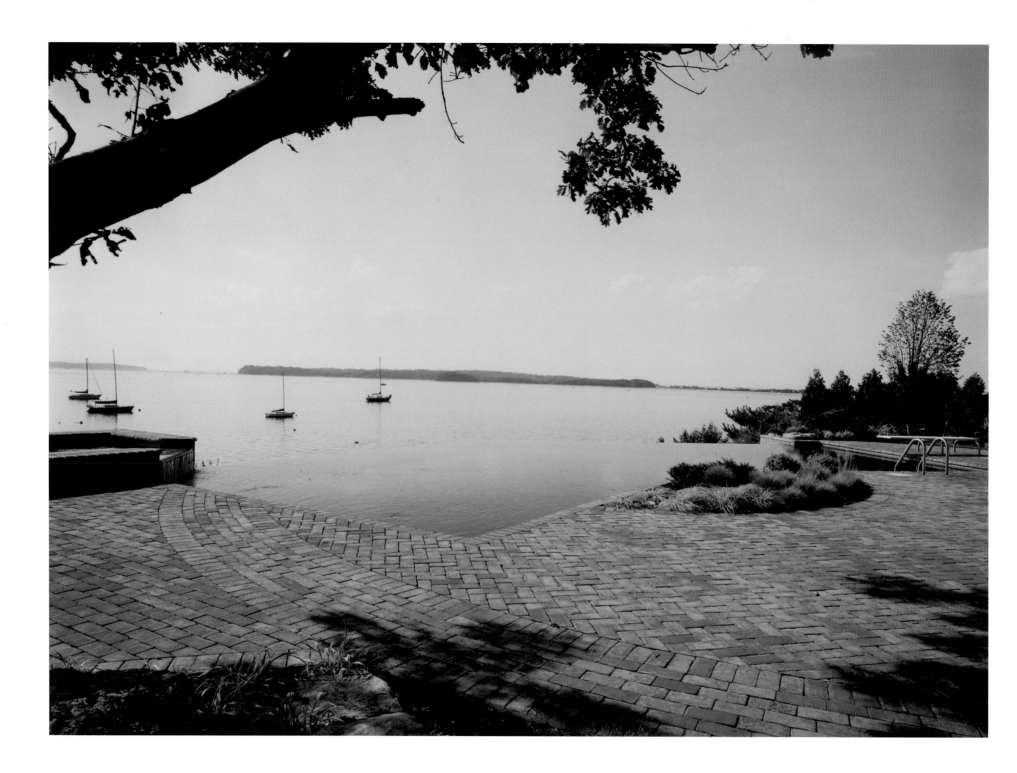

BAY WATCH

This vanishing-edge pool is as much a treat for the boaters passing by as it is for the bathers relaxing by the poolside. That's because the back side of the pool has been transformed into a stunning water feature. As water spills over the vanishing edge, it interplays with the red brick wall and trickles into the catch basin. Beautifully landscaped, the water feature is as integral to the pool design as the vanishing edge is, making the project a sight to behold whether you're standing on the pool deck or a boat deck.

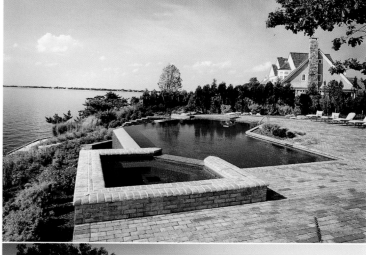

Location: **Northport, New York, USA**
Type of construction: **Gunite**
Pool finish: **Plaster**
Decking and coping: **Brick**

↗
A raised, cut-corner spa spills into the pool.

>
The back side of the pool is a fully landscaped water feature.

<
The 20-by-45-foot (6-by-13.7-meter) vanishing-edge pool visually unites with the bay.

DESIGN DETAILS

Whenever a vanishing-edge pool is placed next to a natural body of water, the idea is to create a visual effect that seamlessly transitions from the man-made to the organic. This is much harder than it appears, especially when one considers the tricks natural lighting plays on different materials. The color of the waters may match at high noon but look strikingly different at sunset.

This vanishing-edge pool comes as close to perfection as one can expect. A dark marble-dust pool finish blends beautifully with the bay most times of the day, and the elevation is such that the catch basin and land between the pool and shoreline remain invisible from most vantage points.

In addition to the vanishing edge, the pool features a raised spa that spills into the pool's shallow end and a diving board at the 8-foot (2.4-meter) deep end. A brick terrace provides ample room for poolside entertaining and helps frame the plant beds and lush lawn.

With so many boats and yachts passing by the house, it was important that the back side of the vanishing edge be fully landscaped. The back side of the pool is faced with rough, red bricks that create a textured surface that diverts water on its way into the catch basin. Colorful perennials enhance the water feature and create a buffer zone between the pool and shoreline below.

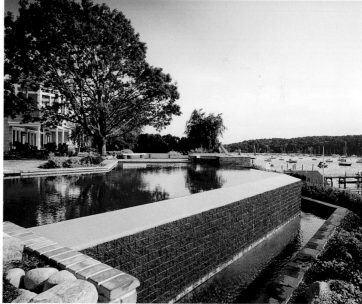

EBONY AND IVORY

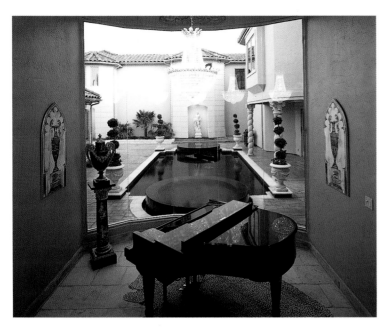

It's difficult to say what's more grand—the piano or the pool. Both have shiny black surfaces, and both are classically designed. The key to both is a balance between black and white—a color combination that is both contrasting and harmonious. Of special note is the pool's two raised water features, one of which doubles as a spa. This symmetry, which is emphasized by the four corner pedestals with urns, makes for an inviting composition. Maybe this is what Handel had in mind when he wrote *Water Music*.

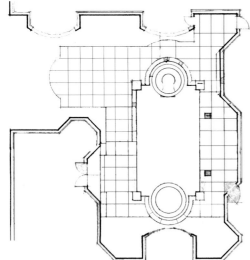

Location: **Plano, Texas, USA**
Type of construction: **Gunite**
Pool finish: **Plaster**
Decking: **Stamped Concrete**

>
Like piano keys, the black pool surface dramatically contrasts with the white coping and white exterior of the home.

⌐
The piano alcove offers an orchestrated view across the pool toward a courtyard statue.

DESIGN DETAILS

Working in perfect harmony, the black plaster surface of this classically shaped pool contrasts with the white coping made from precast materials. Pedestals on each of the pool's four corners are capped with decorative urns potted with topiary. Ornate columns and a stamped concrete deck that resembles stone reinforce the pool's Old World charm.

The pool's classical design is really an extension of the home's, which incorporates some modern twists—such as an angled glass window that provides an almost 180-degree view from the piano alcove. The piano's black lacquer finish looks as shiny and fluid as the pool's watery surface. And the window from this musician's space provides a striking view across the Romanesque pool toward a statue positioned in a lit alcove at the opposite end of the courtyard.

What makes this project a superb example of a vanishing-edge pool are the two circular forms that rise from each end of the pool. One is actually a vanishing-edge water feature and the other is a vanishing-edge spa. Water wells up from these sculptural elements and gently spills down their sides on its way back into the pool.

It just goes to show that you don't need a sprawling estate overlooking the ocean in order to achieve a spectacular vanishing-edge effect. It just takes a bit more ingenuity.

PROFESSIONALS | Landscape Architect/Contractor: **Leisure Living Pools** Photographer: **Guy Sloan Duvall**

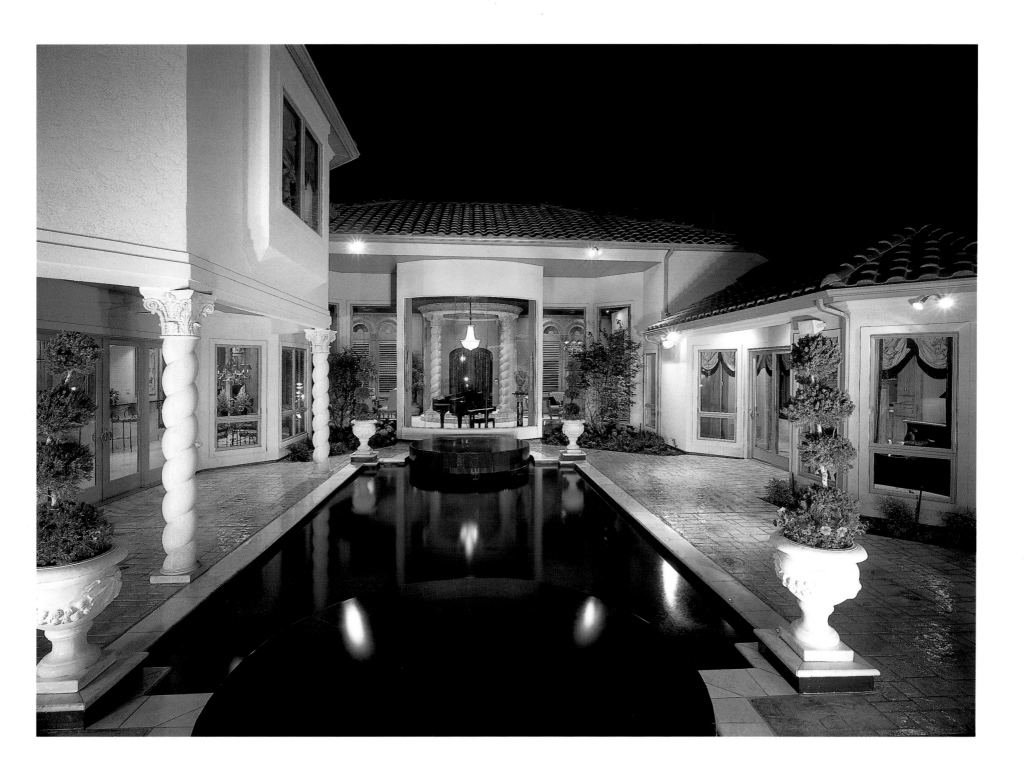

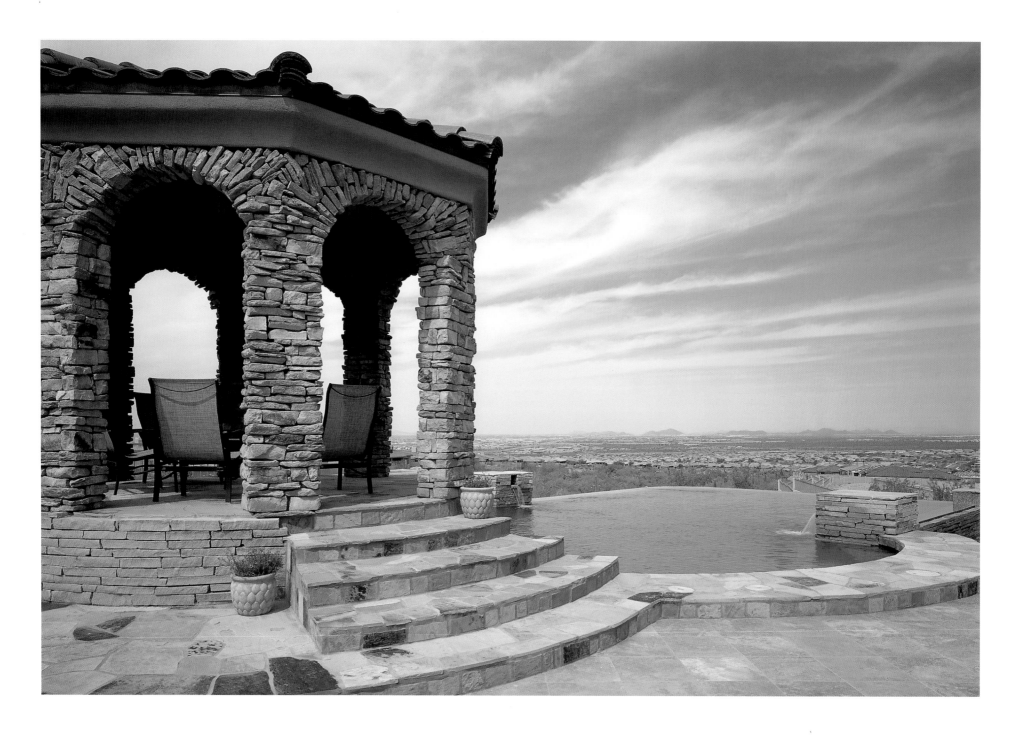

STONE AGE

The focal point of this desert yard is an elevated stone pavilion that provides a shady spot for poolside dining or conversation. From the Romanesque structure, one can enjoy the pool's two vanishing edges—contemporary design elements that visually connect the water with the surrounding landscape. The earthly elements of stone and water also come together with two stacked-stone scuppers that pour water into the dark-bottomed pool as if from an underground reservoir.

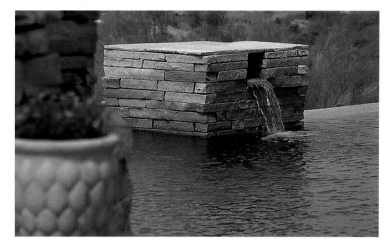

DESIGN DETAILS

Reminiscent of an ancient Roman bath, this desert pool features two scuppers that pump water into the 5-foot (1.5-meter)-deep vessel. The water is then sent spilling over two 18-foot (5.5-meter)-long vanishing edges. A towering stone pavilion reigns over the 30,000-gallon (113,562-liter) pool with its dramatic archways acting like a picture frame to the desert landscape.

Though the project uses a variety of stones, the materials are repeated in a way that brings the installation together without causing the elements to clash. For example, irregular flagstone—used around the pool's perimeter and on the pavilion's steps—seamlessly connects these two architectural elements. Likewise, the pavilion's foundation is surrounded with the same stacked stone used to construct the pool's scuppers.

To emphasize the Roman bath design, the pool is surfaced with a deep-blue exposed aggregate. It complements the rest of the stonework and also creates a reflecting pond effect that echoes the pavilion as well as the clouds sweeping across the sky.

Location: **Scottsdale, Arizona, USA**
Type of construction: **Gunite**
Pool finish: **Exposed aggregate**
Decking: **Flagstone**

∧
Stacked-stone scuppers spill water into the pool as if from a cistern.

<
A stone pavilion reigns over the vanishing-edge pool.

PROFESSIONALS Landscape Architect/Contractor: **Shasta Pools & Spas** Photographer: **Pam Singleton**

"Water, taken in moderation, cannot hurt anybody."

Mark Twain, 1835–1910

SMALL SPACES

In municipalities around the world, residential lot sizes are getting smaller and smaller. But you don't have to flee to the suburbs to have enough space for a swimming pool or hot tub. Efficient designs that make the most of a small yard mean you can have your pool (and skinny-dip in privacy, too).

Often you can gain the illusion of more space by building up instead of out, using terraced decking and elevated seating areas. Another technique is to push the pool or spa to the edge of the property line, if building codes permit, and incorporate functional decking on just two or three sides of the pool. Smaller pools can also be fitted with

swim jets, which enable swimmers to get an Olympic-size workout by paddling against the current.

If you still think a pool won't fit in your backyard picture, consider a custom spa, which can be designed to double as a water feature— giving you twice the enjoyment in the same amount of space.

Some of these landscape solutions require extraordinary feats of engineering, while others just involve scaling things down in proportion to the rest of the architectural elements. Either way, each of the following pool and spa projects is testament to that adage: Good things come in small packages.

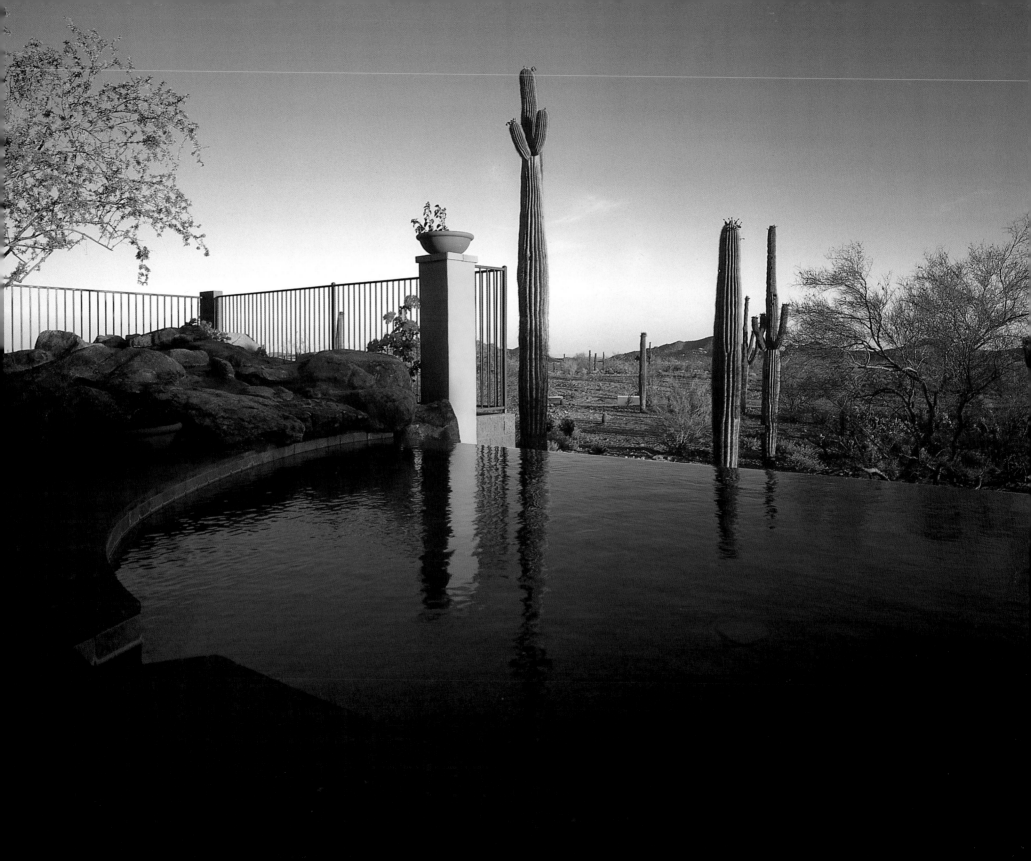

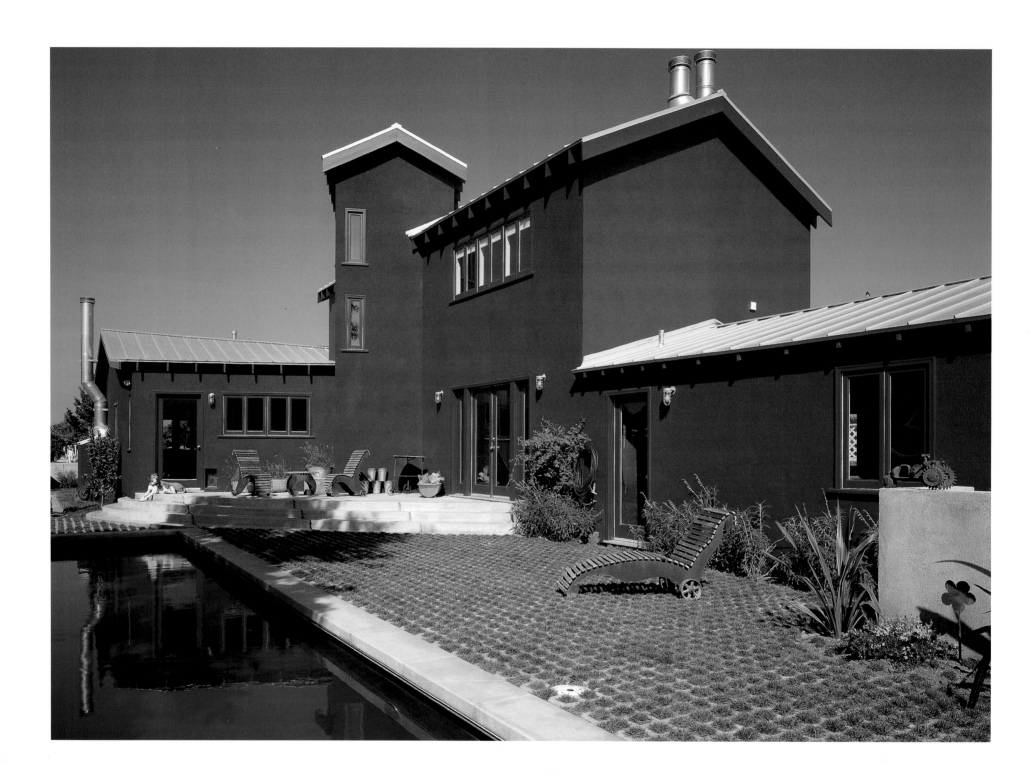

COOL BLUE

If your yard is long and narrow, a lap pool may be the most economical way to use your limited space. To take full advantage of this home's side yard, the designer anchored the lap pool in the corner. A decorative fence provides the necessary privacy, while one of the pool's long edges is raised to provide bench seating for swimmers as well as a retaining wall for poolside plantings. Instead of surrounding the pool with concrete or stone decking, the designer used block pavers planted with sod to create a functional surface that also keeps the "yard" in this outdoor living space.

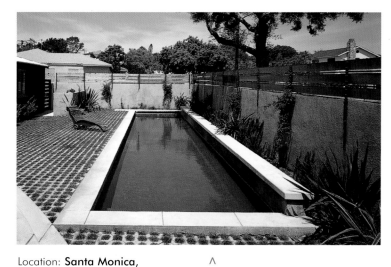

DESIGN DETAILS

When renovating her home, designer Sallie Trout tucked a 42-foot (12.8-meter) lap pool in the side yard where a laundry line once stood. At 9 feet (2.7 meters) across, the pool is wide enough for two swimmers to swim laps simultaneously, making it both functional and elegant.

Situated in the southwest corner of the lot, the pool receives sunlight about seven hours a day. A black bottom finish helps the pool retain heat while creating a reflective surface that mirrors the deep blue

house and its multiple metal rooflines. In addition, pavers set in a grid and planted with tufts of sod complement the simple concrete coping. The deck and raised concrete patio is outfitted with steel-and-teak furniture designed by the architect.

For safety and privacy, stucco walls topped with custom redwood-and-steel fencing surround the yard. The 16,500-gallon (62,459-liter) pool also has a motorized cover, which provides additional safety, keeps out debris, and helps retain heat.

Location: **Santa Monica, California, USA**
Type of construction: **Gunite**
Pool/spa finish: **Black plaster**
Decking and coping: **Concrete**

∧
A raised pool wall doubles as bench seating and a retainer for plantings.

<
A black plaster surface turns this lap pool into a reflecting pond that mirrors the deep blue house.

SMALL WONDER

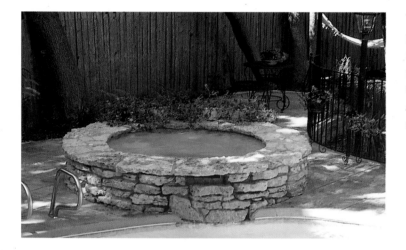

This pool's classic kidney shape maximizes the space while preserving just enough open areas for poolside dining and relaxation. Also, by using cantilevered decking, the design negates the need for special coping and makes the functional areas of the pool deck look larger than they really are. A single grab rail at the center of the steps simplifies the design while leaving even more unobstructed deck space.

Location: **Glencoe, Illinois, USA**
Type of construction: **Gunite**
Pool/spa finish: **Marbelite**
Decking and coping: **Stamped concrete**

^
A small spillway from the spa creates the soothing sound of falling water.

>
Real fieldstones around the spa contrast nicely with the stamped-concrete deck, made to look like stone pavers.

DESIGN DETAILS

Situated between a brick home and a grove of mature trees, this 15-by-30-foot (4.6-by-9.1-meter) pool and spa design manages to leave enough deck area for sunbathing and poolside entertaining. The focal point of the modest, kidney-shaped pool is a raised spa faced with flagstone. A small spillway from the spa to the pool adds visual interest and just enough aquatic sound for this cozy setting.

Though the spa is faced with real stone, the decking is actually stamped concrete that has been colored to resemble random rectangular stone pavers.

The concrete is cantilevered over the water, making for a clean design without the need for special coping around the pool. The poured concrete also made it easier to create smooth curves around flowerbeds and existing trees.

Curved steps complement the shape of the pool, and an underwater bench along one side creates a cool place to relax. What you can't see in these pictures is an automatic sanitization system and state-of-the-art controls that enable the client to manage the pool and spa operation with the touch of a few buttons from within the home.

PROFESSIONALS | Landscape Architect/Contractor: **Downes Pool Co.** Photographer: **John Frantz**

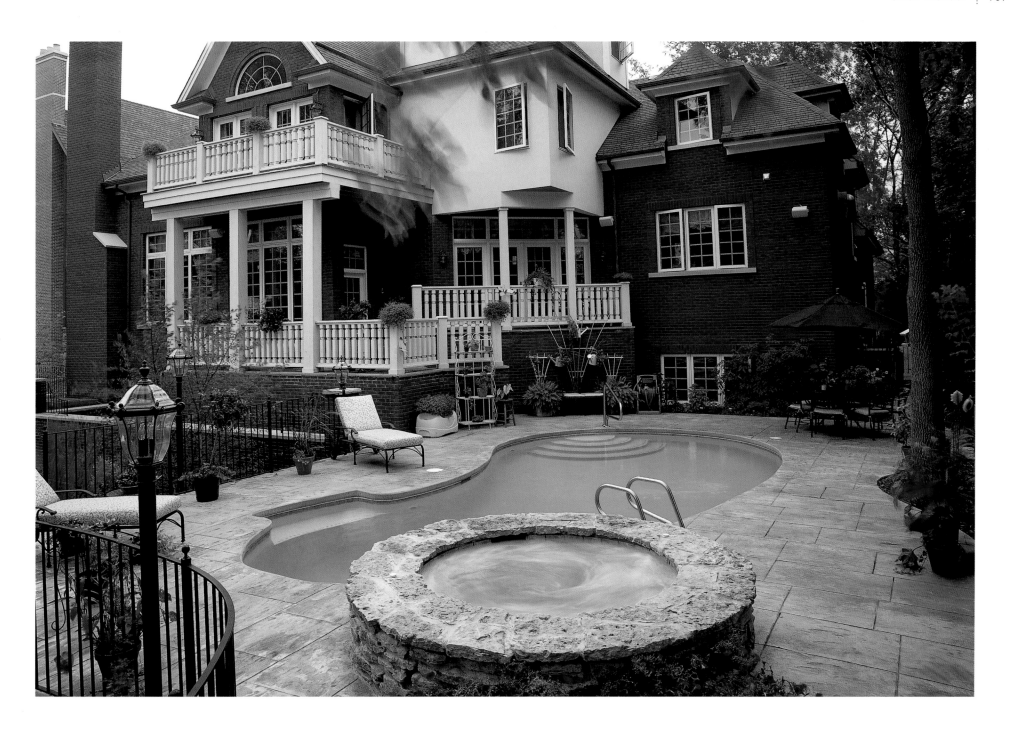

DESERT OASIS

Vanishing-edge pool and spa designs can work well in small spaces because they allow you to position the vessel at the edge of the lot line without it seeming like you're trying to squeeze a size-10 foot into a size-8 shoe. Of course, this works best if the yard looks out upon an attractive topography, such as a golf course, a pond, or, as in this case, a desert landscape. Employed correctly, the design technique maximizes the amount of deck space available for outdoor activities without diminishing the enjoyment of the pool or spa.

Location: **New River, Arizona, USA**
Type of construction: **Gunite**
Pool finish: **Exposed aggregate**
Decking and coping: **Exposed aggregate**

DESIGN DETAILS
Measuring a modest 22 by 10 feet (6.7 by 3 meters), this semicircular pool has many of the amenities seen in much larger installations. A raised-rock waterfall in one corner provides a focal point that adds both visual and aural elements to the patio area. In addition, a vanishing-edge treatment maximizes the limited space while creating a stunning visual effect.

Because the lot slopes slightly, the pool had to be raised in order to create the vanishing-edge design.

The added height makes the most of the vertical space, as well. Boulders and rock outcroppings are incorporated into the pool's perimeter to make the elevation change appear more natural. Exposed aggregate decking also complements the natural setting with its earth-toned hues.

The fence—designed for safety and optimal viewing—stops at each end of the vanishing edge, where tall pillars adorned with terra-cotta pots frame the dramatic desert vista.

<
Water trickles down from a rock waterfall before cascading over the 22-foot (6.7-meter) vanishing edge.

>
Boulders around the raised pool help to anchor it to the barren landscape.

PROFESSIONALS Landscape Architect/Contractor: **Shasta Pools & Spas** Photographer: **Jeff Kidda**

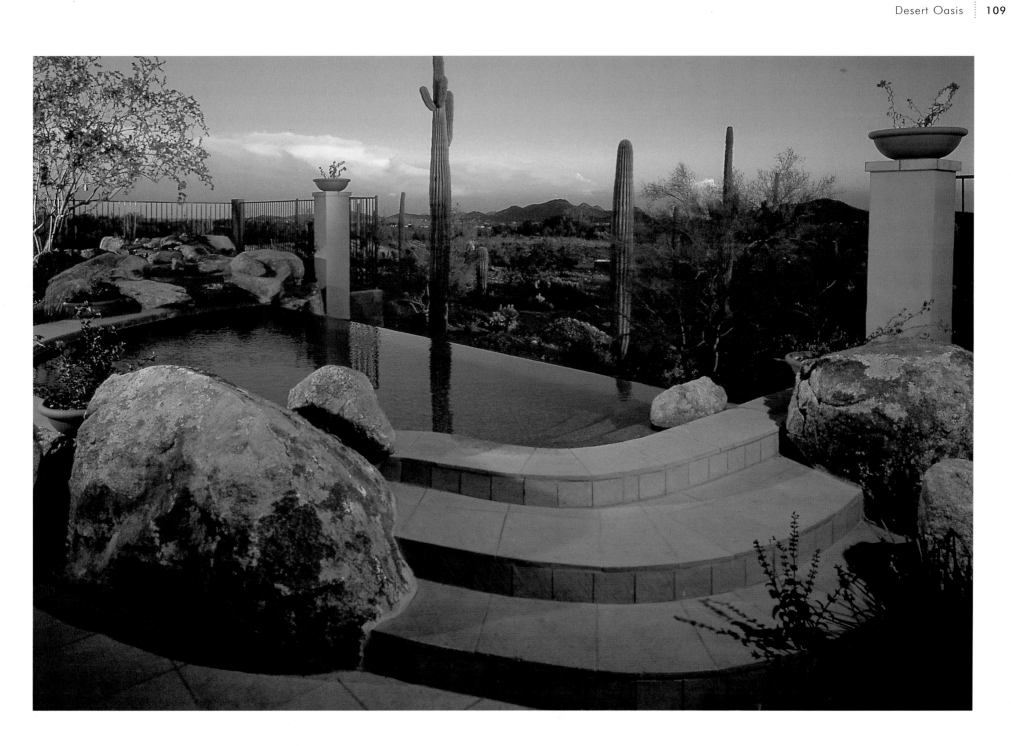

SQUARING OFF

The architect's main objective in designing this pool was to relate the house to the sea. Though modest in size, the pool—a man-made vessel of water—is the perfect architectural transition between the home's modern design and the natural Peruvian coastline. Because of the home's modular outline, the pool naturally took on the shape of a square. The small pool, which is in proportion to the rest of the house, is completely framed by the two-story loggia and fits comfortably on the narrow hillcrest behind the house.

Location: **Canete, Lima, Peru**
Type of construction: **Concrete**
Pool finish: **Plaster**
Decking and coping: **Tile**

<

Vast sliding windows create the illusion of open space and visually bring the poolscape indoors.

< **Far left**

A white tile deck is easily rid of settling sand swept in by the wind.

>

A two-story loggia frames the pool.

DESIGN DETAILS

Sandwiched between the ocean and the Andes, Peru's coastal region is an arid, dusty land that rarely receives rain. Nevertheless, an attractive coastline and wondrous marine life make it a spectacular site for this vacation home.

The modern structure, constructed of reinforced concrete, is a series of rectangles and boxes—a design theme repeated in the modest 130-square-foot (39.6-square-meter) pool. A two-story loggia frames the pool as it looks out over the sandy cliff and the sea beyond.

Ease of maintenance was the driving factor in the pool's design. Because wind deposits blowing sand into the pool, special filtration equipment was installed to maintain the pool's clarity. The white tile deck that surrounds the pool also makes it easy to wash away settling dust. The pool's bright colors contrast with the earth-tone planes of the house, which help define interior and exterior spaces. Meanwhile, floor-to-ceiling windows blur the line between the interior fireside and exterior poolside.

PROFESSIONALS Architect: **Barclay & Crousse Architectes** Photographer: **Jean Pierre Crousse**

CUPS RUNNETH OVER

Oftentimes, space is merely an illusion created by color and light. On this tiny desert patio, a small pool is perceived to be larger than it really is because of its dark blue surface, which gives the perception of great depth even though the pool is only 3- to 5-feet (1- to 1.5-meters) deep. Also, when designing pools and spas for small areas, it's important to determine the available space in cubic measurements, not just two dimensions. In this case, raised fountains provide animation and three-dimensional qualities to the otherwise flat plane.

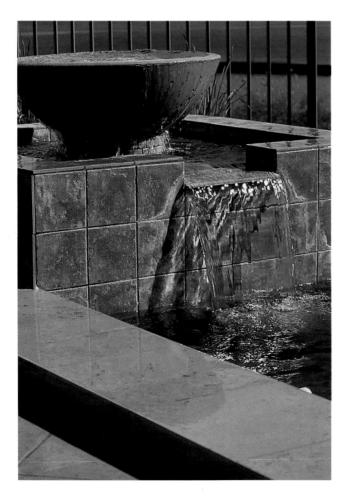

DESIGN DETAILS

Like more and more contemporary pools, this modest design is more for looks than actual swimming. Two raised fountains provide dramatic sights and sounds as water wells up inside the cast-stone bowls and spills over into the square basins, where it then cascades into the dark pool.

A midnight-blue aggregate finish gives this small, rectangular pool a perception of depth that more than accommodates for its meager 15-by-8-foot (4.6-by-2.4-meter) dimensions. Yet, at 3- to 5-feet (1- to 1.5-meters) deep, the 3,150-gallon (11,924-liter) pool is perfect for water aerobics or a cool plunge on a hot summer day.

The two fountains are faced with the same earth-tone tiles used around the pool's waterline, while the raised coping is coated with a textured, sand-colored acrylic that stays cool despite the desert sun's rays. Planting beds lined with stone mulch surround much of the pool in order to preserve the desert garden aesthetic, and a patch of nearby grass provides a soft space for sunbathing.

Location: **Surprise, Arizona, USA**
Type of construction: **Gunite**
Pool finish: **Exposed aggregate**
Decking: **Concrete**

\>
A dark-blue aggregate finish gives this 3,150-gallon (11,924-liter) pool the appearance of great depth.

<
A pair of raised fountains provides the soothing sound of rushing water.

PROFESSIONALS Landscape Architect/Contractor: **Shasta Pools & Spas** Photographer: **Pam Singleton**

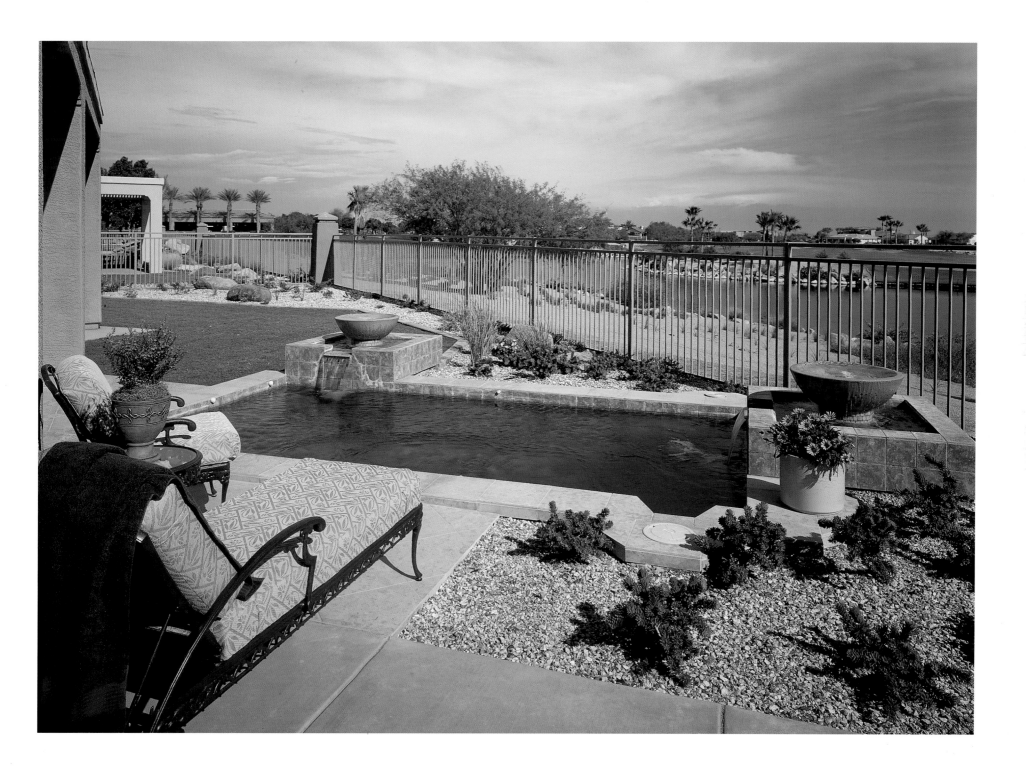

FEATURED ATTRACTION

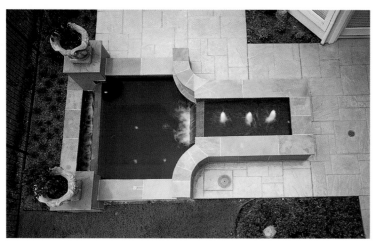

The luxury of a spa with the visual intrigue of a water feature—both are part of this resourceful design that maximizes the use of a nearly nonexistent outdoor living space. Like a Swiss Army knife, the multifunctional project packs a lot into a small space. The fountain's raised stone cap beckons one to sit at the water's edge and listen to the babbling sounds, while the adjoining sunken spa tempts one's body with the promise of soothing hot-water therapy.

Location: **Frisco, Texas, USA**
Type of construction: **Gunite**
Pool finish: **Plaster**
Decking: **Stamped concrete**

↑
A bit of stamped concrete decking adds elegance to the small aquascape.

>
Offering an intriguing focal point from the house, this project combines the beauty of a water feature with the practicality of a therapeutic spa.

> **Far right**
A vanishing-edge effect is created by the raised water feature, which spills into the sunken spa.

DESIGN DETAILS

With nary enough space for a bistro table and chairs, this modest patio is now home to a luxurious spa and water feature. Consisting of three bubbling fountains, the water feature cleverly disguises the sunken spa and creates a unique and attractive focal point from within the home.

The water feature is raised 18 inches (45.7 centimeters) above deck level and is capped with pink Arizona flagstone, which doubles as bench seating in a space where no other furniture can fit. The picturesque fountain spills over a vanishing edge into the 7-by-7-foot (2-by-2-meter) spa, which features its own vanishing edge where water cascades into a narrow catch basin near the property line. Both the spa and water feature are automated and can be controlled from a panel inside the house, as well as via remote controls outside.

The water feature is the first thing one sees when entering the house, and it's from this vantage point that the vanishing-edge effect is most impressive. A dark, gray/green plaster surface enhances the illusion, while a stamped-concrete deck in a rectangular flagstone motif bolsters the formal design. Likewise, two pedestals topped with decorative urns add a classical element that also frames the spa's vanishing edge.

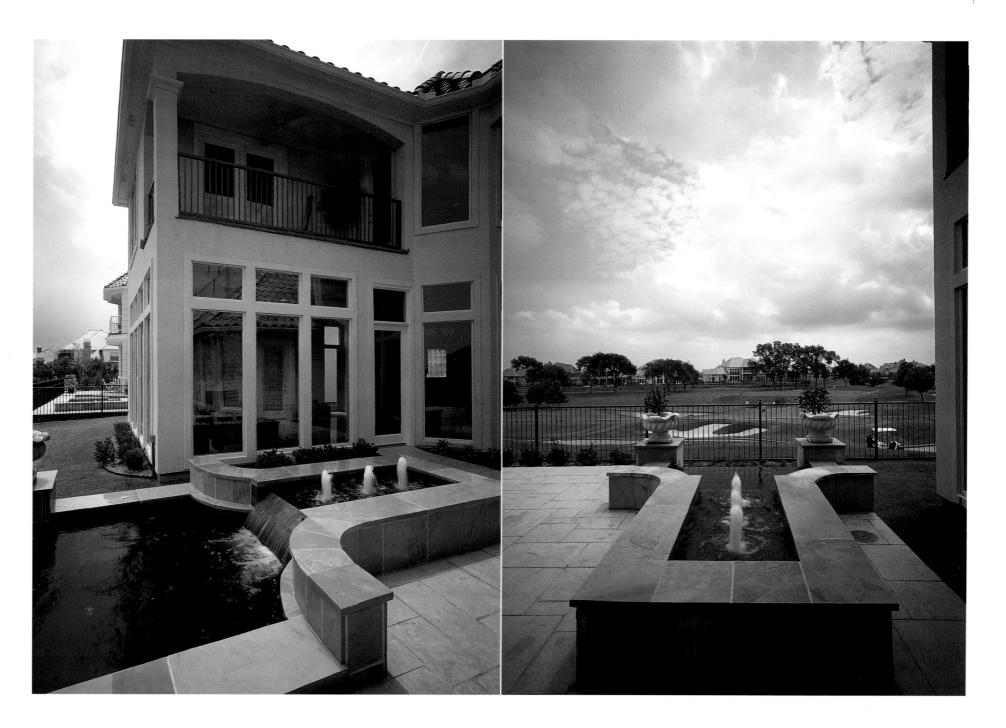

"From birth, man carries the weight of gravity on his shoulders. He is bolted to earth. But man has only to sink beneath the surface and he is free."

Jacques Cousteau, 1910–1997

INDOOR OASES

On a hot summer day when the sun is unrelenting and the heat index soars, nothing is more refreshing than a cool dip in a backyard swimming pool. But for the person who likes to swim or lounge poolside regardless of what the weather is doing, an indoor pool is a necessity.

The most difficult challenge in designing an indoor pool is making it appear like a natural extension of the house and not a new wing to the local YMCA. That means special attention to building materials, color palettes, and lighting. It's worth noting that an indoor pool is not simply an outdoor pool with four walls and a roof. Architecturally, an indoor pool may look like the rest of the house, but in terms of engineering, it's quite different—especially when it comes to heating and ventilation. In fact, the

air-quality equipment can easily cost as much as the pool itself. But when you consider that an indoor pool is a year-round luxury, the additional expense is easily justified.

In fact, the air quality of indoor pool and spa environments has come under heavy scrutiny in recent years. Not only can poor ventilation lead to mold, mildew, and falling plaster, it can cause respiratory problems, too, according to researchers. With appropriate design and engineering, however, there's no need to worry.

With the mechanics taken care of, indoor swimming pools are limited only by the imaginations of their creators. So anticipate a wide variety of designs—from tropical oases to lavish water parks, and everything in between.

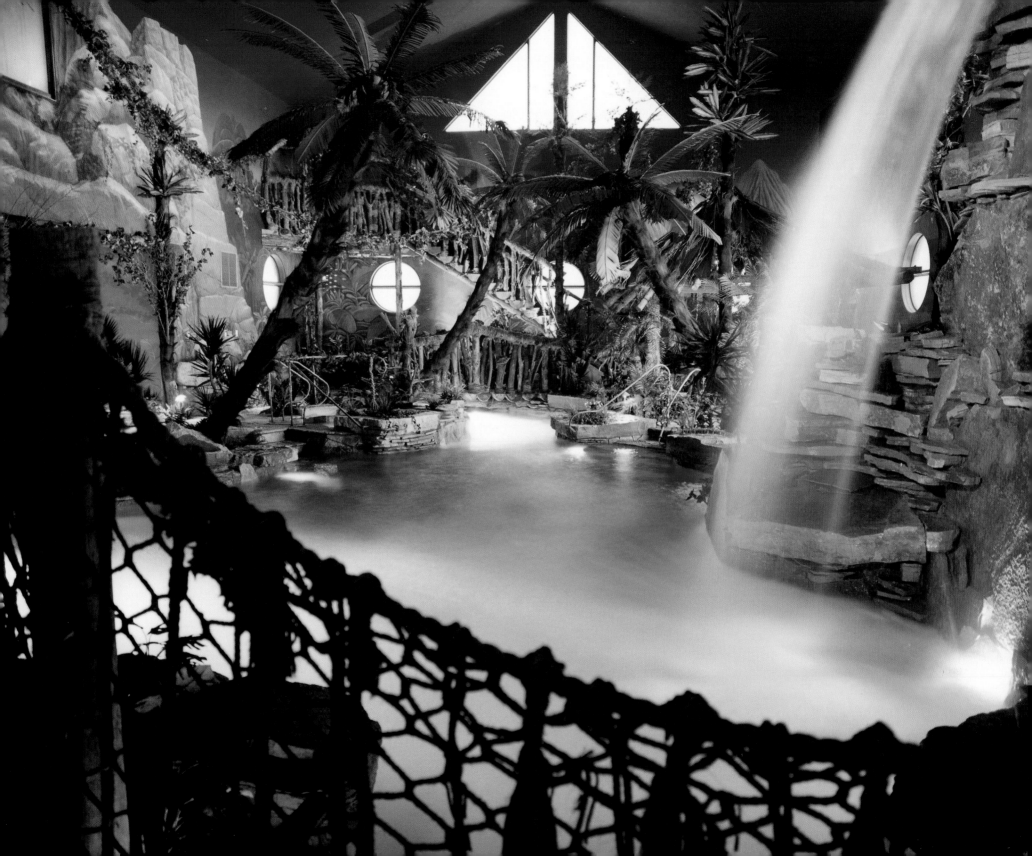

POOL HOUSE IN THE COUNTRY

This thatched-roof pool house appears to organically rise from the quintessential English garden. The dense and neatly trimmed thatched roof hovers above glass walls, which are curtained by wispy grasses along its borders. Respectfully positioned on a country mansion estate, the pool house was inspired by its rural locale and is set against a sixteenth-century stone wall, leaving the other three sides open to the garden landscape.

∧
The thatched roof is a natural backdrop for the classic English garden.

>
A rubberized fabric was used to create the tented ceiling.

Location: **Southern England, United Kingdom**
Type of construction: **Concrete**
Pool/spa finish: **Tile**
Decking and coping: **Limestone**

DESIGN DETAILS

From the south, the pool house seems to emerge from the ground, its thatched-roof paying homage to the rolling countryside. The architect got the idea for the thatched roof from earlier research into the lost art of Japanese thatch, called *shibamune* (which means "green ridge").

The apex of the pool house is covered with wheat reeds held in place by bamboo poles. A glazed skylight runs the length of the pool house, flooding the interior with natural light. From the outside, however, the skylight is partly camouflaged by wild flowers planted in troughs hidden beneath the thatch.

Concrete posts support the gabled building, with the glass walls fixed to hollow steel sections. The uniqueness of the interior comes from the tented ceiling, which is made from a stretched rubber fabric that has been painted white. Light beams through the skylight, curves down the white ceiling, and reflects off of the pool surface and the light-colored limestone deck. Thus, what appears to be a dark structure from the outside is actually quite bright on the inside.

At night, underwater lights illuminate the curvaceous ceiling with aquatic shadows dancing across the white screen overhead.

PROFESSIONALS Architect: **Ushida Findlay Architects** Landscape Architect: **Jonathan Bell** Photographer: **James Harris**

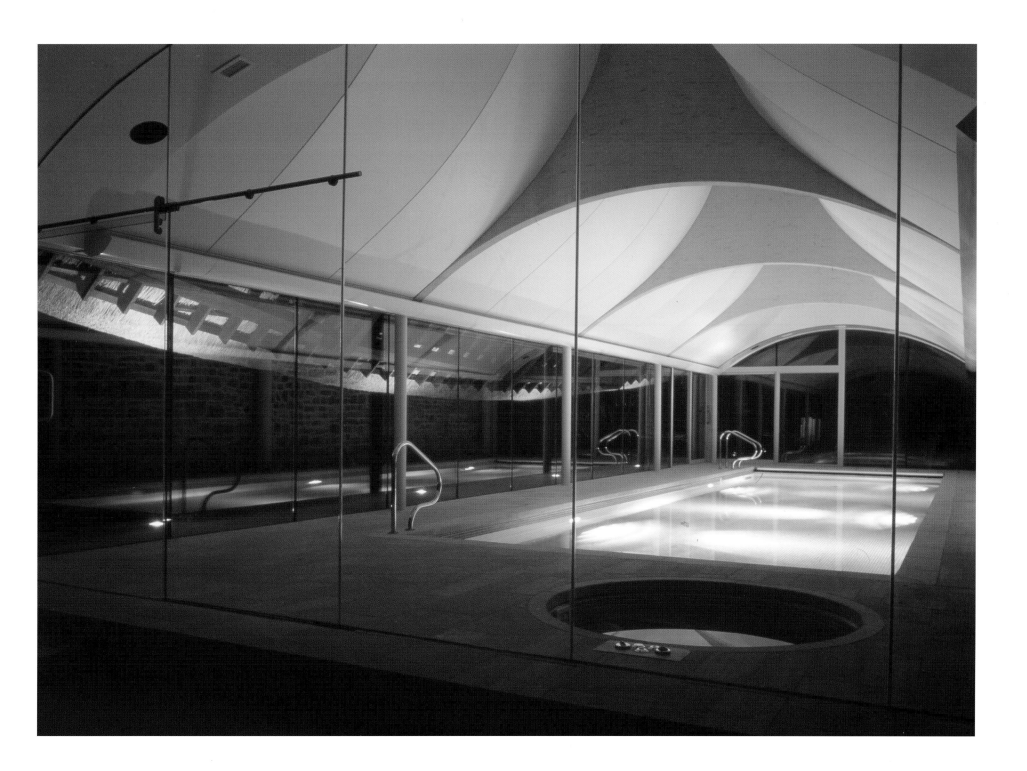

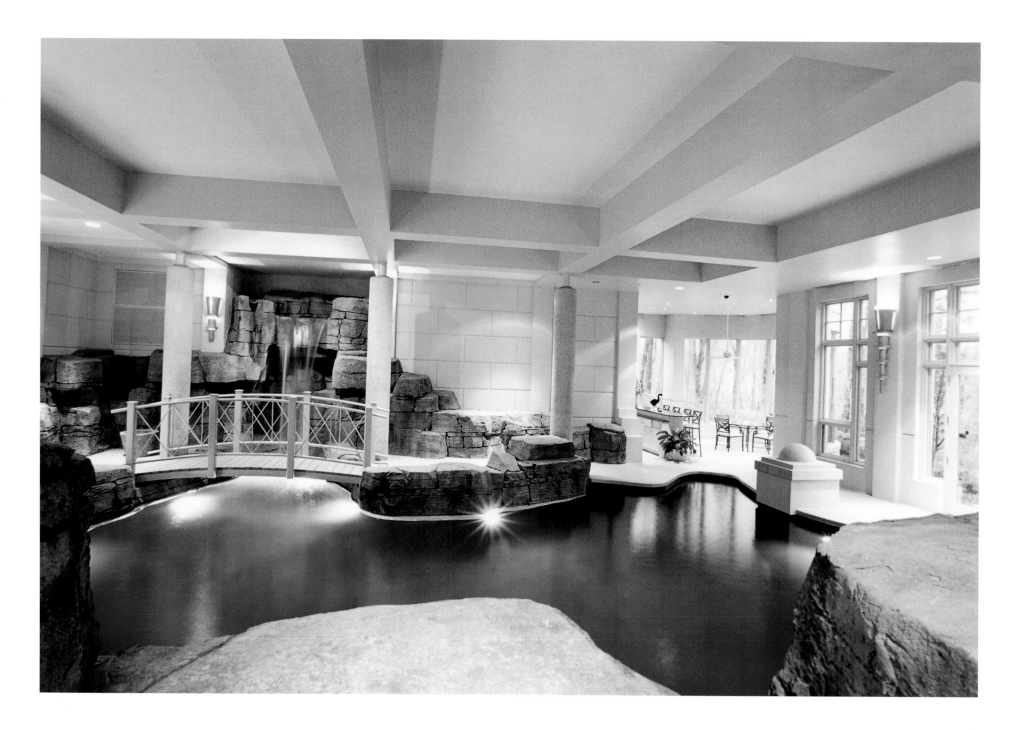

OUTSIDE IN

When your home is four stories high, why not put the pool inside? In this case, the homeowner added a waterfall, slide, and bridge, as well. The bridge passes in front of the artificial rock waterfall, which cascades into the dark-blue water of the lagoon-styled pool. Situated next to an indoor entertainment area, the pool room is flooded with natural light from a wall of windows, which eases the transition between the indoors and outdoors while offering a magnificent view of the rocky hillside.

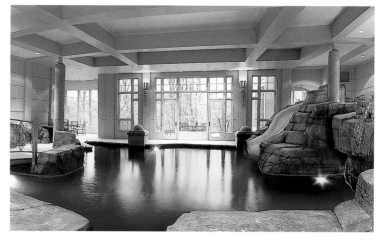

DESIGN DETAILS

This elaborate indoor pool project was a long time in the making. The pool shell was dug and shot with concrete during the first stage of construction of the four-story home. It was then covered with plywood for eighteen months while the rest of the house was being built around it. Eventually, the artificial rockwork and the rest of the pool and deck were finished.

Occupying the center section of the home's first two floors, the 30-by-40-foot (9.1-by-12.2-meter) pool design brings the estate's rocky scenery inside where it can be enjoyed year round. The multilevel installation enables someone to enter the pool area on one floor, meander around the pool,

and cross the custom bridge to access the lower level of the home on the opposite side.

The two-story room features a dramatic, artificial-rock waterfall with underwater seating in its alcove. The natural effect is enhanced by the pool's black Maui Midnight finish. A custom fiberglass waterslide was built on site, providing an exciting trip down the artificial rock ledge.

To conserve energy, the dehumidification system also heats the 40,000-gallon (151,416-liter) pool, which is meticulously lit with fiber-optic lighting around the perimeter. In addition, the coated concrete deck provides an attractive, no-slip surface for both swimmers and passersby.

Location: **Louisville, Kentucky, USA**
Type of construction: **Gunite**
Pool and spa finish: **Plaster**
Decking: **Concrete**

∧
A waterfall, bridge, and slide bring a lot of excitement to this indoor pool.

<
A bridge provides an intriguing spot to view the waterfall or watch children slip down the slide.

PROFESSIONALS Designer/Contractor: **Gym & Swim** Rockwork: **Rock & Waterscape Systems, Inc.** Photographer: **John Lair**

AQUEOUS ATRIUM

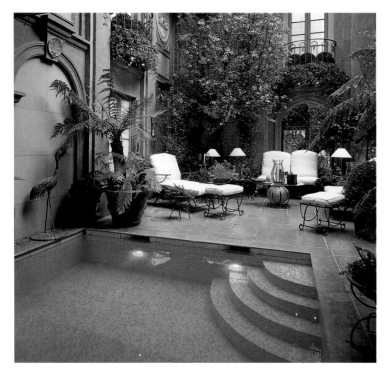

∧
A glazed dome makes it possible to grow life-size oak trees in this interior court-yard.

>
Mirrored walls, a sky-blue ceiling, and extensive lighting make it hard to imagine that this indoor pool is really in the basement of a seven-story estate.

Location: **London, England**
Type of construction: **Concrete**
Pool finish: **Tile**
Decking and coping: **Fossilized marble**

One of the problems with Eaton Square, despite being one of the most famous and desirable addresses in the world, is the lack of private garden space. Outdoor gardens typically offer no privacy and are permanently cast in shadow by surrounding buildings. Constructed inside a three-story void, this interior pool room and garden is capped with a double-glazed dome that floods the space with natural light. In one of the most sought-after areas of the real estate world, this indoor pool and garden offer a silent sanctuary from the hustle and bustle of the London streets just outside.

DESIGN DETAILS

This swimming pool, built at basement level, measures 13 by 36 feet (4 by 11 meters) and serves as the foundation for the seven-story home. Radius steps in one corner provide the only access to the pool, which is surfaced with mosaic tiles in varying shades of blue. At the far end of the pool is a swim jet, which can be left on as a water feature.

Though tucked beneath the estate's library, the pool appears spacious thanks to a trompe l'oeil vista of an Italian landscape. The pool area also includes mirrored walls covered with faux fencing and a sky blue ceiling painted with wispy clouds and fitted with stars created with fiber-optic lights. Wall sconces, recessed ceiling lights, and underwater lights also illuminate the pool.

The garden room can be entered directly from a private elevator or from the first floor via a large ironwork spiral staircase. Designed as a tropical courtyard, the room is planted with mature Italian evergreen oak trees (which had to be lowered by crane through the roof) and a jungle of palm ferns and ivy. The walls are lined with thick slabs of fossilized stone from Portugal, with decorative ironwork balconies and carved pilasters.

The room is climate controlled for entertaining and general relaxation. Within the stone wall are doors leading to a bar, changing room, and a steam room. In addition, a surround-sound system pipes music into the open space.

Simply put, it's gracious living at its best. Yet, such wondrous beauty does not happen overnight. The designer spent more than four years on this project—which proves the adage: All good things are worth waiting for.

PROFESSIONALS Designer: **A.M. Luis Charmat** Photographer: **Fritz von der Schulenburg/The Interior Archive**

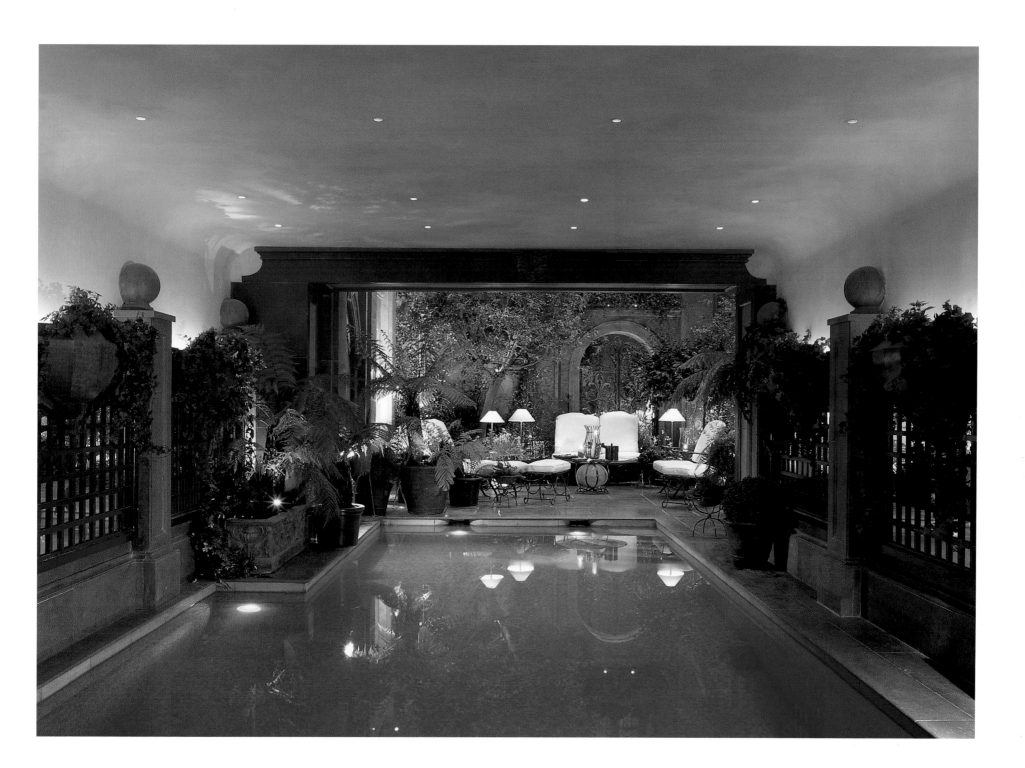

RESIDENTIAL RAIN FOREST

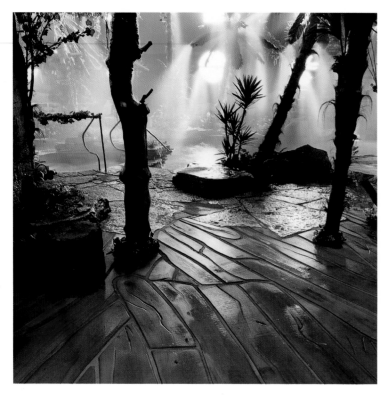

∧
Some deck areas are made from hand-milled and custom-fitted hardwood that has been grouted.

>
A stone-surfaced spa spills into the lagoon-shaped pool surrounded by fiberglass palm trees.

Location: **Olympia Fields, Illinois, USA**
Type of construction: **Concrete**
Pool/spa finish: **Plaster**
Decking and coping: **Chilton stone**

Pool, spa, waterfall, bridges, tropical vegetation—they're all here in this massive 65-by-50-foot (19.8-by-15.2-meter) room. Even more impressive are what the pictures don't show: a tree house that's accessible from the master bedroom two stories above the pool; a 5,000-gallon (18,927-liter) aquarium with eels, tropical fish, and two sharks; a gas fireplace surrounded by one-hundred-year-old barn beams and stone seats; and a tiki hut furnished with a hammock, television, and full bar. The obvious question is, "Who needs a tropical vacation when you can enjoy an indoor paradise like this year round?"

DESIGN DETAILS

Eighteen months in the making, this residential indoor pool and spa rivals the most spectacular commercial water parks. The 12-inch (30.5-centimeter)-thick concrete pool cured for six months before forklifts where allowed to enter it for the construction of the waterfall and 150 tons worth of stonework.

The pool walls, floor, and ledges are surfaced with natural stone slabs, while sandy-colored plaster simulates a sand bar down the center of the pool. Costume jewelry set in plaster gives the appearance of a lost treasure.

The main waterfall looms 15 feet (4.6 meters) high and 8 feet (2.4 meters) wide, with a cave behind it. As much as 500 gallons (1,893 liters) of water flows over the feature every minute, providing a vigorous massage for swimmers brave enough to stand beneath its torrent. A second waterfall is actually a spillway from the spa into the pool.

Tropical wall paintings bring cohesion to the design. Everything further blends together with the use of strategically placed silk foliage and fiberglass palm trees wrapped with natural coconut sheeting. Plumbing lines hidden behind the coconut sheeting feed a misting system in the treetops turning the room into a veritable rain forest.

Some additional design features include the benches and chairs, all made from logs and stumps with animal-print upholstery. A stairway, made from carpeted log halves, leads to the upper-level tiki hut, which features bamboo shades, a television, and stereo system. A radiant heating system lies beneath the stone deck, and other floor areas are made from custom-milled and fitted hardwood.

PROFESSIONALS | Architect: **Black Creek Canyon, Inc.** Photographer: **Chris Cassidy**

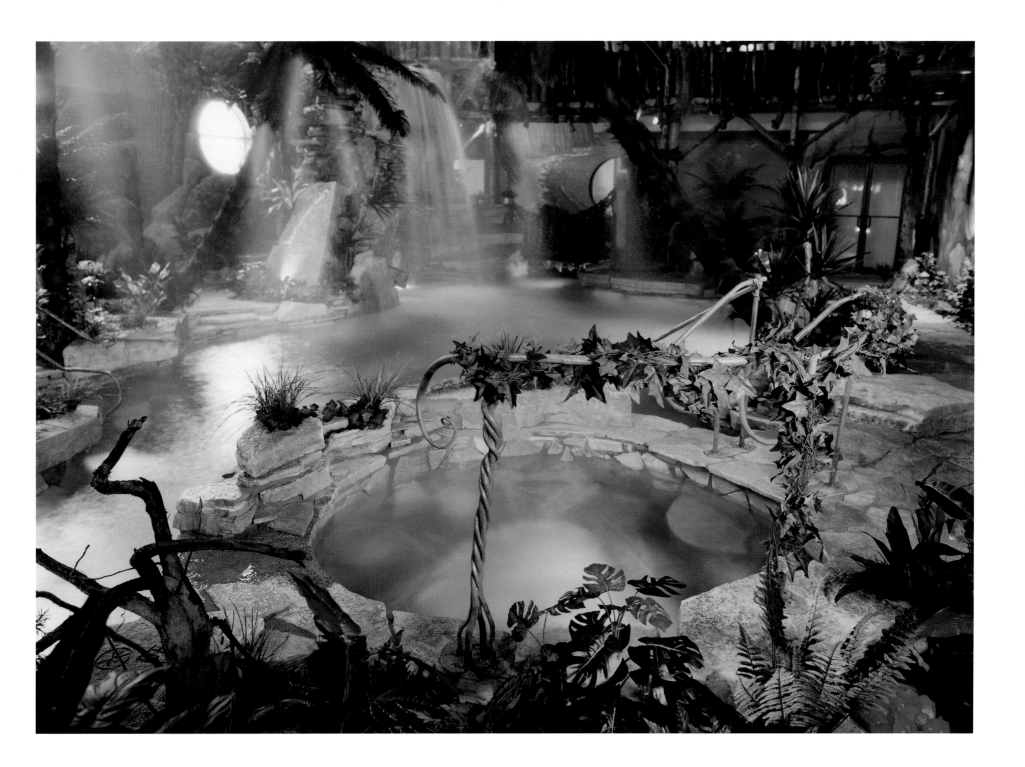

LAP (LANE) OF LUXURY

Wintertime near the Great Lakes rarely brings out the swimmer in anyone—unless you belong to a polar bear club. Fortunate for the owners of this indoor pool on the edge of Lake Michigan, they can pretend it's summertime year round. Arched windows permit sunlight to fill the space, while a landscape mural and bluestone decking hint at the outdoors.

Location: **Winnetka, Illinois, USA**
Type of construction: **Gunite**
Pool/spa finish: **Marbelite**
Decking and coping: **Bluestone**

∧
An abundance of interior and exterior windows, along with plenty of unobtrusive lighting, make sure this indoor pool is always illuminated.

>
As viewed from the living area, the mural on the far end of the pool creates the illusion of being outdoors.

DESIGN DETAILS

The trick with any indoor pool is to create a space that seems as outdoorsy as possible. This project accomplishes that with a series of arched windows and doorways that flood the room with light. At night, unobtrusive yet abundant light fixtures illuminate the room.

A landscape mural at one end of the pool furthers the outdoors illusion. It depicts a beach scene that could be Lake Michigan itself. Recessed lighting illuminates the painting, making it perpetually sunny no matter what the weather is doing outside. The use of

random, rectangular bluestone for the decking also contributes to the outdoorsy feeling. Built over a radiant heat system, the stone deck stays comfortably warm.

Due to limited access, indoor pools are often a challenge to build. In this case, the hole was dug during the winter months while the home's initial construction was under way. It wasn't finished, however, until two years later after the house was completed. By then, access to the pool was greatly reduced, making it nearly impossible to bring in materials and equipment.

The finished 15-by-34-foot (4.6-by-10.4-meter) pool is perfect for swimming laps, while an adjacent half-circular spa provides hot-water therapy and an unobstructed view of the mural. Custom-made tile around the spa's waterline sports a wave motif, and custom tile also marks the racing lanes on the pool floor. An automatic cover was added to the 17,000-gallon pool for safety, heat retention, and humidity control. The cover's tracks are nearly invisible under the pool's coping, and the reel system is stored beneath the pool deck, keeping the design clean.

PROFESSIONALS | Designer: **H. Gary Frank** Pool Contractor: **Downes Pool Co.** Photographer: **John Frantz**

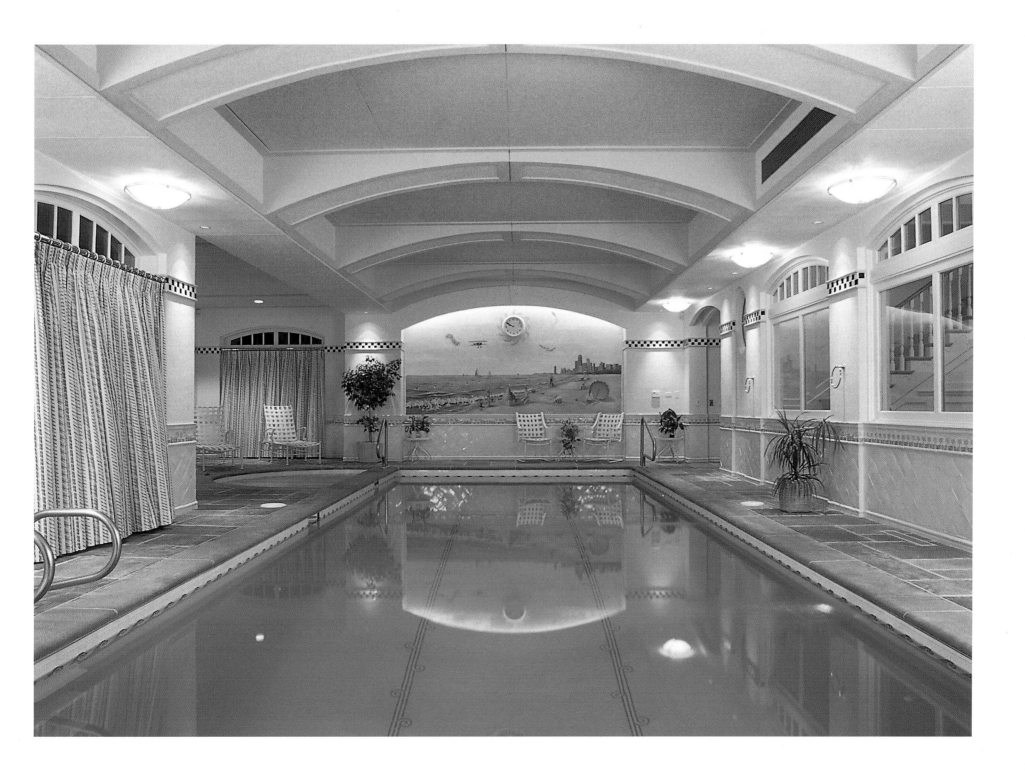

BARN RAISING

Housing both an indoor swimming pool and living accommodations for guests, this rectangular pool house is inspired by the regional tradition of "Dutch-barn" architecture and the concept of the guest house being a "hut in the garden." Surrounded by mature landscaping that's been in the making for more than a quarter of a century, the modern pool house maintains its rustic exterior while allowing bold, primary colors to influence the interior design.

∧
The pool house takes its design cues from the Dutch-barn tradition.

>
Wall-mounted light fixtures illuminate the arched ceiling.

Location: **Pewsey, Wiltshire, United Kingdom**
Type of construction: **Concrete**
Pool/spa finish: **Tile**
Decking and coping: **Tile**

DESIGN DETAILS

Measuring 11.5 feet (3.5 meters) wide and 29.5 feet (9 meters) long, this indoor pool is best suited for short lap swimming. The pool's interior is surfaced with off-white ceramic tile, while the deck is covered with a nonslip version of the same material. The light-colored deck is a stark contrast to the brilliant primary colors used on the walls.

All interior finishes were specified to ensure their water resistance. The ceiling panels are formed from back-cut and curved, birch-faced WBP (weather and boil-proof) plywood with a waterproof sealant. This stain-free finish preserves the natural look of the wood and adds warmth to the space—especially at night when soft rays of light curve along the arched ceiling from wall-mounted fixtures.

The side walls are formed from moisture-resistant MDF (medium-density fiberboard) panels with a spray-applied lacquer finish. They are designed to be easily demounted so that the air-conditioning ductwork behind them can be accessed. Other wall surfaces are made from foil-backed plasterboard with a plaster skim coat and painted surface.

Fresh air is drawn into the semiunderground equipment room through an external wall, then treated via a heat-recovery system and delivered to the pool room through stainless steel ducts. The duct work is briefly exposed as it passes through the tiled deck in front of the windows and up into the blue walls. These walls hide

PROFESSIONALS Landscape Architect/Contractor: **Allford Hall Monaghan Morris Architects** Photographer: **Dennis Gilbert/View**

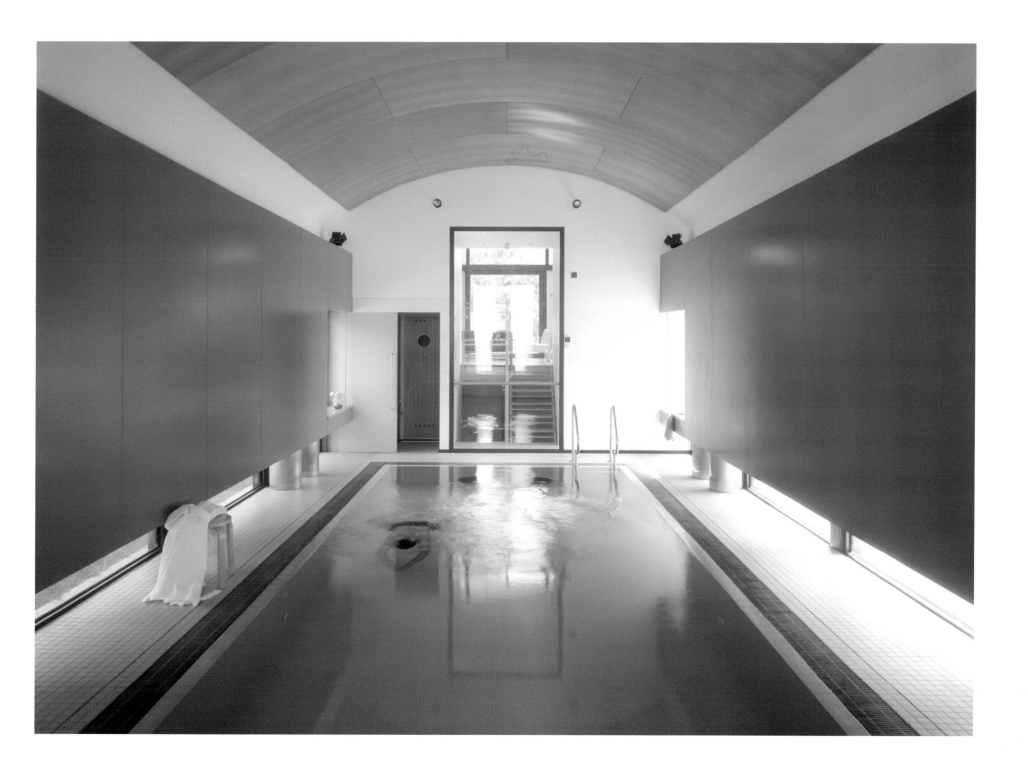

a multitude of ducts that provide air along the bottom of the room and extract it from the top.

There is no coping on the pool. Rather, water is free to spill over the edges and drain into a gutter system mounted in the deck on three sides. The fourth side is a raised tile deck that leads to a small room with a sunken spa. The water for both the pool and the guest accommodations is heated by siphoning water from a slow-moving underground river, running it across a heat exchanger, and then returning it to the river downstream.

To maintain privacy while permitting natural light to enter the pool area, low windows are installed at the deck level. The windows are double-glazed and thermally broken to avoid condensation on the interior surface. For a touch of whimsy, two windows in the stairwell leading down to the equipment room provide an underwater view of swimmers.

⌐

Twin portals provide underwater views of swimmers.

>

A recessed gutter system recirculates water that overflows or splashes out of the pool.

<

The pool area is accessed via a glass door from the elevated living quarters.

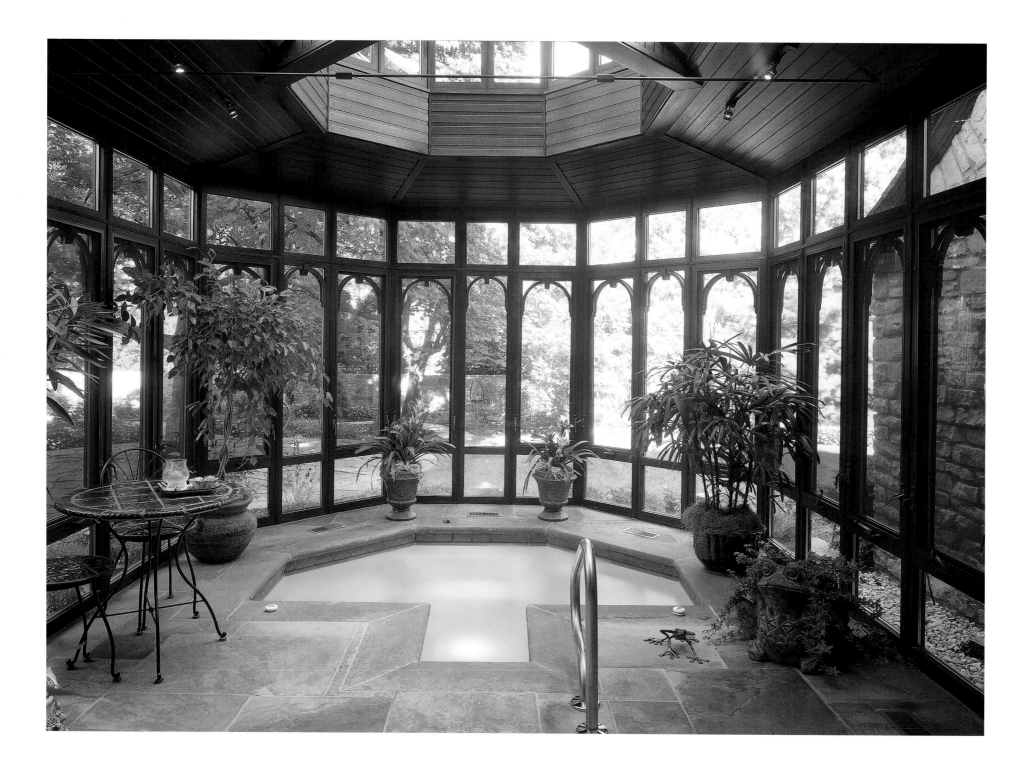

GREENHOUSE EFFECT

As more people try to create a health-spa experience in their own homes, indoor pools, spas, saunas, and steam rooms are growing in popularity. This custom spa provides all the amenities of a commercial installation but in the privacy of the owner's home. Surrounded by a raised-glass structure, the spa room uses natural materials, such as wood and stone, to blur the lines between interior and exterior. The solarium allows natural light to saturate the room, in which potted plants thrive around the water's edge.

Location: **Hinsdale, Illinois, USA**
Type of construction: **Gunite**
Pool/spa finish: **Plaster**
Decking and coping: **Bluestone**

↗

Bluestone decking contributes to the outdoorsy feeling of this spa room.

<

Narrow steps jut out from the main body of the spa to maximize the seating space.

DESIGN DETAILS

A tall glass conservatory gives this indoor spa all the natural lighting of an outdoor spa with the luxury of an interior installation. To foster the sense of being outdoors, natural materials were chosen for construction including exposed wood for the greenhouse's structure and bluestone for both the decking and coping around the spa. Potted plants of varying heights surround the room, blurring the line between indoors and outdoors.

The spa's narrow steps jut out from the main body of the 1,400-gallon (5,300-liter) vessel, creating an arrowhead design. This was done to optimize the seating space in the 9-foot (2.7-meter)-wide spa. A bluish-green slate appears along the waterline, while the rest of the spa is surfaced with white plaster.

The hot tub is equipped with a mineral purification system, which dramatically reduces the amount of bromine or chlorine needed to sanitize the water—thereby reducing chemical odors in the house. Meanwhile, a ceiling fan and adequate ventilation along the windows ensure that the backyard view will never fog up.

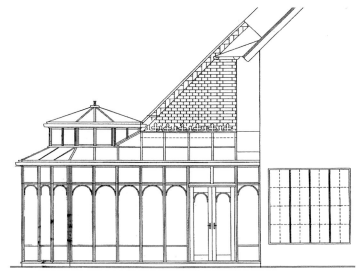

PROFESSIONALS | Landscape Architect/Contractor: **Downes Pool Co.** Photographer: **John Frantz**

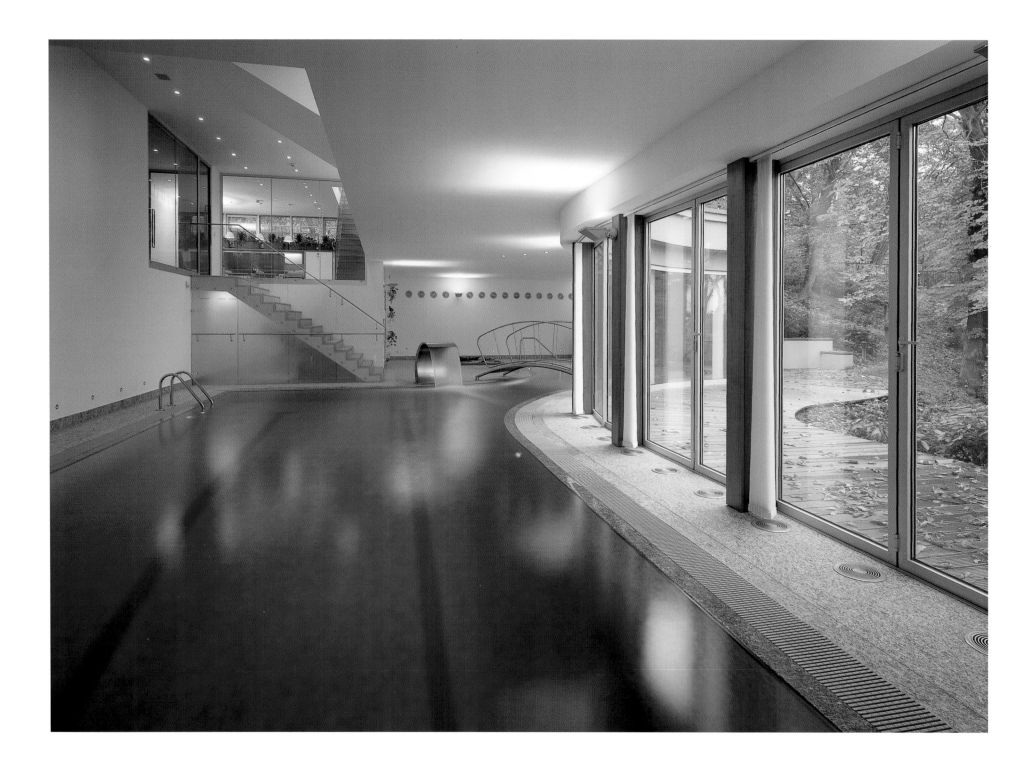

AQUATIC ADDITION

During the general renovation of this contemporary home, the indoor swimming pool was added. The task required expert engineering because the pool was to be partially tucked under the existing home. Major feats of construction retained the integrity of the home's foundation while creating an indoor pool that blends naturally with the existing architecture. In addition, the spectacular aquatic addition serves as a flawless transition between the modern interior and beautifully landscaped exterior.

DESIGN DETAILS

Extensive use of glass breaks the barriers between interior and exterior spaces, permitting natural light into this indoor pool room and making it visible from other areas of the house. This can be seen in the oversized windows, glass banisters, and the bank of glass walls that opens up to the adjacent outdoor garden area. Astute attention to air conditioning and ventilation ensures that the glass remains moisture free at all times to preserve the view and prevent mold and mildew from growing.

The pool is divided into two areas—a shallow area for the children to play and a deeper area for adult swimming. The two sections are separated by a bottleneck that can be crossed over by way of a wood and stainless-steel footbridge, making movement around this end of the pool much easier.

The pool itself is surfaced with glass mosaic tiles measuring just 3/4 by 3/4 inches (2 by 2 centimeters) each so they fit smoothly around the gentle curves. They were set by color in gradation, from dark blue on the bottom to white along the sides, to create a greater sense of depth. A recessed gutter system surrounds the pool, and the stone paving deck has a burnt surface so that it does not get slippery.

Location: **Prague, Czech Republic**
Type of construction: **Concrete**
Pool finish: **Glass mosaic**
Decking and coping: **Stone**

∧
In a marvelous feat of engineering, the indoor pool was nestled into the existing home.

<
A bar and conservatory are accessible from the glass-enclosed swimming pool, which opens up to the garden.

PROFESSIONALS · Architect: **ADR s.r.o.** Photographer: **Pavel Stecha**

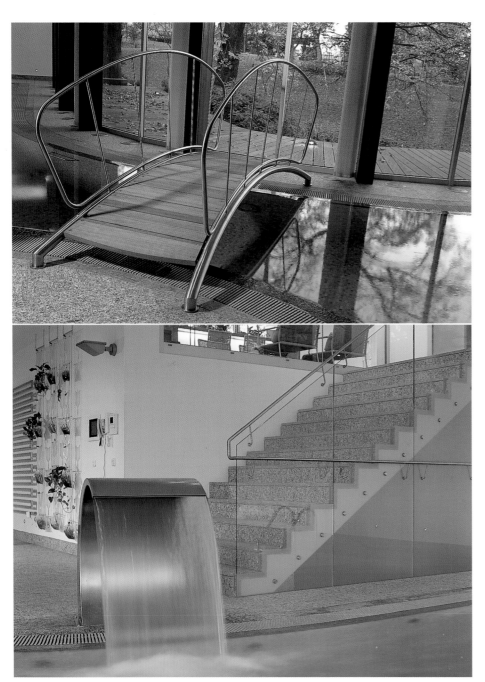

Other pool amenities include two swim jets, which provide a current of water for swimmers to paddle against; foot massage jets for hydrotherapy; and a sheeting water feature that doubles as a poolside sculpture. The pool and air-quality equipment is simply operated with automatic controls.

An adjoining conservatory and refreshment area adds to the health-spa atmosphere. The "chill-out" area, as the architect calls it, overlooks the pool and is furnished with a bar and chairs, while the conservatory one floor up is furnished with cozier wicker furniture. It offers an elevated view of the wooded garden. Glass banisters on the stairs between the various levels help to maintain the open-air atmosphere and clear views.

⌐
A footbridge separates the shallow children's area from the adult lap lanes.

<
A sheeting water feature adds a sculptural poolside element.

>
One passes through the "chill-out" room on his or her way up to the conservatory.

"If you gave me several million years, there would be nothing that did not grow in beauty if it were surrounded by water."

Jan Erik Vold, *What All the World Knows*, 1970

GARDENS OF EDEN

Professional horticulturalists will agree that no backyard garden is complete without some element of water—be it a pond stocked with koi, an ornamental fountain that trickles with the sound of falling water, or even a simple birdbath. Some of the most impressive gardens, however, are those that incorporate swimming pools and hot tubs. The evergreen smell of fresh arborvitae or the sweet fragrance of roses provides natural aromatherapy as one luxuriates in the soothing waters.

Placing a pool in a garden setting has its challenges. By bringing sod, trees, shrubs, and flowers closer to the pool, you create a situation where organic debris—everything from grass clippings to dried leaves and petals—can easily dirty the pool water and wreak havoc on the filtration system. Also, some delicate plantings don't do well next to sun-baked concrete decks or when splashed with chlorinated water.

Nevertheless, with the right planning (and maybe a little help from a landscape architect) it is possible to have the best of both of these worlds. In the following projects, you'll see how designers have narrowed the void between swimming pools, hot tubs, and gardens to create lush and unified environments.

FIRE AND WATER

All of the earthly elements come together in this tranquil garden setting, which includes an elliptical pool framed by brick inlays and surrounded by stone-and-brick pedestals. Fire bowls from Polynesia and bronze-glazed urns adorn the pedestals, which are reflected in the black plaster pool surface, along with the rest of the garden landscape. Meanwhile, a trio of frog fountains sends arcing sprays of water into the pool, producing a relaxing sound that attracts birds to the aquatic habitat and draws guests toward the pool.

DESIGN DETAILS

The ideal garden pool is an integral part of the surrounding landscape. This urban pool and spa accomplishes this in a small, 40-by-40-foot (12-by-12-meter) space through the use of well-chosen building materials.
An earth-toned palette of brick coping matches the house, while bluestone decking is the perfect "floor covering" for this outdoor room. Bluestone is also used on the steps leading into the pool, which is surfaced with black plaster and green glass tile to give the pool the dark hue of a natural pond.

A series of strategically placed planting beds creates continuity from the curbside gardens at the front of the house to the backyard pool. By limiting the number of materials and interweaving them, the pool, terrace, and surrounding gardens become a unified space.

The raised spa, set against a lush background of deciduous trees, is accessed on either side of the pool by a small set of round steps. Three bronze frogs spout water into the pool from atop the brick wall that separates the pool and spa, adding soothing sounds to the already relaxing environment.

For convenience, an antique chrome shower is mounted poolside against a backsplash made from the same translucent green tiles used in the spa and around the pool's waterline.

Location: **Portland, Oregon, USA**
Type of construction: **Gunite**
Pool/spa finish: **Glass tile**
Decking and coping: **Bluestone and brick**

∧
The pool's garden design is an extension of the curbside plantings in front of the house.

<
Metal bowls, once used in Polynesia for syrup production, now serve as braziers that warm and light the garden.

PROFESSIONALS Landscape Design: **Samuel H. Williamson Associates** Photographer: **John Hughel**

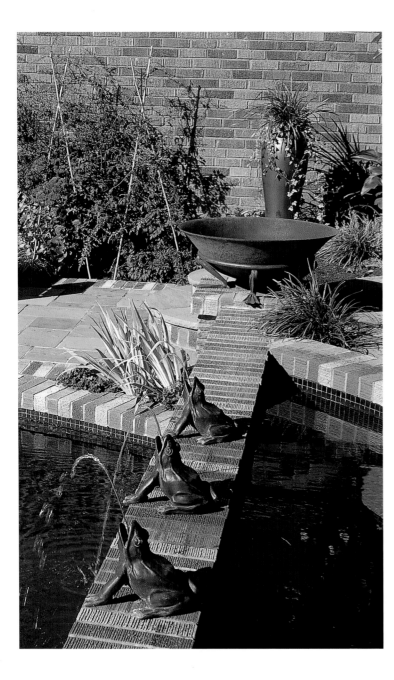

A fence made of ipé hardwood and bands of brushed aluminum enclose the garden, while cable trellises run the top length of the fence and support a veil of passionflower and clematis vines. Aluminum-and-hardwood furniture complement the fence perfectly.

Though the client wanted an outdoor fireplace, it would have taken up too much space. As an alternative, the designer created low, bluestone pedestals with brick caps. Four showcase bronze-glazed urns, and four more surround the pool with fire braziers from Polynesia, where they were once used for sugar-syrup production. A blacksmith was employed to craft frog-feet stands for the bowls to rest in. The fire bowls provide heat and light for evening summer gatherings and also reflect their glimmer in the pool's surface. Planting beds surround the pedestals, further blending them into the garden landscape.

<
A chorus of frog fountains sends arcs of water streaming into the adjacent pool.

>
The bluestone deck provides just enough space for poolside dining and sunbathing.

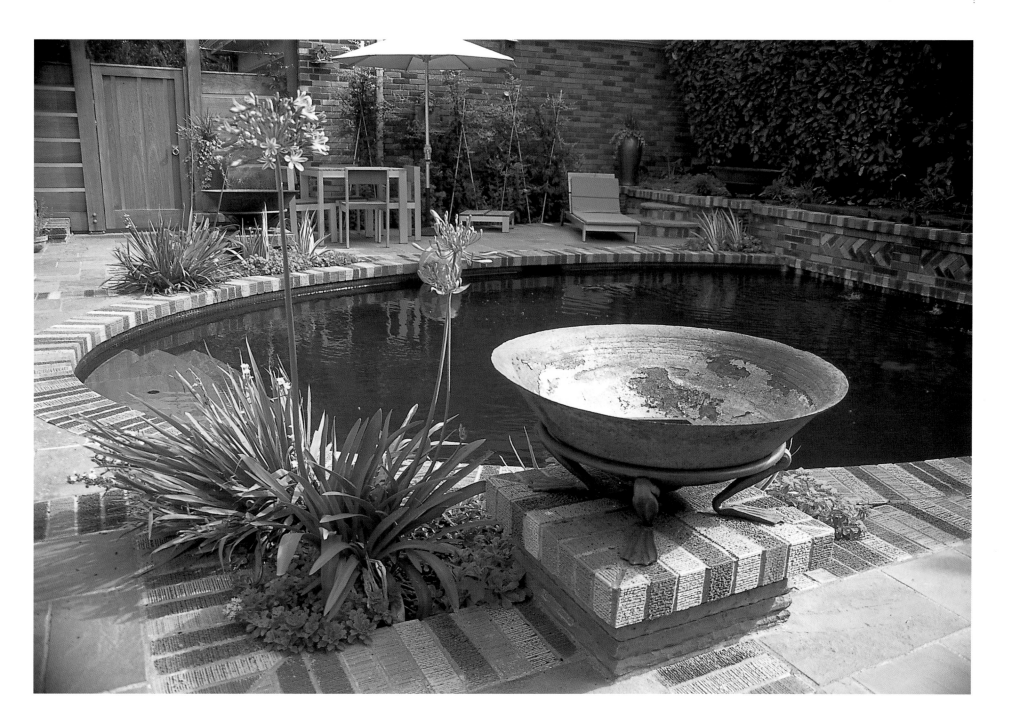

GRECIAN GRANDEUR

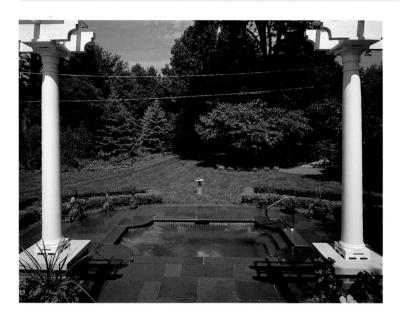

Framed by the house and a series of arbors, this home's raised patio provides a perfect spot for outdoor dining and entertaining. The real excitement, however, occurs as you pass through two of the classical columns and step down into the yard. Surrounded by a variety of trees, ornamental bushes, shrubs, and colorful plantings, the space feels a bit like a sunken garden with an 8-by-13-foot (2.4-by-4-meter) Grecian-style spa as its focal point.

Location: **Elmurst, Illinois, USA**
Type of construction: **Gunite**
Pool/spa finish: **Tile**
Decking and coping: **Bluestone**

⌐
Ornamental shrubs and plantings surround the sunken hot tub.

>
Custom radius corners on the all-tile hot tub make it more organic in design yet still formal in shape.

DESIGN DETAILS

Although this yard has plenty of space for a pool and a spa, the clients favored just a hot tub. With a short swimming season in the northern climates, many homeowners there opt for a spa, which they can use year round—no matter how cold the temperature gets or how high the snow is piled.

Lined with 3-inch (7.6-centimeter) royal-blue tiles, the gunite spa reflects the blue sky and offers a nice complement to the greenery that abounds. Random rectangles of bluestone pavers were chosen for their formality, keeping with the classical theme. A stainless steel handrail indicates where it's safe to enter the hot tub. Bench seating surrounds the interior and multidirectional jets provide relaxing hydrotherapy.

To bring the garden closer to the water's edge, while keeping organic debris out, the homeowner uses a host of flowerpots filled with colorful annuals. A pathway lined with boxed hedges encourages visitors to stroll around the edges of the lawn. Flowerbeds hug the wall of trees and shrubs, which serve as a natural fence for privacy.

PROFESSIONALS Landscape Architect/Contractor: **Downes Pool Co.** Photographer: **John Frantz**

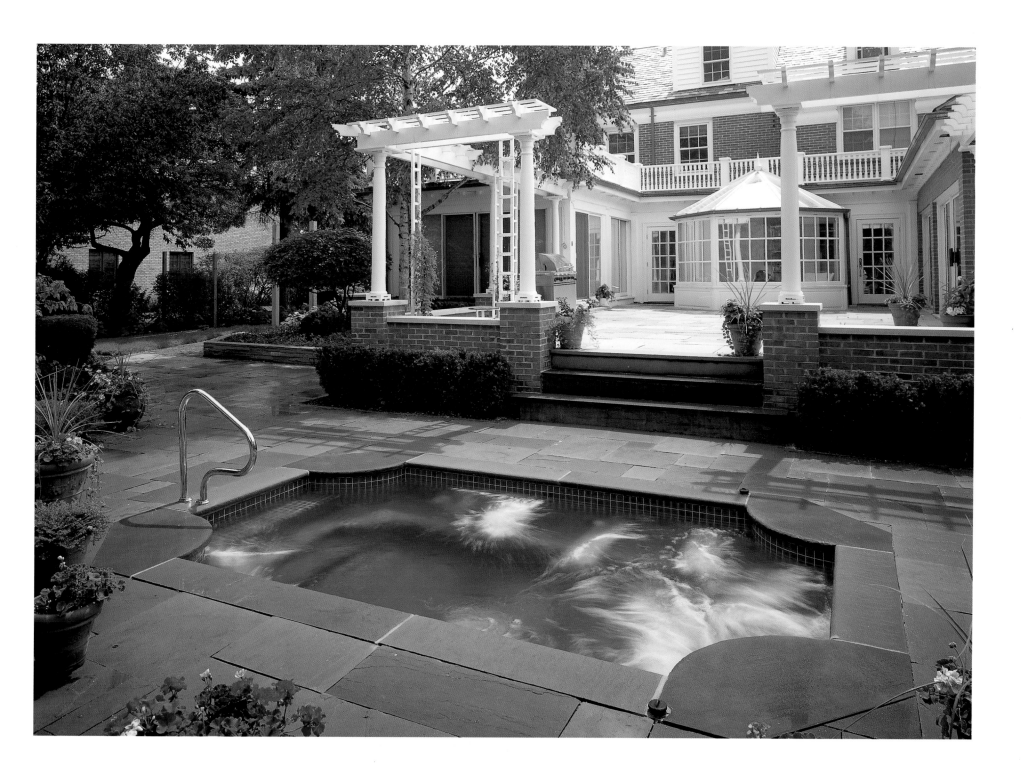

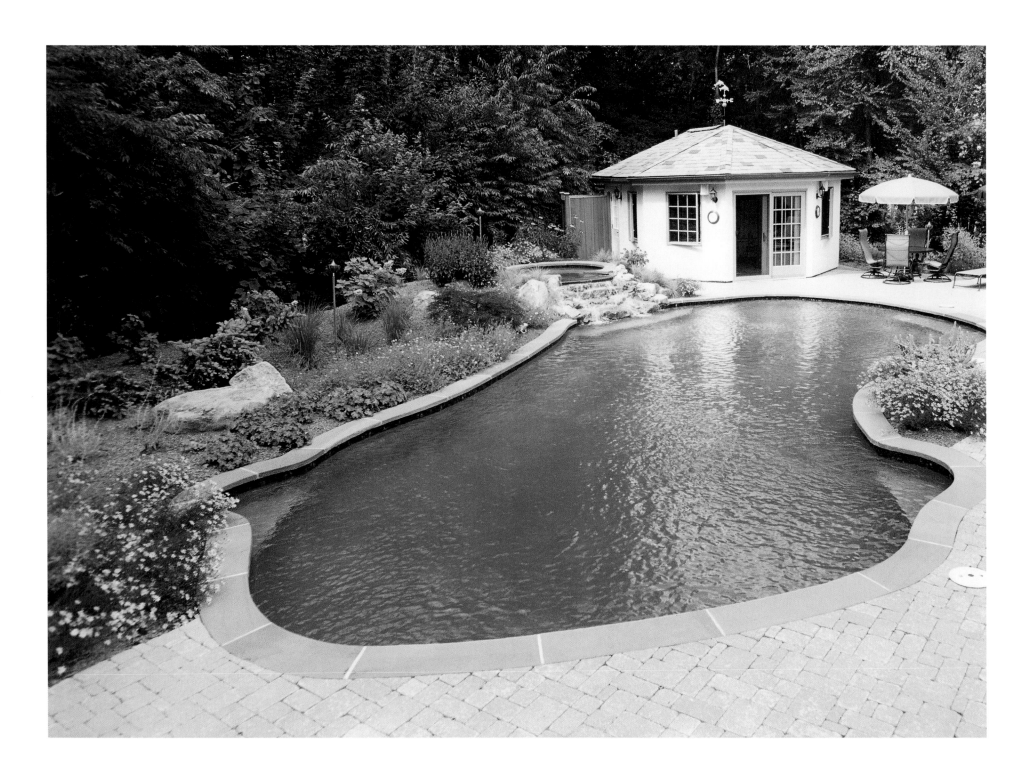

FREE-FORM PLEASURE

Free-form shapes are naturally organic, which is why they're so popular in garden pool installations. The carved-from-the-earth design makes the pool look more like a natural pond, which is the goal of many master gardeners. In this case, the pondlike illusion is furthered by the use of a medium gray exposed aggregate for the pool and spa surfaces. The aggregate darkens the pool water slightly while maintaining a clear-water aesthetic.

Location: **Franklin Lakes, New Jersey, USA**
Type of construction: **Gunite**
Pool/spa finish: **Exposed aggregate**
Decking and coping: **Bluestone and concrete pavers**

⤴
Colorful plantings surround the spa and pool for a true garden aesthetic.

<
A natural rock waterfall adds visual interest and sound to the garden setting.

DESIGN DETAILS

A rock waterfall originates from the raised spa and spills into the free-form pool adding natural sound and motion to this garden environment. Nestled into the landscape with rocks and plantings, the spa resembles a fresh-water spring feeding into a pond. Colorful perennials planted right up to the pool coping enhance the pond effect, and underwater bench seating allows swimmers to relax next to the flowers.

Two-inch (5-centimeter)-thick bluestone coping—chosen to match the waterfall rocks—surrounds the 37-by-21-foot (11.3-by-6.4-meter) pool and hot tub. Gray concrete deck pavers were chosen for their versatility as well as the way they blend with the other natural materials.

The property slopes considerably behind the cabana where the pool equipment is stored, so a stone wall was built to step down the grade. To reduce the reliance on chemicals to sanitize the pool and spa water, ozone and mineral purifiers are installed. In addition, automatic controls simplify operation of the spa equipment and lighting. Meanwhile, oil-burning torches emit ambient lighting at night and double as garden sculptures during the day.

PROFESSIONALS Landscape Design: **Scenic Landscapes** Contractor: **Creative Master Pools** Photographer: **Eric Auerbach**

"GOLF" COAST

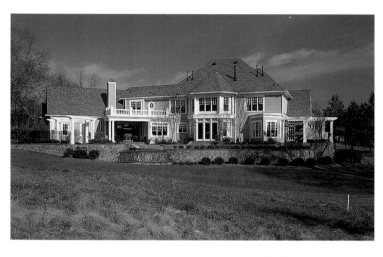

If your yard backs up to a Tournament Players Club golf course, it ought to be as manicured as a putting green. Though photographed in late fall when many of the plantings are dormant, this showcase pool and spa drip with colorful perennials, flowering vines, and bright container plantings during the summer months—giving golfers a beautiful garden vista to cast their eyes upon between efforts to improve their swing.

∧
A natural rough separates the home and the golf course, from which there's a spectacular view of the pool's water feature.

>
The vanishing-edge pool appears to flow into the golf course beyond.

Location: **Raleigh, North Carolina, USA**
Type of construction: **Shotcrete**
Pool/spa finish: **Plaster**
Decking and coping: **Bluestone**

DESIGN DETAILS
Because of a steep grade, the pool and deck areas were built almost entirely above ground. To take advantage of the change in levels, the pool incorporates a curved vanishing edge, which is fully landscaped on the back side to create a stunning water feature. Two sets of equipment were required: one pump and sand filter to handle the overflow basin and another circulation pump and filter to manage the pool water.

The 40-foot (12.2-meter)-long free-form pool is surfaced with a gray plaster to create a natural-pond effect with a reflective water surface. All skimmers, main drains,

and fittings in the pool are black to make them "disappear." The warm colors of the Pennsylvania bluestone decking and the cultured stone walls further add to the natural design.

Mimicking the architecture of the house, white arbors cover the raised deck area, which provides an intimate space for poolside entertaining or relaxation. Meanwhile, in the pool, three concrete stools covered with black tile form a swim-up bar.

The spa area is also covered with an arbor and surrounded by a trellis fence for privacy. A see-through fireplace—shared between the master bedroom and the spa area—warms the outdoor

PROFESSIONALS Landscape Architect: **Peg Bergner** Pool Contractor: **Master Pools by New Bern Pool** Photographer: **Frank Hart**
Home Builder: **Youngquist Homes** Landscaper: **Myatt Landscaping**

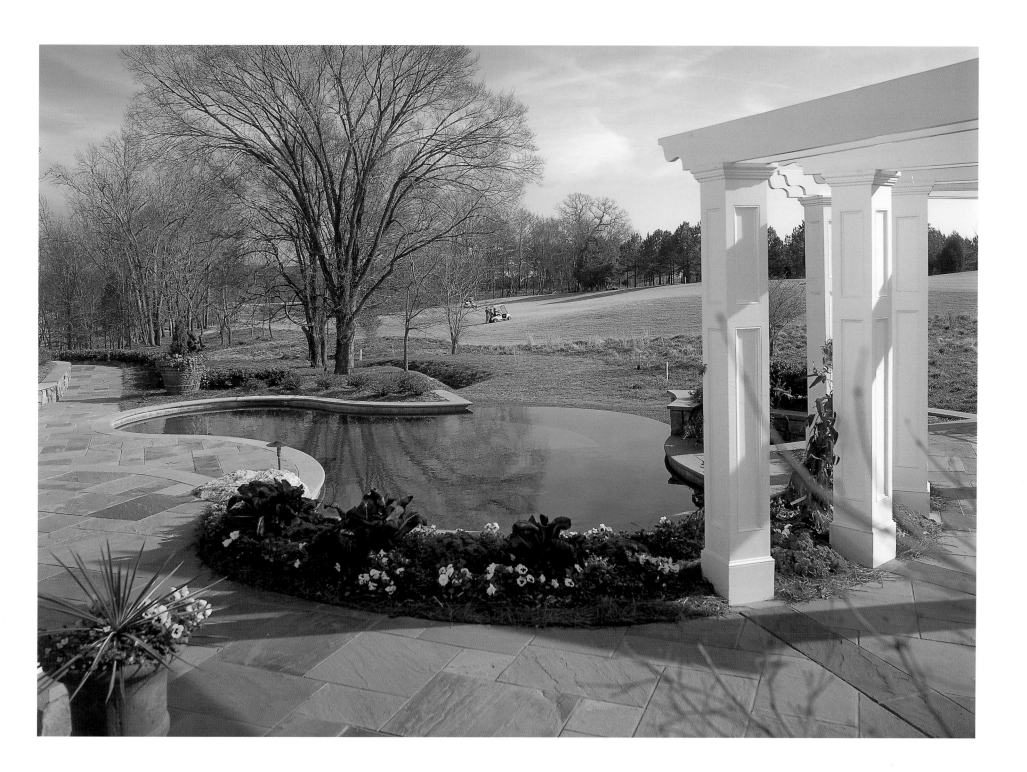

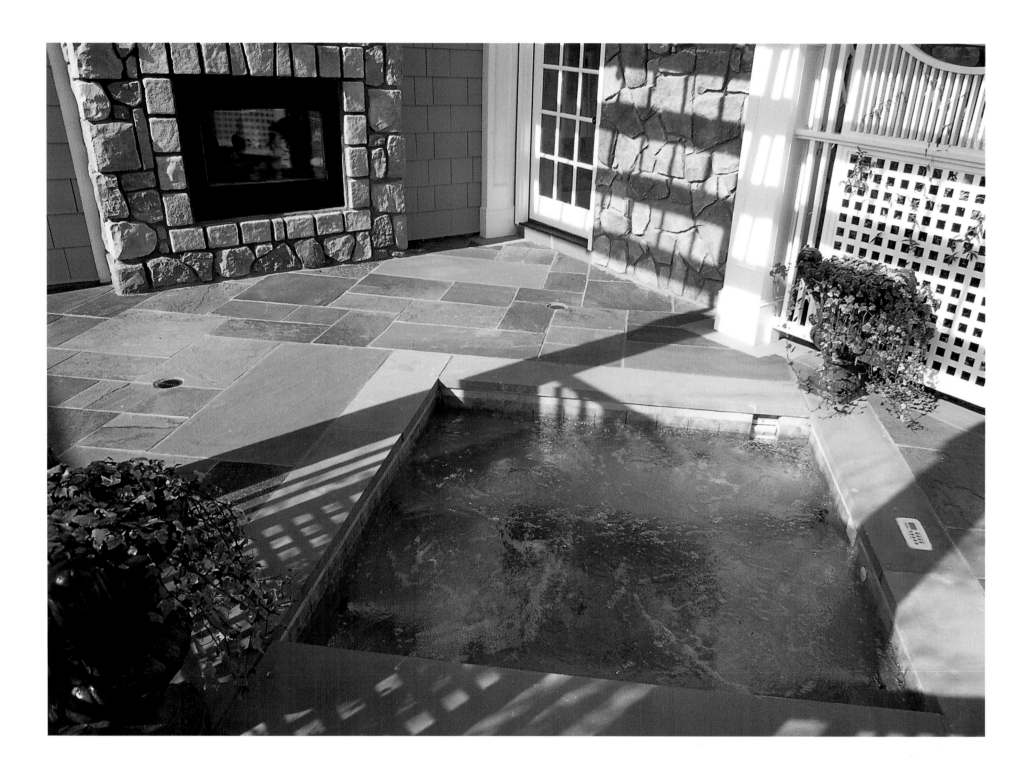

room and provides ambient lighting. Measuring 6 by 6 feet (1.8 by 1.8 meters) square, the raised spa is about 12 feet (3.7 meters) above grade—a feat accomplished with retaining walls and gravel backfill.

To keep the garden setting lush year round, the landscaping contains numerous evergreen shrubs and trees. As the plantings mature, jasmine, wisteria, and clematis will cascade from the trellises, while colorful annuals will spill into the pool from adjoining flowerbeds. Already, bluestone paths are lined with gardenias, myrtle, nandina, and a variety of holly, while a couple of Japanese maples help shade the deck. Urns overflowing with annuals bring the garden even closer to the water's edge, especially in the spa area.

⌐

Raised decking and a vanishing-edge pool design make the most of a steep grade.

>

The back side of the vanishing edge doubles as a water feature that can be viewed from the golf course.

<

A see-through fireplace is shared with the master bedroom, adjacent to the spa.

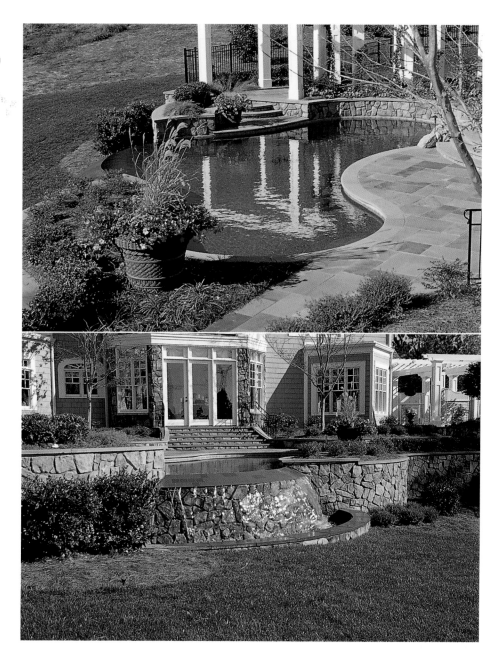

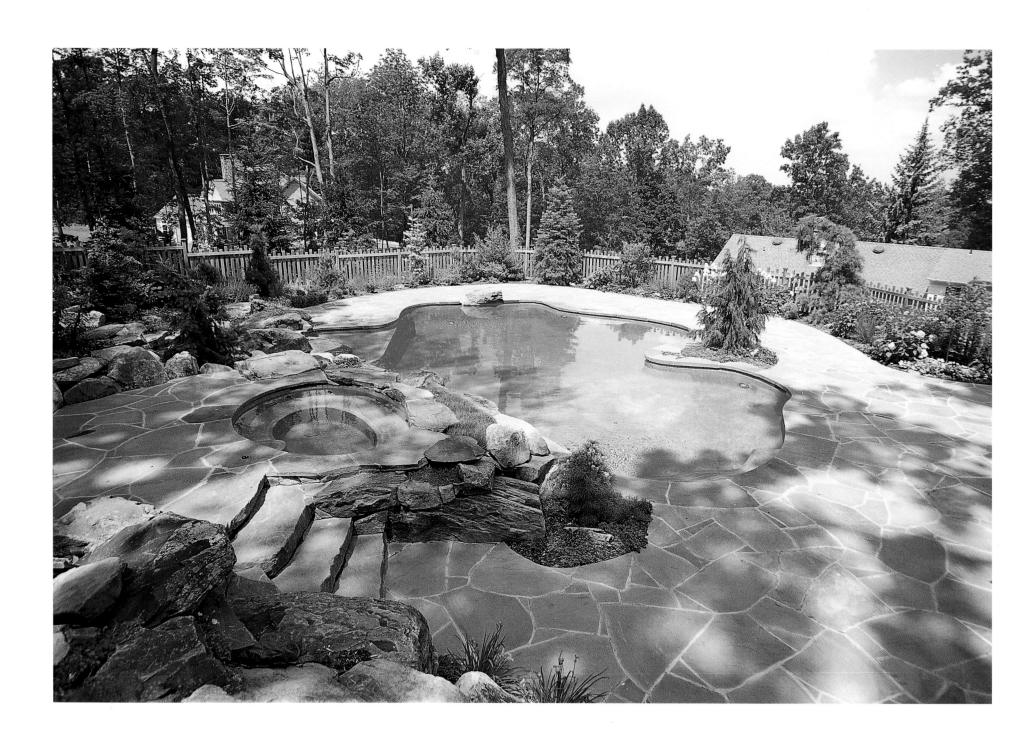

TERRACED RETREAT

A terraced garden provides the only access to this pool and spa installation, which sits atop a 40-foot (12-meter) slope behind the house. Yet the climb to the summit is as enjoyable as the final destination, thanks to the colorful flowerbeds that line the stone steps. At the top, a bluestone deck surrounds the pool and spa, visually tying it to the rest of the landscape. Best of all, a poolside cabana with kitchen means there's no need to trek up and down the stairs every time your glass of iced tea runs empty.

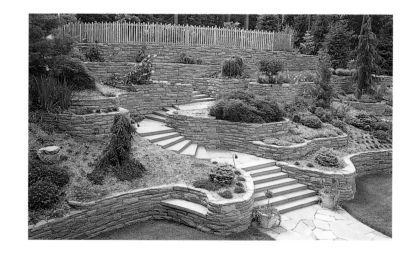

Location: **Franklin Lakes, New Jersey, USA**
Type of construction: **Gunite**
Pool/spa finish: **Exposed aggregate**
Decking and coping: **Bluestone**

↗
Access to the pool area is up a stairway that meanders through a terraced garden.

<
A variety of plants and shrubs soften the rockwork around the pool and spa.

DESIGN DETAILS
This garden-pool design incorporates lots of plantings while reserving plenty of deck space for entertaining. In fact, a cabana (not visible here) sits next to the pool—complete with a full kitchen and built-in barbecue grill.

Building materials were chosen to reflect the lush environment. Bluestone, which occurs naturally in this region, was chosen to complement the boulders, which were brought in to create a natural-looking retaining wall behind the pool. Less formal than rectangular pavers, the irregular shape of the bluestone lends a casual elegance. In similar fashion, the pool surface is a medium-gray exposed aggregate that reflects the natural colors of the stonework.

The pool sits atop a 40-foot (12-meter) slope, with the house at the bottom. The only way to get to the pool is to walk up a winding, bluestone staircase through a terraced garden composed of stone walls. Surrounded by a thick forest, the pool and spa are blended into the native terrain with additional planting beds. When the shrubs and flowers mature, the stonework will appear even less barren.

The pool and spa can be automatically controlled from either the house or cabana, and the water is sanitized with a combination of ozone and mineral ionization, thereby greatly reducing the amount of chemicals required.

PROFESSIONALS Landscape Architect: **Paul Keyes** Contractor: **Creative Master Pools** Photographer: **Eric Auerbach**

STREAM-FED SCENERY

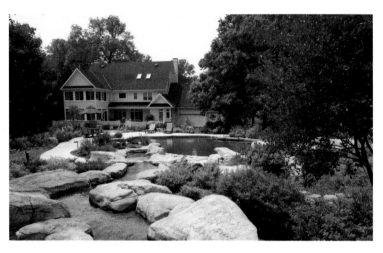

Fresh water from a natural stream appears to flow into this garden pool, accompanied by the soothing sounds from a rock-based waterfall. Designers manipulated the grade of the property to acquire the height necessary for the eye-catching water features. Other garden design elements are as practical as they are attractive. For example, the poolscape incorporates a wooden bridge that spans a dry streambed designed to handle excessive surface water.

∧
A streambed lined with artificial rock appears to feed the pool.

>
A wooden bridge crosses a dry streambed, designed to hold water runoff.

Location: **Low, Kentucky, USA**
Type of construction: **Gunite**
Pool/spa finish: **Plaster**
Decking and coping: **Artificial rock and coated concrete**

DESIGN DETAILS

Disguised as a stream-fed pond, this garden pool features a custom plaster finish that's lighter than a traditional "pond" finish, yet gives the pool the natural look the homeowners requested.

Presented with a virtually flat lot, the designer created vertical interest by adjusting the grade to incorporate a streambed and water feature made from artificial rock. Artificial rock also cantilevers over parts of the pool for a carved-from-nature look.

Closer to the home, a dry streambed was constructed to provide visual interest and to control surface water created by the grade change. A wooden bridge crosses the dry streambed, connecting the home to the pool area.

An abundance of plantings—from ornamental trees to flowering annuals and perennials—line the streambeds and water feature, making for a verdant and flourishing garden environment. Meanwhile, a coated concrete deck, which stays cool despite the sun's unrelenting rays, provides ample space for poolside dining and lounging amongst the colorful foliage.

PROFESSIONALS Landscape Architect/Contractor: **Gym & Swim** Photographer: **Charles Lipschutz**

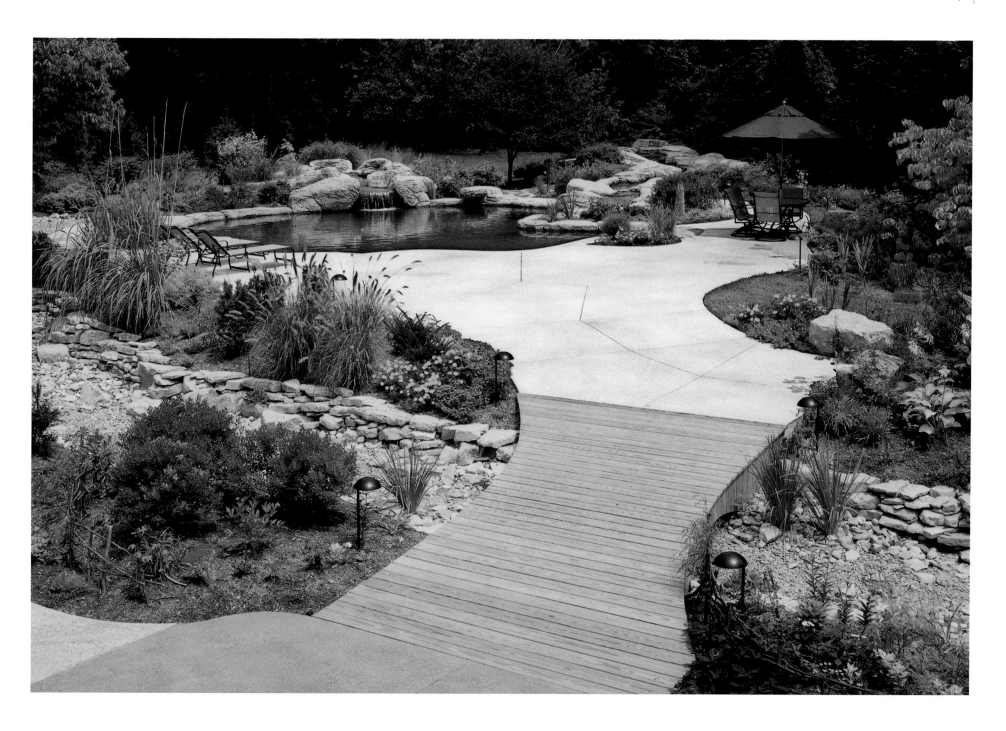

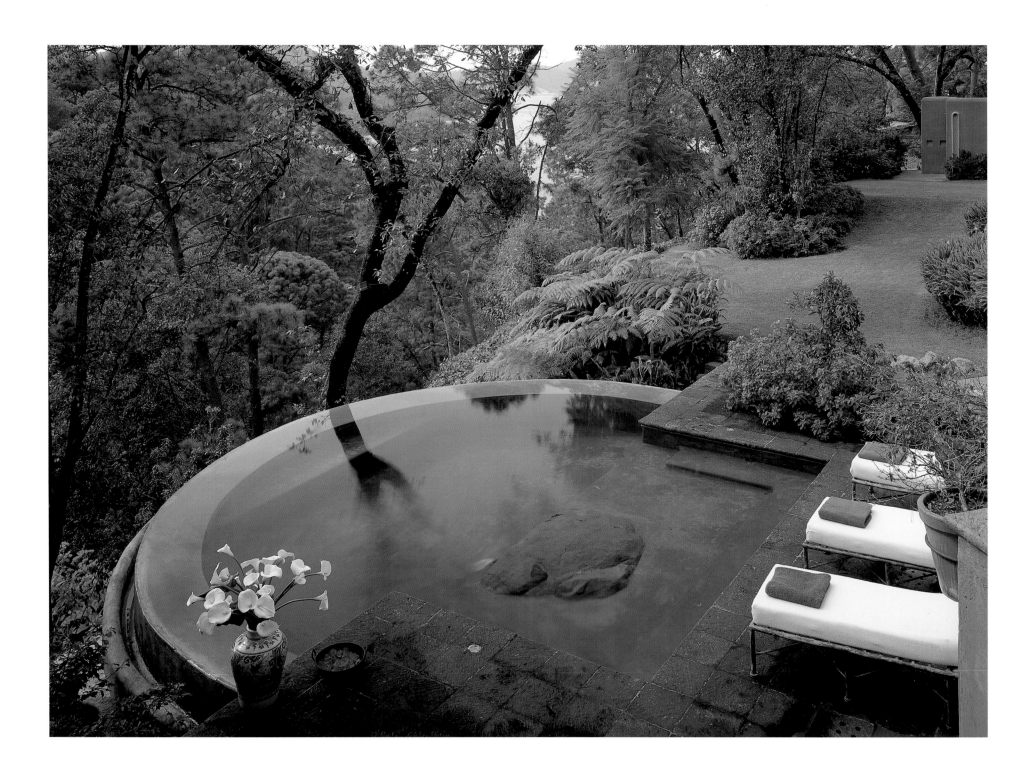

A NATURAL BOND

Before negative-edge pools became all the rage, this modest garden pool was built in the mountains of central Mexico so that the water appears to flow into the treetops and lake beyond. At just 14 feet (4.3 meters) wide, the restrained, semicircular pool doesn't dominate the space, yet its unique design enhances the garden aesthetic with the tranquility of moving water and the earth tones of a simple paver deck.

DESIGN DETAILS

Gray cement was chosen for the pool surface to help it blend softly with the surrounding landscape. The result is a "pond" that reflects passing clouds and towering trees like an enchanted mirror. Not seen in this picture is a hot tub positioned like an eagle's nest atop a concrete tower. Accessed by a bridge, the hot tub offers dramatic views of the garden pool and rolling hillside.

A boulder sits in the shallow section of the pool, emerging like a natural outcropping where one can sit and dangle his or her feet in the 4-foot (1.2-meter)-deep pool. By adding an expansive mixture with the concrete used to cast the pool shell, the seam around the boulder remains watertight.

Meanwhile, the pool's vanishing edge acts like a skimmer, removing debris from the water's surface. It also serves to naturally heat the pool water, as it takes the warmer water from the surface and exposes cooler water to the sun's rays.

A small, gray cement deck provides just enough space for poolside lounging, where sunbathers are greeted with the fragrance of colorful perennials and the saturated green hues of flowering shrubs, ferns, and other tropical foliage.

Location: **Valle De Bravo, Estado de Mexico, Mexico**
Type of construction: **Concrete**
Pool/spa finish: **Cement**
Decking and coping: **Concrete tiles**

<
A small, cement pool is the perfect complement to this lush garden setting.

PROFESSIONALS Landscape Designer/Contractor: **Manolo Mestre** Photographer: **Tim Street-Porter**

"Water has no taste, no color, no odor; it cannot be defined, art relished while ever mysterious. Not necessary to life, but rather life itself. It fills us with a gratification that exceeds the delight of the senses."

Antoine de Saint-Exupéry 1900–1944, *Wind, Sand, and Stars,* 1939

ARTISTIC INTERPRETATIONS

The vast majority of backyard swimming pools are of the cookie-cutter variety—packaged pools that come in a limited number of shapes and sizes. That's because the most cost-effective pool to build is the one that can be produced over and over again with relative ease. On a hot summer day, these humdrum pools are cable of cooling you off just as well as those costing ten times more, but they're not as likely to evoke a sense of architectural wonderment or convey the owner's personal style.

For many people, their pool or hot tub—like the car they drive and the clothes they wear—must reflect their individual fashion, their unique chic.

They wouldn't dream of putting a cookie-cutter pool in their backyard anymore than they'd consider buying a vinyl-sided tract house in the suburbs. For them, it's all about design and attention to detail.

On the following pages, you'll bear witness to some highly stylized pools and spas that required as much artistic inspiration as they did technical know-how. Adorned with exclusive embellishments—from marvelous mosaics to sculptural superfluities—these projects offer as much for the soul as they do for the swimmer.

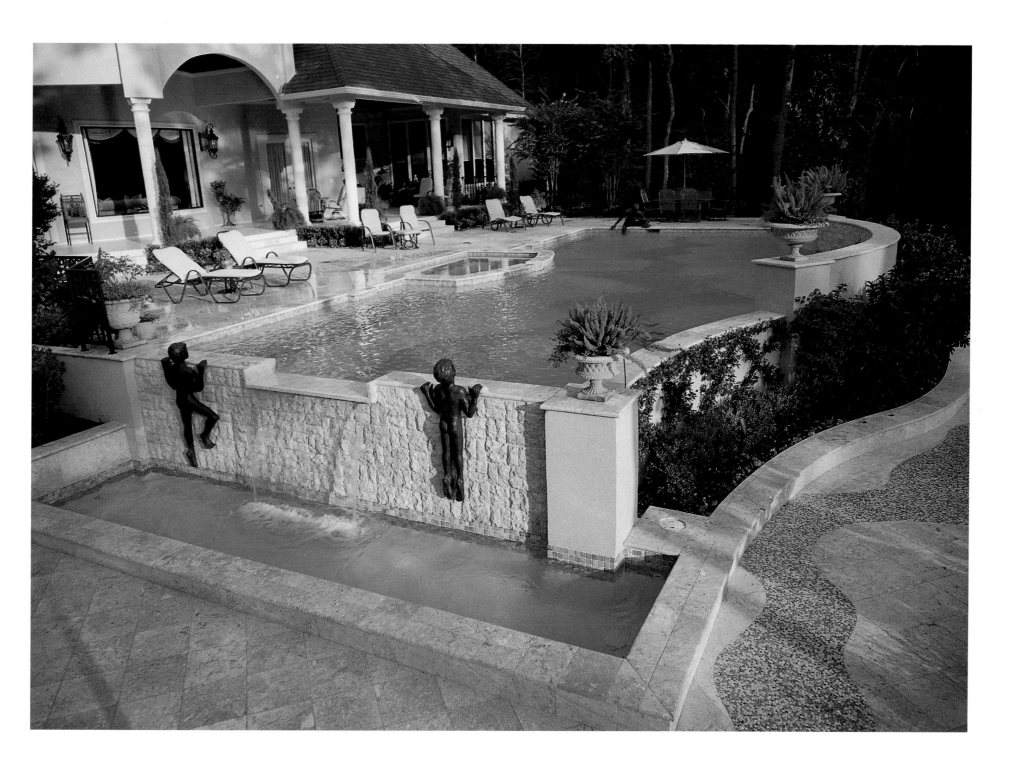

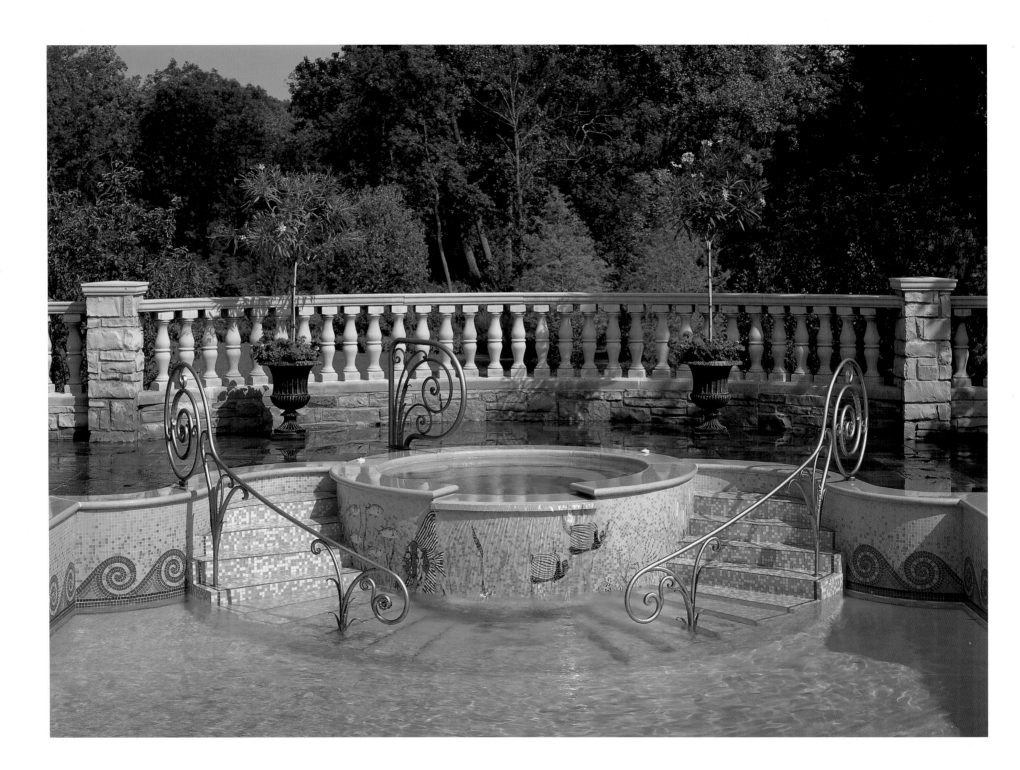

CLASSIC ARTISTRY

Roman baths, Italian mosaics, and French art nouveau—it all comes to mind with this updated interpretation of a classical pool and spa design. The client, who hired an artist to spend six months painting scenes of Greek mythology on his foyer ceiling, knew he couldn't live with just any type of pool in his backyard. So he borrowed some of his favorite design elements from classic architecture and incorporated them in this modern-day pool and spa.

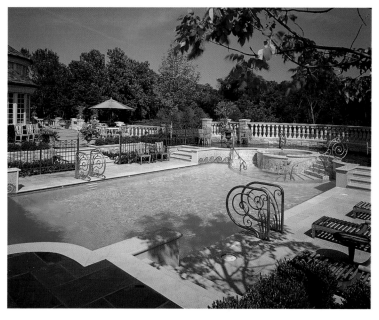

DESIGN DETAILS

Despite all of the antiquities associated with the project, the idea was not to replicate history. Rather, the homeowner's goal was to take important elements of the past and create an eclectic look by tastefully incorporating design themes from different periods into a contemporary pool and spa.

Some of the most striking elements of this pool and spa installation are the art-nouveau, stainless steel railings, which were custom designed and manufactured by a local metals fabricator. Though the graceful, organic curves are straight from the Belle Époque era, they're also reminiscent of rolling waves.

The 20-by-40-foot (6.1-by-12.2-meter) pool is a modified Grecian shape with a raised spa on one end and an imposing colonnade on the other. The colonnade ties the pool architecturally to the neo Classical home while offering stunning views of the pool and a forest preserve beyond. A Greek banister behind the spa balances the design, while two staircases leading up each side of the spa reinforce the elegant and classical symmetry of the project.

To accommodate severe changes in elevation from the house to the pool area, the design incorporates two tiers of stone decking that mirror the stonework used around the home. The lower tier features limestone decking and coping; the upper tier boasts bluestone decking.

Location: **Oak Brook, Illinois, USA**
Type of construction: **Gunite**
Pool/spa finish: **Marbelite**
Decking and coping: **Limestone and bluestone**

∧

Sandstone was chosen for the lower decking and stairs; bluestone was introduced on the upper tier.

<

Tile mosaics, custom-made railings, and classic architectural elements make this pool and spa a work of art.

PROFESSIONALS Designer: **Cannon-Frank** Pool Contractor: **Downes Pool Co.** Photographer: **John Frantz**

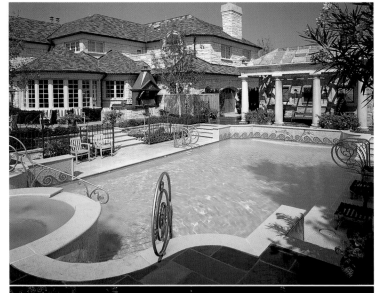

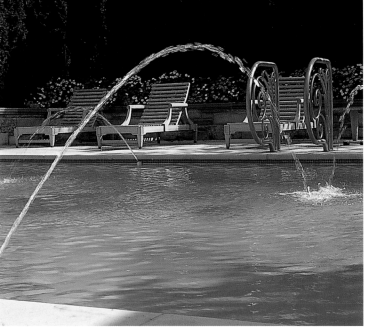

Italian influences are seen in the glass tile mosaics on the raised pool walls. The client and his interior designer worked on the mosaic design before contracting it out to a tile supplier. It features a sea-life theme, complete with tropical fish on one end and dolphins on the other. Blue waves tie it all together.

↑

Severe changes in elevation required the designer to create a two-tiered pool and spa area in order to keep the aquatic environment visually connected to the home.

<

Six arcing waterspouts create both visual and audible drama.

>

A sheer sheet of water cascades over the glass tile mosaic beneath the imposing colonnade.

As if the static visual weren't enough, the 30,000-gallon (113,562-liter) pool also boasts a waterfall on each end of the pool and three water arcs along each side. The sheeting waterfalls were designed to be thin enough as not to obscure the colorful mosaics behind them, and the water arcs originate from custom-designed nozzles tucked under the pool's coping.

For nighttime enjoyment, the pool and spa are equipped with five fiber-optic spotlights hooked up to color illuminators for a variety of lighting effects.

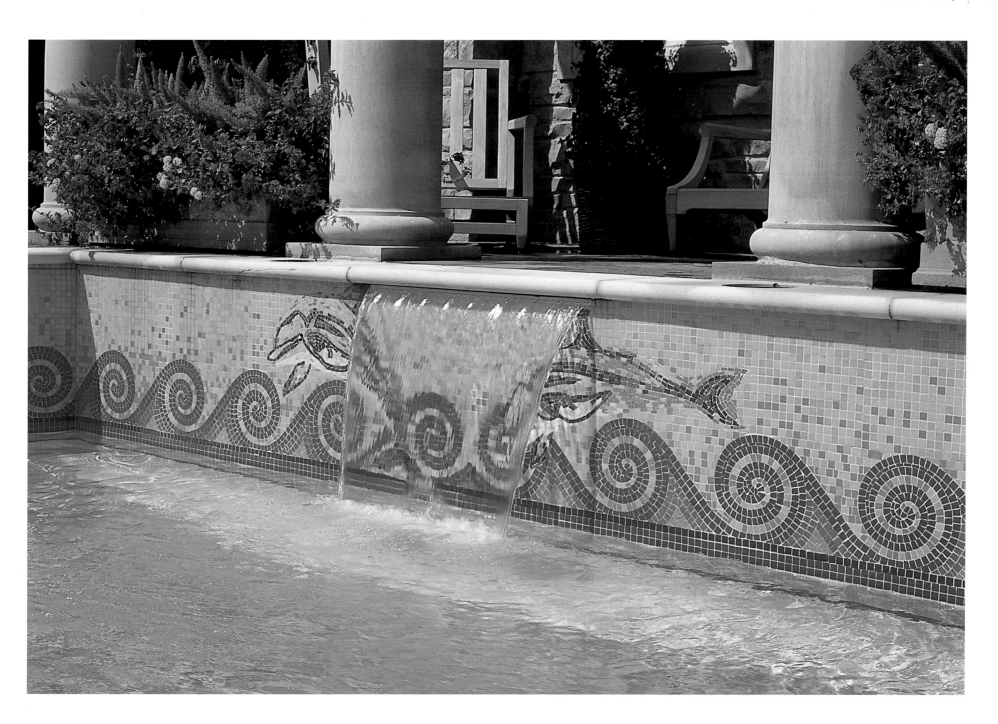

ELEGANT WHIMSY

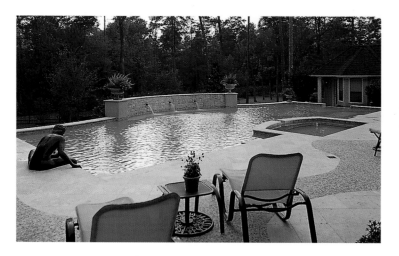

The challenge of this design was to create a massive, 50-foot (15.2-meter)-long swimming pool that would also feature a trio of bronze sculptures created by renowned Mexican artist Victor Salmones. A limestone wall frames the pool and provides a textured background for two of the statues to climb. The third bronze figure sits contemplatively as he faces three fountains pouring from the pool's raised back side. The result is a dramatic installation that makes both an elegant and playful statement.

Location: **The Woodlands, Texas, USA**
Type of construction: **Gunite**
Pool/spa finish: **Plaster and tile**
Decking and coping: **Limestone**

↑

At the shallow end, a bronze figure dangles his foot in the clear water.

>

At night, lighting draws attention to the sculptures and water features.

DESIGN DETAILS

Built primarily above ground, this pool and spa are supported with beams and surrounded with beautiful, cream-colored stone. An international combination of Marbella limestone from the sea beds of the Philippines and mosaic tiles from Italy provide an interesting contrast in pattern and texture.

The tiles are swirled throughout the pool and repeated in the deck, while a sheer wall of limestone provides a spectacular waterfall cliff for the amusing and youthful climbing sculptures as they peek mischievously over the pool.

At the opposite end, a life-size bronze figure sits in contemplative repose, dangling his leg languorously into the water.

Triple fountains accent a curved rear wall that frames a parklike setting beyond the pool. Opposite the fountains, a spa juts partially into the pool and features a spillway for water to pass through.

Potted urns top the outer walls of the pool, adding visual interest while also softening the extensive rockwork. At night, the fountains, as well as the bronze statues, are illuminated with fiber-optic lighting.

PROFESSIONALS | Landscape Architects: **Michael E. Cartwright and Associates, Inc.** Contractor: **Wise Pool Company** Photographer: **Ted Washington**

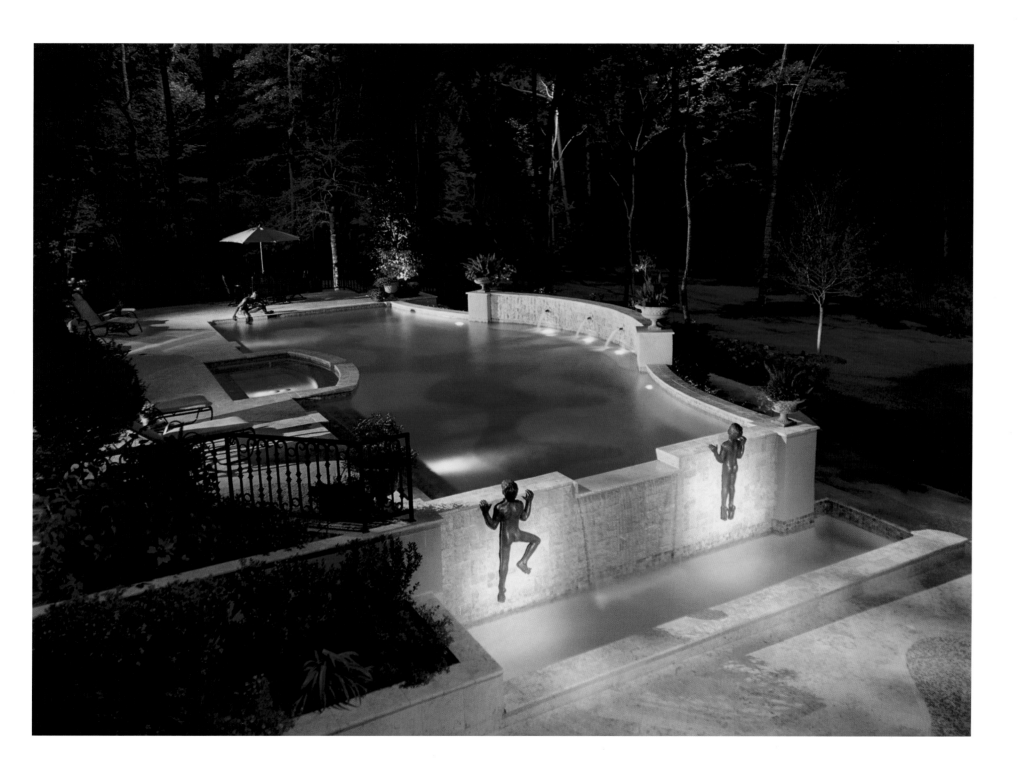

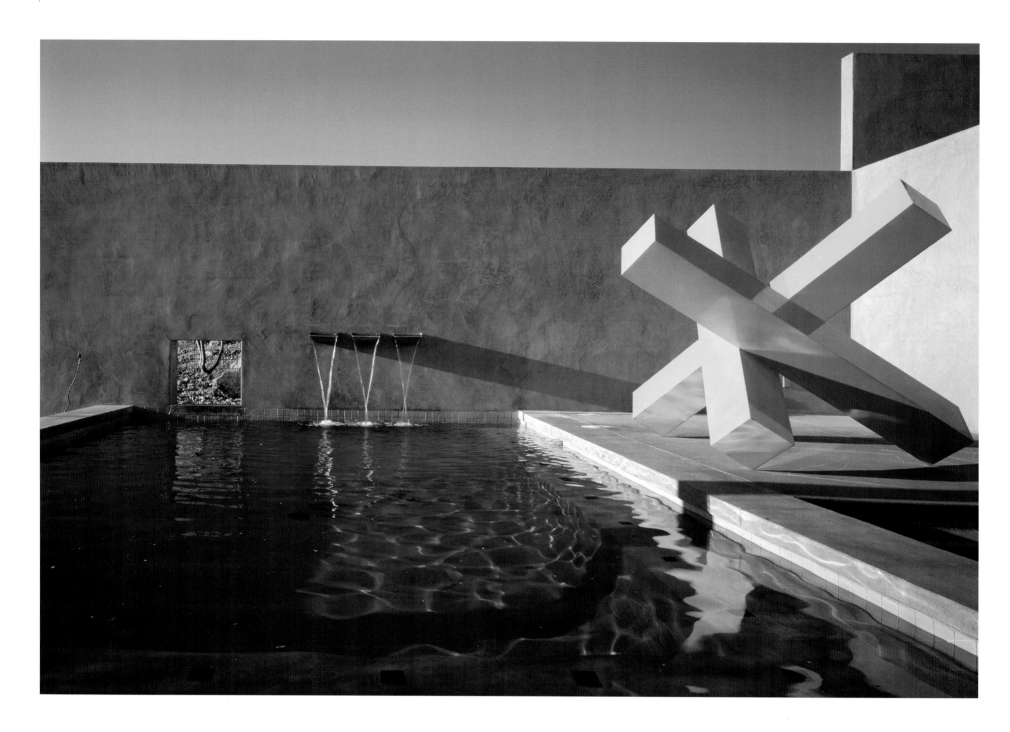

GRIDLOCK

A bright-yellow sculpture reigns over this gray concrete landscape. Ruled by straight lines and grids, the strict layout of the house and yard is in stark contrast to the rambling desert landscape and jagged mountaintops in the distance. Yet, the modern design brings comforting order to the untamed terrain. And the dark pool surface reflects the modern sculpture, visually uniting the two design elements against the concrete canvas.

DESIGN DETAILS

Wholly contemporary in its design, this 16-by-24-foot (4.9-by-7.3-meter) pool in the Arizona desert is equally inventive. Like so many modern artists who work from a grid, the designer of this outdoor space has taken that design tool to the extreme by planting square pods of grass amongst a grid of concrete lines. The rigidity mirrors that of the concrete house, with its concrete partitions that cast stark shadows across the ground.

The grid continues into the pool area where the lawn's concrete lines define the pool's dimensions. Even the first step leading into the pool is a perfect square, as is a window in the towering retaining wall that serves as the pool's fourth side.

Natural, gray plaster covers the pool surface to blend with the surrounding hardscape. The unyielding design and gray color scheme is in stark contrast to the canary yellow sculpture stationed poolside. Framed by massive concrete walls, the playful monument's three intersecting posts are reflected in the pool's surface and provide a counterbalance to the trio of stainless steel troughs that spill water into the pool from the retaining wall.

Location: **Paradise Valley, Arizona, USA**
Type of construction: **Gunite**
Pool/spa finish: **Plaster**
Decking and coping: **Concrete**

∧
A grid pattern defines the pool's placement.

<
The pool's retaining wall bears a window into the desert landscape, as well as a trio of fountains.

PROFESSIONALS Architect: **DeBartolo Architects Ltd.** Landscape Architect: **Steve Martino & Associates** Photographer: **Timothy Hursley**

COLORFUL CUBISM

Whimsical swimming pool designs have been around for ages, and an artistic owner typically can be found behind each one. Guitar- and piano-shaped pools have been commissioned by famous musicians, while other creative pool designs simply reflect the owners' personal taste in art. A cubist painting was the inspiration behind this colorful yet abstract pool design. Nevertheless, the pool is both fashionable and functional. A lap lane accommodates aquatic workouts while tiled tables within the pool give swimmers a place to enjoy refreshments.

∧
A Cubist painting inspired the pool design.

>
A deck made of neutral stone surrounds the colorfully tiled pool.

Location: **Ormand Beach, Florida, USA**
Type of construction: **Concrete**
Pool finish: **Tile and coral**
Decking and coping: **Marble and tile**

DESIGN DETAILS

Based on a Cubist painting, this brightly tiled pool is as practical as it is fanciful. A center lane is ideal for lap swimming, while a series of bright yellow tables offer swimmers a place to set refreshments. These handy features, however, may appear camouflaged by the pool's lively and artistic design.

A variety of vividly colored tiles and coral were chosen to create abstract patterns on the pool's floor and walls. Special attention was paid to how light reacts with the materials to ensure that the design can be fully appreciated day or night. In fact, every tile was hand laid with the designer's direct oversight.

Measuring 20 by 50 feet (6.1 by 15.2 meters), the pool contains shallow, 1-foot (30.5-centimeter)-deep sections that provide underwater bench seating. In addition, a travertine marble deck of muted tones frames the aquatic masterpiece with a neutral background, allowing the colorful tile and coral to take center stage.

Around the pool, deck furniture in bold hues complements the pool design and serves as a visual transition from the house to the pool.

PROFESSIONALS | Architect: **Steven Harris Architects** Photographer: **Timothy Hursley**

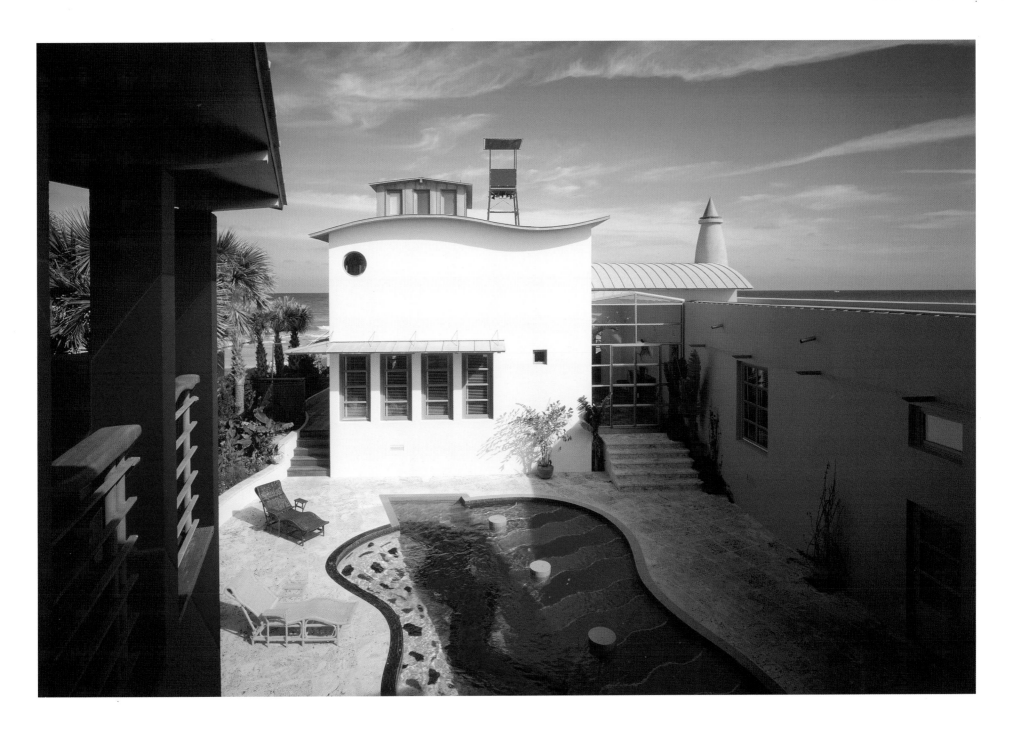

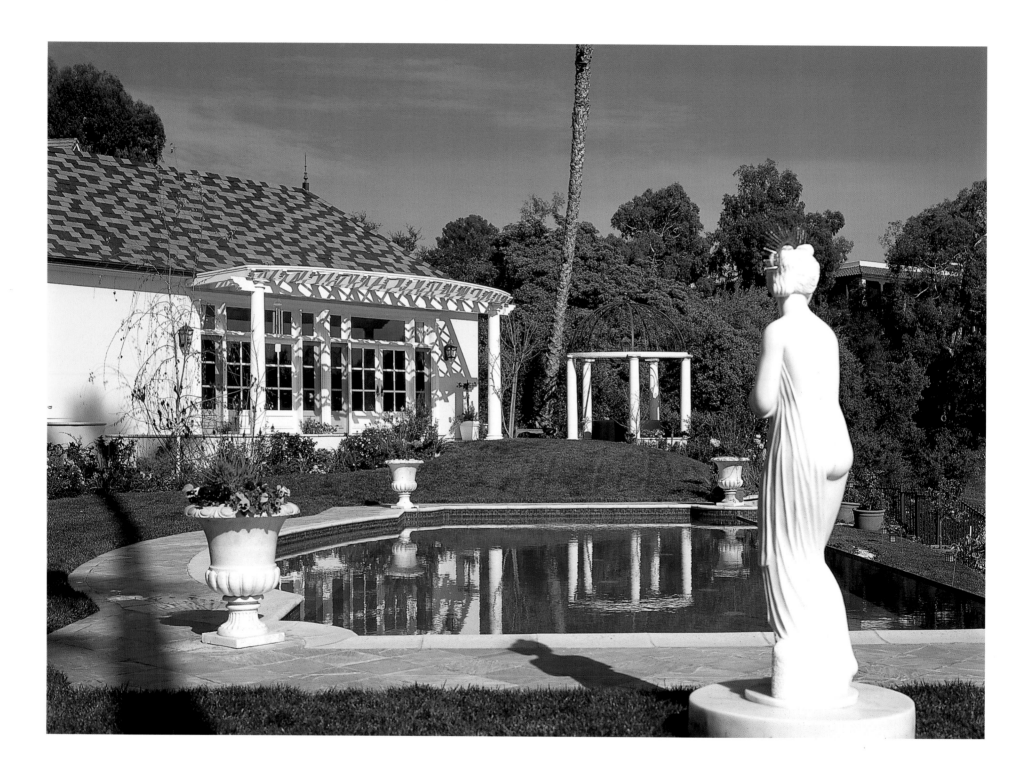

WHAT'S YOUR SIGN?

One of the best things about spa ownership is being able to luxuriate in hot-water splendor while gazing up at the celestial heavens on a clear, dark night. It's a moment of Zen-like proportions, the soothing powers of which some spa owners may underestimate. But not the owners of this portable spa, who take their hot tubbing so seriously that they designed and commissioned a temple dome for their spa that incorporates several major constellations. So even on cloudy nights the couple can relax beneath the protection of Orion and the glittering guidance of Ursa Major.

DESIGN DETAILS

A wrought iron dome, featuring five major constellations, caps a hillside temple designed specifically for a 7-foot (2.1-meter)-diameter portable spa. The dome was conceived by designer/owner Angie Thornbury, with astronomical help from the Griffith Observatory. An ornamental iron specialist executed the final design, which incorporates Orion, Taurus, Leo, Ursa Major, and Scorpio.

The foundation for the temple also serves as a retaining wall, allowing the temple to be perched on the hillcrest. Due to the extra weight of the spa, as well as the lateral forces of earth, oversized footings and rebar were used for extra safety.

The temple floor is covered with desert-tan slate to complement the nearby pool deck and surrounding patios. The pool's gray surface contrasts with the concrete coping and stone deck, while the glass mosaic waterline tile mirrors the blue vinyl covering of the hot tub.

Throughout the landscape, architectural elements pay homage to the temple. Marble Grecian urns surround the pool with colorful annuals, while a marble statue stands vigil. The Greek-inspired figure looks out toward the rolling vista, emphasizing the flow of water over the vanishing edge of the pool. The crown she wears is actually a cleverly devised deterrent to birds.

Location: **Los Angeles, California, USA**
Type of construction: **Gunite**
Pool finish: **Plaster**
Spa finish: **Vinyl**
Decking and coping: **Stone and concrete**

Λ
Five constellations are incorporated into the wrought iron dome above the spa.

<
A marble statue faces the spa temple and reigns over the poolscape.

PROFESSIONALS Landscape Architect: **Imagination! (Design Concepts)** Photographer: **Joey Terrill**

DIRECTORY OF DESIGN PROFESSIONALS

ADR, s.r.o.
Libinska 3127/1
150 00 Prague 5
Czech Republic
Phone: 420-2-5721-0252
Fax: 420-2-5721-0244
E-mail: adr@adr.cz
Web: www.arch.cz/adr

Allford Hall Monaghan
Morris Architects
2nd Floor, Block B
Morelands, 5-23 Old Street
London, EC1V 9HL
England
Phone: 0207-251-5261
Fax: 0207-241-5123
E-mail: info@ahmm.co.uk

Allgood Outdoors, Inc.
5235 Union Hill Road
Cumming, GA 30040
USA
Phone: 770-889-2207
Fax: 770-889-8815
E-mail: designn@alldoodoutdoors.com
Web: www.allgoodoutdoors.com

Antoine Predock Architect
300 12 Street NW
Albuquerque, NM 87102
USA
Phone: 505-843-7390
Fax: 505-243-6254
E-mail: studio@predock.com
Web: www.predock.com

Barclay & Crousse Architectes
22, rue de la Folie Méricourt
Paris, 75011
France
Phone: 33-1-49235136
Fax: 33-1-40216914
E-mail: archi22@club-internet.fr

Jonathan Bell
11 Sinclair Gardens
London, W14 0AU
England
Phone: 020-7602-8623

Peg Bergner
105 Pebble Springs Road
Phoenix, AZ 85014
USA
Phone: 602-532-3788
Fax: 602-532-3748
E-mail: pegbergner@earthlink.net

Black Creek Canyon, Inc.
12546 W. 159th Street
Lockport, IL 60441
USA
Phone: 708-645-7900
Fax: 708-645-7902
E-mail: brf3515@aol.com
Web: www.blackcreekcanyoninc.com

Cannon-Frank, A Design Corp.
340 W. Diversey, Suite 2516
Chicago, IL 60657
USA
Phone: 773-327-4099
Fax: 773-327-4005
E-mail: designer@cannonfrank.com
Web: www.cannonfrank.com

Michael E. Cartwright & Associates, Inc.
2019 Corral Drive
Houston, TX 77090
USA
Phone: 281-397-6120
Fax: 281-537-7373
E-mail: mecartwright@houston.rr.com

A. M. Luis Charmat
31 Egerton Gardens
London SW3 2DE
England
Phone: 020-7584-8544
E-mail: luis.charmat@lineone.net

Construction Zone
3002 N. 3rd Street
Phoenix, AZ 85012
USA
Phone: 602-230-0380

Creative Master Pools
537 Commerce Street
Franklin Lakes, NJ 07417
USA
Phone: 201-337-7600
Fax: 201-337-6826
E-mail: creativepools1@earthlink.net
Web: www.creativemasterpools.net

Custom Pools & Patio
4048 Chinden Boulevard
Boise, ID 83714
USA
Phone: 208-345-2792
Fax: 208-345-5299
E-mail: lorierchandler@att.net
Web: www.poolsandpatio.com

De Bartolo Architects Ltd.
4450 N. 12th Street #268
Phoenix, AZ 85014
USA
Phone: 602-264-6617
Fax: 602-264-0891
E-mail: debartolo@aol.com

Downes Pool Co.
433 Denniston Court
Wheeling, IL 60090
USA
Phone: 847-465-0895
Fax: 847-465-0970
E-mail: miachaelpdownes@aol.com
Web: www.downespool.com

Enrique Browne y Asociados
Los Conquistadores 2461
Providencia, Santiago
Chile
Phone: 56-2-2342027
Fax: 56-2-2345630
E-mail: ebrowne@entelchile.net

Duccio Ermenegildo
345 E. 56th Street, Apt. 16G
New York, NY 10022
USA
Phone: 212-754-2621
E-mail: dermenegildo@compuserve.com

Essig Pools
1800 NE 151 Street
N. Miami, FL 33621
USA
Phone: 305-949-0000
Fax: 305-649-5336
E-mail: essigpool@aol.com
Web: www.essigpools.com

Frangiamore Architects
500 Bishop Street
Atlanta, GA 30318
USA
Phone: 404-350-0719
Fax: 404-350-0829
E-mail: royf@mindspring.com

Ron Gibbons Swimming Pools
2995 Sunrise Highway
Islip Terrace, NY 11752
USA
Phone: 613-581-8258
Fax: 631-581-8273
E-mail: rgpools@aol.com

Macon E. Gooch, III,
Building Consultants, Inc.
742 Dacula Road
Dacula, GA 30019
USA
Phone: 678-442-1198
Fax: 678-442-1298

Juan Grim and Maria Angelica Schade
Zurich 221, OF.12
Los Condes
Santiago de Chile
Chile
Phone: 2341245
Fax: 2429815
E-mail: juangrim@terra.cl

Gym & Swim
8130 New La Grange Road
Louisville, KY 40222
USA
Phone: 502-426-1326
Fax: 502-429-8187
Web: www.gymandswim.com

H. Gary Frank Architects
723 Elm Street
Winnetka, IL 60093
USA
Phone: 847-501-4212
Fax: 847-501-4217

Steven Harris Architects
50 Warren Street
New York, NY 10007
USA
Phone: 212-587-1108
Fax: 212-385-2932
E-mail: sh@stevenharrisarchitects.com
Web: www.stevenharrisarchitects.com

Hoffman Landscape Design
9118 Sweetbrush
Houston, TX 77064
USA
Phone: 281-469-8316
Fax: 281-469-6276
Web: www.hoffman-landscape.com

Horvat Design Group
403 Rockland Road
Lake Bluff, IL 60044
USA
Phone: 847-234-5400
Fax: 847-234-5447

Imagination! (Design Concepts)
577 Perugia Way
Los Angeles, CA 90077
USA
Phone: 310-471-5025
Fax: 310-471-0098
E-mail: thornbury@earthlink.net

International Stone
6733 W. State
Boise, ID 83702
USA
Phone: 208-853-8600
Fax: 203-853-8602

Karzen-Langan-Burrus Construction, LLC
6500 Glenridge Park Place, Suite 3
Louisville, KY 40222-3450
USA
Phone: 502-429-5533
Fax: 502-426-2327

Katerina Tsigarida Architects
N. Votsi 3
54625 Thessaloniki
Greece
Phone: 30-310-535918
Fax: 30-310-535916
E-mail: tsigarch@spark.net.gr
Web: www.tsigarida.com

Kengo Kuma & Associates
2-12-12-9F Minamiaoyama
Minato-ku
Tokyo 107-0062
Japan
Phone: 81-3-3401-7721
Fax: 81-3-3401-7778
E-mail: kuma@ba2.so-net.ne.jp
Web: www02.so-net.ne.jp/~kuma

Landscape Horticulture Assoc.
44 Cortlandt Place
Tenafly, NJ 07670
USA
Phone: 201-568-1660
Fax: 201-568-5085

Leisure Living Pools
8720 Main Street
Frisco, TX 75034
USA
Phone: 972-335-2777
Fax: 972-335-2779
Web: www.leisurelivingpools.com

Loring Montgomery Evans
3900 N. Croft
Eagle, ID 83616
USA
Phone: 208-939-9636
Fax: 208-939-3847

Mack Scogin Merrill Elam Architecs
75 John Wesley Dobbs Avenue NE
Atlanta, GA 30303
USA
Phone: 404-525-6869
Fax: 404-525-7061
E-mail: office@msmearch.com

Steve Martino & Associates
3336 N. 32nd Street Suite 110
Phoenix, AZ 85018
USA
Phone: 602-957-6150
Fax: 602-224-5288
E-mail: steve@stevemartino.net
Web: www.stevemartino.net

Master Pools by Artistic Pools, Inc.
3884 North Peachtree Road
Atlanta, GA 30341
USA
Phone: 770-458-9177
Fax: 770-451-1899
E-mail: rcsr@artisticpools.com
Web: www.artisticpools.com

Master Pools by New Bern Pools
3646 Capital Boulevard
Raleigh, NC 27604
USA
Phone: 919-873-1777
Fax: 919-873-9030
E-mail: mhagemann@earthlink.net
Web: www.newbernpool.com

Manolo Mestre
Reforma 2009
Mexico, DF 11000
Mexico
Phone: 52-555-596-9545
Fax: 52-555-251-2498
E-mail: mmestre@mail.internet.com.mx

Myatt Landscaping Concepts
217 Technology Park Lane
Fuquay-Varina, NC 27526
USA
Phone: 919-577-6050
Fax: 919-577-6054

Natural Design
1360 Grass Valley Highway
Auburn, CA 95603
USA
Phone: 530-823-5164
Fax: 530-823-1974
Web: www.shastapools.com

Rock & Waterscape Systems, Inc.
11 Whatney
Irvine, CA 92618-2808
USA
Phone: 949-770-1936
Fax: 949-458-6331
E-mail: marketing@rockandwaterscape.com
Web: www.rockandwaterscape.com

Juan Eduardo Saavedra, Constructora
Lagosal
Serrano 149, 2° Piso
Santiago Centro
Santiago de Chile
Chile
Phone: 6336866
Fax: 6394500
E-mail: lagosal@entelchile.net

Scenic Landscaping, LLC
7 Argyle Street
Haskell, NJ 07420
USA
Phone: 973-616-9600
Fax: 973-616-5288
E-mail: scenicland1@aol.com
Web: www.sceniclandscaping.com

Shasta Pools & Spas
2930 N 7th Street
Phoenix, AZ 85014
USA
Phone: 919-401-2677
Fax: 919-401-2677
E-mail: pegbergner@earthlink.net
Web: www.shastapools.com

Michael Shelor Architect
1645 E. Turney Avenue
Phoenix, AZ 85016
USA
Phone: 602-532-9978
E-mail: meshelor@yahoo.com

Slaysman Engineering
1124 W. Camelback Road
Phoenix, AZ 85013
USA
Phone: 602-280-7777
Fax: 602-280-7773

Supreme Pools & Saunas, Inc.
9420 E. Doubletree Ranch Road, Suite 108
Scottsdale, AZ 85258
USA
Phone: 480-391-3830
Fax: 480-451-1772
E-mail: info@supremepools.net
Web: www.supremepools.net

Trout Studios
2727 11th Street
Santa Monica, CA 90405
USA
Phone: 310-581-0660
Fax: 310-581-9030
E-mail: strout@flash.net
Web: www.troutstudios.com

Ed Tuttle
71 Rue Des Saints Peres
Paris, 75006
France
Phone: 33-1-42-22-65-77
Fax: 33-45-49-18-49
E-mail: dretcm@compuserve.com

Ushida Findlay Architects
31 Oval Road
Camden Town
London, NW1 7EA
England
Phone: 020-7482-6204
Fax: 020-7482-6143
E-mail: info@ushidafindlay.com
Web: www.ushidafindlay.com

Watermania, S.A.
Avenida Hincapié 22-52
Zone 13
Gautemala City, C.A. 01013
Guatemala
Phone: 502-360-2734
Fax: 502-360-2724
E-mail: waterman20@hotmail.com
Web: www.watermaniaonline.com

Samuel H. Williamson Associates
120 NW Ninth, Suite 213
Portland, OR 97209
USA
Phone: 503-226-7742
Fax: 503-226-7763
E-mail: samw@shwa.net
Web: www.shwa.net

Timothy R. Winters Architect
317 Wallace Avenue, Suite 201
Louisville, KY 40207
USA
Phone: 502-893-2265
Fax: 502-899-5661
E-mail: trwint@iolky.com
Web: www.timwinters.com

Wise Pool Company
9016 Highway 242
Conroe, TX 77385
USA
Phone: 936-321-4242
Fax: 936-321-4221
E-mail: wisepool@flex.net
Web: www.wisepool.com

Youngquist Homes
2401 Weston Parkway, Suite 101
Cary, NC 27513
USA
Phone: 919-460-0047
Fax: 919-460-0108
E-mail: info@younquisthomes.com
Web: www.youngquisthomes.com

DIRECTORY OF PHOTOGRAPHERS

Eric Auerbach
421 Suzanette Place
Wyckoff, NJ 07481
USA
Phone: 201-847-8299

Suzie Bell
2037 Pandora
Boise, ID 83702
USA
Phone: 208-429-8334

Alan Benchoam
Alan Benchoam Photography
16 Calle 8-41, Zone 14
Guatemala City, C.A. 01014
Guatemala
Phone: 502-368-3655
Fax: 502-368-3681
E-mail: alanbenchoam@hotmail.com

Tony Benner
Tony Benner Photography
1039 N. Virginia Avenue NE
Atlanta, GA 30306
USA
Phone: 404-875-7889
Fax: 404-875-1187
E-mail: tbenner@mindspring.com

Tom Bonner
Tom Bonner Photography
1201 Abbot Kinney Boulevard
Venice, CA 90291
USA
Phone: 310-396-7125
Fax: 310-396-4792
E-mail: tbphoto@aol.com

Chris Cassidy
Chris Cassidy Photography, Inc.
1035 W. Lake Street
Chicago, IL 60607
USA
Phone: 312-733-4110
Web: www.cassidyphoto.com

Tom Cooney
TLC Creations
11601 S.W. 104 Court
Miami, FL 33176
USA
Phone: 305-235-5957
Fax: 561-619-0179
E-mail: tc246@aol.com

Jean Pierre Crousse
22, rue de la Folie Méricourt
Paris, 75011 France
Phone: 33-1-4923-5136
Fax: 33-1-4021-6914
E-mail: archi22@club-internet.fr

John Parris Frantz
JPF Assoc. Photographics
2626 N. Lakeview Avenue, Suite 4206
Chicago, IL 60614
USA
Phone: 773-871-2600
Fax: 773-871-2600
E-mail: jpfrantz@earthlink.net

Mitsumasa Fujitsuka
Helico
1-22-11-206 Sendagaya Shibuya-ku
Tokyo 151-0051
Japan
Phone: 81-3-5401-9221
Fax: 81-3-5410-9230

Dennis Gilbert
View
14 The Dove Centre
109 Bartholomew Road
London, NW5 2BJ
England
Phone: 020-7284-2928
Fax: 020-7284-3617
E-mail: info@viewpictures.co.uk
Web: www.viewpictures.co.uk

James Harris
10 Monthope Road
London, E1 5LS
England
Phone: 44-20-7247-0775

Frank Hart
114 Oak Ridge Lane
Wilmington, NC 28411
USA
Phone: 910-792-9602
E-mail: ghfilm@ec.rr.com

John Hughel
John Hughel Photography
265 N. Hancock Street
Portland, OR 97227
USA
Phone: 503-372-0640

Timothy Hursley
The Arkansas Office, Inc.
1911 West Markham
Little Rock, AR 72205
USA
Phone: 501-372-0640
Fax: 501-372-3366

Jeff Kidda
Kidda Photography
1593 W. Curry Street
Chandler, AZ 85224
USA
Phone: 480-820-4153

John Lair
John Lair Studio
800 E. Main Street
Louisville, KY 40206
USA
Phone: 502-589-7779
Fax: 502-589-4427
E-mail: john@johnlair.com
Web: www.johnlair.com

Charles Lipschutz
Charles Lipschutz Photography
2404 Aintree Way
Louisville, KY 40220-1025
USA
Phone: 502-485-1060
E-mail: charles@lipschutzphotography.com
Web: www.lipschutzphotography.com

Jacques P. Nuijten
6603 Walton Heath
Houston, TX 77069
USA
Phone: 281-586-8901

Christine Rydell
Natural Design
1360 Grass Valley Highway
Auburn, CA 95603
USA
Phone: 530-823-5164
Fax: 530-823-1974
E-mail: naturaldes@foothill.net

Carl G. Saporiti
Carl G. Saporiti, Inc.
108 Hidden Ridge Drive
Jamestone, NC 27282
USA
Phone: 336-883-8289
Fax: 336-883-8282

Michael Shelor
Michael Shelor Architect
1645 E. Turney Avenue
Phoenix, AZ 85016
USA
Phone: 602-532-9978
E-mail: meshelor@yahoo.com

Pam Singleton
Image Photography
P.O. Box 783
Scottsdale, AZ 85252
USA
Phone: 480-946-3246
E-mail: ps@photoexcursions.com
Web: www.photoexcursions.com

Guy Sloan Duvall
Guy Sloan Duvall Commercial Photography
13122 Red Fern Lane
Dallas, TX 75240
USA
Phone: 972-239-9899
Fax: 972-239-9899
E-mail: gsduvallphotography@hotmail.com
Web: www.gsduvallphotography.com

Bud Smith
Bud Smith Photo/Video
4300 South Second Street
Louisville, KY 40214-1522
USA
Phone: 502-558-3686
Fax: 502-366-1769
E-mail: fotojb@bellsouth.net
Web: www.bud-smith.com

Pavel Stecha
V Horce 189
CZ 252 28 Cernosice
Czech Republic
Phone: 420-2-51-64-24-08
E-mail: stecha@iol.cz

Tim Street-Porter
2074 Watsonia Terrace
Los Angeles, CA 90068
USA
Phone: 323-874-4278
Fax: 323-876-8795

Joey Terrill
Joey Terrill Photography
18653 Ventura Boulevard
Suite 135
Tarxana, CA 91356
USA
Phone: 818-991-5599
Fax: 818-991-2006
E-mail: joey@joeyterrill.com
Web: www.joeyterrill.com

Katerina Tsigarida
Katerina Tsigarida Architects
N. Votsi 3
54625 Thessaloniki
Greece
Phone: 30-310-535918
Fax: 30-310-535916
E-mail: tsigarch@spark.net.gr
Web: www.tsigarida.com

Fritz von der Schulenburg
The Interior Archive
6 Colville Mews
Lonsdale Road
London, W11 2DA
England
Phone: 44 20 7221 9922
Fax: 44 20 7221 9933
E-mail: karen@interior-archive.netkonect.co.uk
Web: www.interiorarchive.com

Ted Washington
42 Twisted Birch
The Woodlands, Texas 77381
USA
Phone: 281-367-0966

Guy Wenborne
Altura Ltda.
Ebro 2740 of 703
Las Condes
Chile
Phone: 56-2-2316123
Fax: 56-2-2333201
E-mail: foto@guy.cl

ACKNOWLEDGMENTS

Writing a book is not an enterprise one embarks on lightly—or alone. Though this book has been in my head for ten years, it began making its way onto paper just a year ago, after a lifestyle change afforded me the time to undertake such an assignment. Yet, it takes more than time to accomplish a project of this magnitude; it requires the support of family, friends, and colleagues—all of whom had to suffer through my oohs and ahs each time a new pool and spa project came in the mail.

A special thanks goes to my wife, Jen, who did the first read on the manuscript and kept my spirits high throughout the lengthy process with her constant plans for a book party, and to my young daughters, Olivia and Ivy, who did their best to keep our cat out of the office so she couldn't chew on photographs.

A note of gratitude also goes to Julie D. Taylor, an accomplished author and dear friend who helped me get the ball rolling. In addition, I thank Jennifer Bartlett for contributing the foreword to this book. Her art—especially her images of pools—has been an inspiration to me for decades.

Of course, my deepest appreciation goes to the highly skilled architects, builders, landscape designers, and artisans who put their hearts and souls into these pools and spas, as well as to the talented photographers who captured these spectacular projects on film. I know their work will encourage countless homeowners to embrace the pool and hot-tub lifestyle and wonder what's taken them so long.

ABOUT THE AUTHOR

During his twenty years as a writer and editor for newspapers and magazines, Alan E. Sanderfoot spent nine of them editing *Aqua Magazine*, a trade journal for swimming pool and hot tub professionals. The job combined his fondness for magazine journalism with that of aquatic recreation.

Mr. Sanderfoot's love affair with swimming pools began when he was just five years old and passed the skills test required to swim in the city's public swimming pool, where he spent countless summer hours splashing sun-bronzed lifeguards and challenging friends to water sports. In the late 1970s, his family moved to the country and installed a backyard pool of their own.

After high school, Mr. Sanderfoot worked his way through the University of Wisconsin at Eau Claire as a swim instructor and lifeguard while honing his journalistic skills. Following college, he worked several magazine publishing jobs in New York City before returning to his home state of Wisconsin to start a family.

© DAVID JOLES

Currently, he runs his own editorial, public relations, and graphic design firm in Madison, Wisconsin, where he lives with his wife and two daughters—all enthusiastic swimmers who enjoy relaxing soaks in the family's hot tub.